# Agony & Alchemy

## Sacred Art and Tattoos

# Agony & Alchemy

## Sacred Art and Tattoos

M. Young

The following artwork © 2005 by Marcus Allsop: *Om Kali*, p. 151; *Green Tara*, p. 153; *Ganga*, p. 155; *Snow Lions*, p. 157; *Amitayus Buddha*, p. 159; *Mayuresvara Ganesha*, p. 161; *Nepalese Ganesh*, p. 163; *Iswarya Lakshmi*, p. 165; *Red Alokes*, p. 167; *Yellow Hase*, p. 167; *Madurai Minakshi Makara*, p. 169; *Krishna*, p. 171; *Kiriti Mukha*, p. 173; *Green Tara Bazuband*, p. 175; *Medicine Buddha*, p. 177; *Anjaneya Vinayaka*, p. 179; *Durga*, p. 181.

Cover design: Zachary Parker
Book layout: Becky Fulker

Library of Congress Cataloging in Publication Data

   (Application submitted)

ISBN: 1-890772-49-6

Hohm Press
P.O. Box 2501
Prescott, AZ 86302
800-381-2700
www.hohmpress.com

This book was printed in China on acid-free paper using soy ink.

09  08  07  06  05            5  4  3  2  1

For Lee

AUTHOR'S NOTE:

For the sake of simplicity, diacritical marks have not been used for
Sanskrit words, phrases and names that appear in the text.

# Contents

# Preface

If you are reading this, you have begun an excursion into the world of tattoos—most specifically, the land of sacred image as skin art. It is, at the very least, a photographic odyssey that reveals the ancient art of tattooing as an expression of the divine in the contemporary world today. Tracing the path of the tattoo experience through historical perspectives into the counterculture's embrace of *tatouage* as art and icon of freedom, this is a journey that goes beyond personal change and the usual considerations of popular trends into a transpersonal, universal experience of art and alchemy that is compelling, primal and sublime.

The explorations presented in these pages are not based on ideas or theories, but are the fermentation of real experience, communicated most vividly in the photographs of flesh and blood people and their tattoo art. My passion for both Eastern and Western spiritual traditions has led me to contemplate the relationship between creativity and mysticism, archetype and art, and so in the world of tattoos I have discovered a symbolist's treasure trove: it "reads" like a waking dream, laced with universal and personal symbolism of rich nuance and variety that leads to the archetypal world. In writing about sacred tattoos, I found it only natural to turn to the insights of renowned mystic, scholar and psychologist C.G. Jung, whose realizations about the nature of reality and the collective unconscious have changed our understanding of the world in many ways.

Most of all, this is a book that looks at tattoos with the eye of the heart. It is a work in praise of beauty as an expression of the sacred. The need for personal and global transformation at the level of the human heart has never been more urgent than it is at this time in history. It is in the spirit of that aim that the transformational possibilities of sacred images emblazoned on the canvas of the human body—the alchemy of tattoos, as they are presented here—is offered to the reader.

This book features Aaron Funk, a tattoo artist in southern California who tattooed the images that appear here, and Nara, the artist who created the mixed media art that appears in the photographs and original art color plates. It has been a great joy to honor their work in this endeavor. Nara is a long-time tattoo enthusiast and student of the spiritual path, whose natural talent as an artist and passionate love for sacred art has been finely honed in his ongoing apprenticeship to British artist and *thangka* master Robert Beer. Unless otherwise indicated, the artwork presented in this book is the creative work of Nara; however, as noted in the captions, many of the tattoo images are from popular sources of Hindu, Buddhist or Christian iconography as interpreted by Aaron Funk, and several of the line drawings were originally executed by Robert Beer.

My deepest appreciation goes to all those who were willing to share their tattoos by posing for the photographs in this book, and to the photographers, Laurent Belmonte in France and Dana Dieterich and Sylvan Incao in the United States. Many thanks also go to the artists and staff at Tattoo Revolution in Redlands, California, and to Gita Lozowick Duddridge, all of whom graciously agreed to appear in this book. Thanks to Paula Zuccarello, who made many valuable suggestions in reading the manuscript, and to Becky Fulker, Zachary Parker and Nachama Greenwald for their help.

In particular, I would like to thank Robert Beer, who wrote the Introduction for this work. Finally, I would like to express my gratitude to both Aaron and Nara for the largest of their contribution to this project and most of all to Lee Lozowick, who brought Aaron and Nara together and opened wide the doorway to the creative world of tattoos and sacred art.

M. Young
March 21, 2005
Prescott, Arizona

# Foreword

Tattoos. They have inspired wonder, awe, derision, curiosity—you name it, tattoos have gotten that response. Sacred tattooing has existed, most likely, as long as mankind. In fact, what is usually called "the world's oldest profession" is probably the world's second oldest profession, for it is almost certain that said professionals were tattooed to enhance their beauty, mystery, desirability and to distinguish themselves. Yes, tattooing goes back a long, long time.

Of course not all tattoos are sacred, but the mundane nature of much contemporary tattoo work certainly does not detract, diminish or negate that area of tattoo art, and make no mistake about it, tattooing is a genuine art form that is truly sacred in the holiest sense of the word. In tattoo culture the inking of the skin is not only initiatory; it is an act of devotion, of worship, though many might not use that language to describe it. The mood or feeling still persists, even when the images are more secular, and when the images are themselves of the sacred traditions—are themselves objective symbols of prayer or adoration—what miraculous consequences are engaged!

This book is about the Sacred, and the art of the tattoo is the medium through which this subject is approached. Yes, I am a great addict of "tatouage," but don't let my enthusiasm fool you. It is the commitment to the Sacred that is really the issue. The skin is temporary. It changes form, even quite dramatically, as the years fly by, but the subtle impressions that sacred imagery engrave upon the soul do not fade or pass away when the skin ceases to exist. Herein lies the essence or heart of the sacred tattoo. The tattoos in this book are not ornaments or decorations, dare I say, not even a luxury of self-indulgence. They may even be a necessary element of the sacrifice of the body and mind to the inevitable laws of time and space.

So read this book not just as throwaway entertainment, but as a study guide to your being and to the universal influences of the cosmos itself. And enjoy the pictures. It is a pleasure to see the extent to which the multiple talents of fine artists can effect the worlds we live in. Well, we could go on and on, but I will leave that to the author of this book. See you on the other side.

lee lozowick
Prescott, Arizona
13 November, 2004

# Introduction

Having grown up in post war England my reflective impressions of the human tattoo are perhaps stereotypical. I remember my father's arm and the bright blue and red heart that bore a scroll bearing the name of my mother Nadia. And my seafaring uncle Ron, who periodically arrived in a taxi bearing exotic gifts, like a Brazilian tray made from iridescent butterfly wings, or a baby monkey from Bombay that soon began to wreck the house, and ever a new tattoo that told of yet another distant ocean or exotic seaport. Through association the tattoo came to represent the image of confinement: an insignia of freedom and self-respect for the prisoner, a symbol to mark the passage of return for the homebound sailor, and an enduring witness of racial inhumanity for the indelibly numbered Holocaust survivor. Yet somehow the tattooed arm or shoulder spoke of masculinity, of courage and hope in the face of the recent world war, of premature manhood and the prospect of returning safely home to the warmth of a mother's or sweetheart's arms.

There were names and hearts, crosses and skulls, daggers and anchors, and saucy women with mermaid's tails. There were backstreet tattoo parlours in seedy red-light areas, with neighbouring shops that sold surgical trusses, and where men in raincoats secretly fingered through the pages of nudist magazines. Yet these were the days of innocence, of family values and Sunday school, of rationed goods and grazed knees. But then came the days of experience with their promises of individuation and gratification into excess, and with the birth of rock and roll came all the thrills of the fair, bikers and beatniks, birth pills and beads, and rumours of the dawning of a new age called Aquarius.

When I was about nine years old my uncle brought me back an enamel medallion from one of his long sea voyages. I believe that it came from Egypt, and was probably bought from a trader along the Suez Canal. This medallion displayed the image of a six-pointed star with a swastika at its center, and a short inscription underneath in either Coptic or Hebrew. Somehow this amulet with its protective prayer resonated with something in my soul, and this 'something' was a deep and innate sense of primordial magic. At that time I had no understanding that this symbolic design was actually a *yantra* or 'visualization device,' but I fell madly in love with it and mourned its passing when it finally disappeared—as all of the things that we love tend to do. Yet throughout my life this symbol of a six-pointed star with a swastika at its center has remained with me, and even now whenever I doodle or 'leave my mark' through scratching on a stone or a piece of wood, it is always this symbol that springs from the unconscious. And although I personally bear no tattoos or wear any jewellery, this symbol would be my immediate choice were I to do so.

The dictionary defines the word 'symbol' as something that represents or stands for something else, especially a material object used to represent something abstract. As vehicles of abstraction in a material world symbols have a way of clinging, a way of penetrating into the brightest luminosity and darkest recesses of the human soul. As abstractions they may simultaneously point towards spiritual heavens and the darkest shadows of the underworld, they tell of our aspirations, our hopes, dreams, fears and secrets. For me personally my childhood medallion served as an 'initiatory sign' into the interior world of esoteric symbolism, especially into the realms of Hindu and Buddhist Tantric symbolism, which I have studied deeply throughout my life. A similar event happened to a good friend of mine, who as a young man was given a copper plaque of a Tibetan astrological diagram, and from his initial interest in its symbolic meaning he is now one of the world's greatest experts on Tibetan astrology and Buddhist cosmology. From an acorn a mighty oak tree can grow, but it takes much time, nourishment and determination. William Blake once wrote: "Eternity is in love with the products of time, and a little flower is the product of ages."

If we wish to find water we sometimes have to dig very deeply to establish a well. We also have to have belief in this process,

as faith is the evidence of things not seen. It rarely transpires that we can find water with just a shallow digging, and to dig shallow holes everywhere will never alleviate our thirst. In recent years religious symbols have become fashionable decorations in tattoo art, and I am aware that many of the line drawings that I originally made for my *Encyclopaedia of Tibetan Symbols and Motifs* are now being used as body designs. I am occasionally asked how I feel about this and there is not much I can say, as it is every individual's free choice of how they perceive and express their self-image to the world. For me personally the spiritual path is not about self-expression and outer appearance, but about self-annihilation and inner transformation. But behind all this is an awareness that these esoteric motifs—be they deities, mantra syllables, geometric *yantras* or auspicious symbols—may impinge repetitively as mental icons in an individual's search for meaning and act as catalysts for genuine spiritual transformation. In India there are holy men (*sadhus*), whom in an act of devotion to their beloved deity Lord Rama have the mantra *ram* tattooed over their entire body from head to foot. As individuals we all tend to self-identify with our favourite characters in fiction. We must choose our role models well, and there are none better than the divine gods and goddesses that mankind has fashioned in his or her own innate image. It is my hope that some of the sacred tattoo designs illustrated in this book may inspire people to delve deep into their own waters of devotion, for as the *I Ching* or 'Book of Changes' states: "The city may change or move, but the well is immoveable."

> Longing is the core of the mystery,
> Longing itself is the cure.
> The only rule is—suffer the pain.
> Our desires must be disciplined,
> And all that we want to happen in time sacrificed.

Robert Beer
Oxford, England
March 2005

# Prologue

# Prologue

My passion for tattoos started when I first went under the needle to get one small word in Sanskrit tattooed on my skin. That word carried very big reverberations of meaning for me and was the beginning of an ongoing experiment with skin art that became a source of revelation. Little did I know that the world of tattoos, taboo for so many decades in the West, would lead me more deeply into my lifelong passion for the sacred, or *Sattyam Sivam Sundaram*—truth, bliss, beauty.

I met tattoo artist Aaron Funk, whose tattoo work appears in this book, in 1999 through my friend Gita, whom I had known for many years and at the time was in school at the University of Redlands in California. That year I watched her get the mantra "Om Mani Padme Hum" tattooed in tribal black across the pristine surface of her perfect young back. When she showed the image to me before the tattoo started, the first thing I said was, "You can get that reduced, you know?" It was huge! At the time Gita had only a few well-placed delicate tattoos, a beautiful lotus and an Om sign.

"No," she said with straightforward certainty, "I want it this size."

"Are you sure?" I asked, incredulous. I hadn't been bitten with the passion for tattoos quite yet—Gita was way ahead of me. The mantra now covers her upper back, from the edge of the right shoulder to the edge of the left shoulder. The next day I had my first initiation into the tattoo experience. At the time Aaron was twenty-one years old.

Several years and a few tattoos later, I drove with friends from Arizona to Los Angeles in mid-May 2004, passing through the familiar dry bones of the desert, where sand and rocks are punctuated by chaparral and sage, and purple jutting mountains rise to meet the distant horizon. The desert always inspires my imagination, and on this trip it seemed a lot like the tattoo experience taken to its depth, where a certain raw power and primal intensity speaks to something in the soul. In the desert the friction of opposites creates a delicate alchemy—the burning sun mixed with the precious rain that falls now and then to soak parched earth and make the arroyos run in torrents.

Arriving in Redlands, California on the outskirts of L.A., we headed for Aaron's new shop, Tattoo Revolution, in search of more tattoos, which meant we would do a lot of sitting over the next three days while we took turns getting inked. Over the weekend I got acquainted with some of the people who work at Tattoo Revolution—an interesting group of guys immersed in the tattoo subculture of our times: the "Brent Man," Aaron's partner and fellow tattoo artist; Trino Ayala, a former school teacher, now a professional body piercer; Jimmy Martinez, a tattoo artist who learned his art from Aaron; and Alan Fitzgerald, also a body piercer and novice tattooer.

The guys who work at Tattoo Revolution are heavily tattooed, and some have multiple piercings, but there is nothing faddish about their lifestyle. They are real people, some of whom have seen the harsh side of life and lived to carry on. Aaron himself lived on the streets as a teenager and then spent two years in a juvenile detention facility. From rough beginnings, he has completely turned his life around; now it's about art, managing a business and taking care of his young son, Gabriel.

Aaron was the first tattoo artist I'd encountered in the winding course of a life that has taken me through many different experiences, people and places. In the process, I've discovered that the sacred—the central focus of this book—often hides in ordinary life, even in the profane, and especially in the invisible places where we don't think to look. This was never more true than in the multi-dimensional encounter of hanging out in a tattoo shop with friends for three days.

At Tattoo Revolution I found a world populated with the sacred and the profane: demons and angels that co-existed, in a strange kind of harmony, along with tribal designs, beautifully rendered images of Jesus with the crown of thorns, Mary, Queen of Heaven, death heads, skulls growing roses, frankly sexualized caricatures of women and enough lurid flash art to make your head swim. The wall above Aaron's stall was graced with a print of Avalokitesvara, the great Buddhist bodhisattva of compassion.

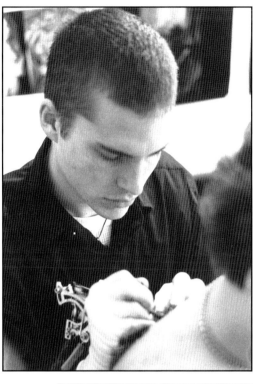

It has taken some years of life experience to know with certainty that there is no conflict between these apparent opposites, but rather a flow of continuity. As we waited for the first tattoo to get started, I looked around and reflected on the great Taoist symbol of the yin and yang—the two polarities in Chinese philosophy, from whose interaction and fluctuation the universe and its diverse forms emerge. In the same way, without the profane there is no sacred; at the core of each we find the seed of the other.

Two hours after we arrived I was sitting in the waiting area with a friend while our companion was getting a tattoo from Aaron. The grinding buzz of the needle had become a very familiar background drone as we sat on the faux leather couches watching *Big Fish*, a popular movie directed by Tim Burton, on a television mounted

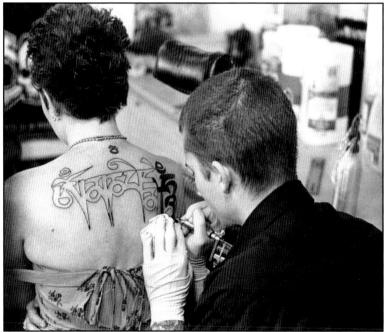

*Aaron tattooing Gita's back.*

high on the wall above the reception desk. Aaron's five-year-old son, Gabriel, and body piercer Alan Fitzgerald had joined us. Now and then Gabriel would pipe up with a question about the movie, which he watched with avid enthusiasm. He had made a little game of the thick silver chain he'd taken from around my neck because it reminded him of a snake.

Alan struck up a conversation with us and responded candidly to my question about his tattoos, which covered his arms, legs and neck. Since he was wearing a big T-shirt and low-slung baggy jeans, belted below his butt in street punk style, with white cotton undershorts to the waist, I couldn't tell exactly how much of his body was covered with tattoos. He looked like he was about twenty-four years old.

"I've gotten nine thousand dollars' worth of tattoos since I was nineteen years old," he said, showing us the mass of interlaced tattoos on his arms.

"It's a better habit than drugs," my friend remarked.

"I don't do drugs," Alan stated flatly. "You know, I *look* worse than anybody else in my family, but I'm not a problem—I'm the least problem of them all!"

We turned back to the movie. The scene was playing in which the giant is being convinced to stop terrorizing the local people by the main character, played by Ewan McGregor. The giant in *Big Fish* is played by actor Matthew McGrory, a seven-and-a-half-foot tall man.

"I actually met him, at the Ripley's Believe It or Not Museum in Hollywood," Alan interjected. "You know, his parents are really little—normal, in fact. He weighed fourteen pounds when he was born."

Alan told us that "giants" like Matthew McGrory don't live to be

very old because of the strain on their hearts caused by carrying so much weight and height. Alan then spoke passionately about the difficulty experienced by boys, like himself, who grow very fast during puberty—the emotional pain of suddenly being very different, the feeling of being out of control of one's body and trapped in an awkward, sometimes bumbling frame that seems too big for the person inside it.

"Imagine what it was like for the giant when he was growing!" Alan mused thoughtfully. "When I talked to him, he was sad because he can't do anything for a living but be a 'spectacle.' He's just a freak to most people. Like the two midgets I saw at Ripley's Believe It or Not. You know, I've chosen to be different. I could *choose* this," he gestured to his tattoos and facial piercings, "but they were born with that—they didn't have any choice."

He shook his head in dismay as we thought about the pathos of Matthew McGrory's life: the burden of being treated like an outcast, an aberration in the fabric of the social order. As I looked closely at Alan, I thought about the choices he has made. He had large spool earrings in his earlobes, which had been stretched to accomodate them with holes about one inch in diameter. In his lower lip two silver studs protruded like fangs on each side of his mouth. His head was shaved, and tattoos splashed boldly up and across his arms and neck.

Alan was a friendly and thoughtful conversationalist, but many people would judge him because of his appearance and chosen lifestyle. It's the kind of prejudice that has made tattoos one of our society's long-held tabboos. As clients, we were three people of an older generation, with our own context for getting sacred art engraved into our skin, and yet the staff at the shop accepted us fully. A few months later I read in *Tattoo* magazine that Tattoo Revolution bears the distinction of being known as a friendly shop that welcomes everyone, regardless of age, beliefs, taste in art or personal persuasion. That was certainly my experience.

We began to talk enthusiastically about the tattoo work we were getting: Sanskrit words and Hindu deities. Alan mentioned a tattoo artist he knew in San Francisco.

"You'd really like his work—he does the same kind of tattoos you're getting," he offered enthusiastically. "My aunt and uncle spent five years in India. I'm really close to them. They like it when I come over 'cause I love to look at all their cool things from India. I really like the Indian art.

"I remember a Shiva tattoo I saw once. It was really fine, done in gold and reds and pinks, the hand coming out like this," he gestured gracefully to show us. "Beautiful!

"I can't believe the things people have tattooed on their bodies," Alan continued, "like barbed wire. Why? I like monsters and anything mythological . . . I see people come in and look through incredible portfolios of tattoo art by the tattoo artist and then say, 'I'll have a star.' What's the point? What are they getting the tattoo for?

"I'm not into single tattoos. I'm getting my whole body tattooed from the neck down. You know, there are tattooed people and then there are people who have tattoos. Those of us who are really into tattoos—we do our own thing. We stick together. We've made that choice."

"A kind of community, would you say?" I ventured.

"Yeah, sort of," he responded, then turned back to the movie.

What Alan was describing—a commitment to a certain way of life that exists outside the mainstream culture—was something I could easily understand, coming of age in the radicalized generation of the late sixties. "Tattooed people," as he was describing them, seemed to have some things in common with my generation. We refused to fall into line as model citizens who would conform, get a nine-to-five, pay our insurance, buy a house in the suburbs, join the consumer frenzy and feed the system. But times have changed since then—in the sixties a song like Bob Dylan's *Masters of War* could still be aired over prime

radio stations. Nowadays it would most likely be censored or banned.

I reflected further: Alan was right. We are extremely fortunate indeed that we still have the opportunity to choose to be different. Anyone who chooses a life of honesty, dignity, a life of creative fire informed by self-knowledge, must forge a path through the morass of our contemporary culture. The possibility of a noble and just society—Walt Whitman's great vision of America as a poem in and of itself—is a long-broken dream. Aldous Huxley's "brave new world" is already here; it has been here for thirty years or more. This is the brave new world, only it's not brave, and it's not new; it is insidious, dark and treacherous.

Everything around us is lulling us into a sleep of no return; the sirens that seduce us into sheer mediocrity are everywhere. I have found it extraordinarily amazing that tattoos—one of the great taboos of our society—have turned out to be a powerful reminding factor of what I really want in life. It is a juxtaposition of grand proportions that tattoos, of all things, could be one of the most potent reminders of our highest potential. Yes, I thought, we can still choose to be different.

*Big Fish* kept unreeling on the television as we watched the outlandish stories of the main character unfold before our eyes. The storyline asks the question: Are the stories of the father real or not? Is he just telling lies, as his cynical grown son believes? As it turns out, the father's stories are all true, but mythologized in a way that gives the story of his life a depth and radiance, a numinosity. With these mythologized stories, actor Albert Finney's character is making soul.

"This is a really good movie," Alan commented after a while. Then he said, "It's a sad movie."

"Sad in a good way," I added, enjoying the subtle flavors of our conversation.

"Yeah," Alan agreed. An easy silence fell over our little group as we reflected on these things, until Alan said, "I love Tim Burton! He's my favorite director. Have you seen *Mars Attack?*"

Yes, of course I had—I laughed all the way through it.

"I'm gonna get my whole back done in the characters of *Mars Attack,*" Alan confessed lightly, and yet he was serious. Talk about mythological monsters! *Mars Attack* is one of those movies that satirizes the falsity of modern culture—the nostalgic, sentimental face of denial that keeps us from seeing the imminent danger of our folly, as we fiddle while Rome burns. Do we really believe what the masters of war tell us? Can we trust our leaders, preachers, our new age gurus?

The next day at Tattoo Revolution a young man named Jeff Baker stopped by to talk with Aaron. Immediately I noticed that Aaron treated him like a brother or close family member. After he left, Aaron explained to us that they had known each other since they were fourteen, when Jeff was the recipient of Aaron's first attempt to give a tattoo.

Known to Gabriel and the guys around the shop as "King Jefftowne," Jeff had recently been released from a one year prison sentence for drugs, and Aaron had given him a job at the shop. His affection and loyalty to Jeff were a strong testimony to the heart Aaron brings to his life and work. After telling us a little of Jeff's story, Aaron said, "I'm lovin' on him a lot. I want to keep him off heroin and off the streets."

One of the things I've learned about Aaron is that he goes out of his way to help others turn their lives around—like extending himself to rework prisoner's tattoos for free so that when they come out of prison, they aren't branded with "fuck you" scorched in permanent black ink across their knuckles or forehead. A large part of why we three travelers from Arizona, with our own context for skin art and sacred image, were so easily accepted at Tattoo Revolution was because of Aaron. At age twenty-seven he has already been forged in the fires of life. Aaron is a devoted father to his son, a highly successful tattoo artist and kick-boxing enthusiast. He strikes me as someone so fundamentally true to himself that he doesn't need to wear his street stripes in any visible way, and therefore he appears to be very ordinary, with the exception of the maze of tattoo work that covers his arms and legs.

That night, as I lay on the massage table in Aaron's cubicle, needle to flesh, Jeff stopped by again. Later I would write about it in my journal:

*It's a meditation on pain. For some reason this tattoo is much harder than the others. In the tattoo studio, laboring under fluorescent lights, I see the young man we met earlier today walk up and look down at me.*

*"Does that hurt?" Jeff asks. It is not an idle question, nor is it the question of someone inexperienced in the ways of pain. He is covered with tattoos himself—arms and neck a labyrinth of underworld*

*images, symbols of betrayal and loss flowing in shades of black down the soft skin of the inner arms. I think that he has probably pushed more heroin needles into his skin than anyone knows.*

*Looking up, I nod, "Yes, it hurts."*

*"I would never get a tattoo there," he points to the tender skin along the ribs just above the waist, where Sanskrit mantras now appear as dancing, living beings that encircle my body. "Ouch! No way!" He shakes his head appreciatively.*

*Pain is pushing me up against an edge inside myself as the needle hits some primal place. There are moments when I have the unsettling sense that I may not be able to breathe and meditate my way through this one. It passes, I manage not to whince too much, but swim in the river of all things under those bright city lights.*

*The next day I am blissful and feverish. The Sanskrit words on my body are like flames; they have a life of their own that whispers to me. I am washed and rocking in an ocean of mercy, burning in a sea of emptiness. These Sanskrit words will be with me until the end, when this body turns to dust, but the Hindus say that sacred tattoos go with us to heaven and earn merit for future lives. Maybe, just maybe, a sacred image lives on in the mystery of the soul.*

After the tattoo was done, with body and mind altered, senses raw and open, I walked two doors down to the corner liquor store, whose clientele are the neighborhood working class people, some local indigents and folks off the street. As I reached for a bottle of cold water, I imagined that the more affluent, privileged shoppers would probably frequent a different shop for their Romanee Conti. At the counter I was greeted politely by a gritty and seemingly bone-tired Lebanese man who smiled at me very sweetly, made change and then said, "Thank you very much. You have a good day." Clearly he appreciated my business, even for a bottle of water. In return, his sincerity generated gratitude in me—authenticity is a highly valued commodity in this world of hype and spin tactics.

On the way back to Arizona on I-10 through Death Valley I reflected on our time at Tattoo Revolution. We had visited a crossroad where two or more worlds met and merged; somehow it is there, at the tangent point, that something magical happens—a mutual enrichment, a cross-pollination. I pulled out my notebook and wrote down the conversation I'd had with Alan. As we crossed the Colorado River into Arizona I was still thinking about it. What a contrast it was to an experience

I would have five months later in Paris, recorded in my journal during a time when I was traveling and encountering the tattoo world in various ways:

*Went to interview a woman in Paris who does tattoos—she was recommended by a friend who saw her work. "Sure, come on Friday at eleven," she said. "It's a dangerous neighborhood," she said. "No problem," I responded with enthusiasm, "we love Paris and know it well. We'll be there." We stood on the street corner for over an hour outside her shop, waiting for her. The neighborhood wasn't exactly uptown, but it wasn't rough in any way. The sign at her address said "art gallery." She never showed, never called to cancel.*

*Paris is full of tattoo shops, as is every large city in France, Germany and most of Europe, where tattoos and graffiti art proliferate. It's great to see how the love affair with skin art has traveled all over the Western world. I heard from a young Parisian friend that the best tattooists in France are in the south, in Aix en Provençe.*

*I was introduced by friends to a tattooist named Pele in St. Galan, Switzerland. He was warm, friendly, busy tattooing a man who was getting his whole back inked. He stopped his work long enough to shake hands, and, despite the language barrier, we met on a common wavelength. He reminded me a little of Aaron.*

*Later I heard about a place that touted "Sacred Art Tattoos" in the States—another young tattoo artist seeking the fast-growing edge of this industry that has its own competitive angles. He never returned my calls. Hmm. We pay lip service to "the sacred" and yet we can't even show basic integrity to others, like answering phone calls. It wasn't the first time I'd run into the disagreeable way the new age orientation takes what was once alive, original and vitally real and makes a watered down, syrupy version of it.*

*There is nothing watered down and syrupy about tattoos. The heritage of the tattoo is one of primal and elemental realities of life not easily accessed in our white-washed consumer culture of complaisance.*

*The gypsies in Europe are one of those marginal groups of people who understand about tattoos. In the French countryside outside a marché au puce I saw a gypsy woman selling handmade baskets. The bright sun shone on her forearms, wrists and hands where strange tattoo marks flashed in the light. Three blue-black dots configured in a particular way on her hand between the thumb and forefinger caught my attention. She spoke to me in a French dialect,*

*insisting that I buy a basket. "No, merci," I answered several times. She knew I was curious about something and kept offering a basket. My French not being good enough to really converse with her, finally I had to walk away, feeling a bit like just another gorgio.*

Later that summer I found a book in Paris about street people in France and found this same symbol—three dots—to be the sign of a particular gang. *Les durs, les vrais, les tatoues*, the text stated: The tough ones, the true ones, the tattooed ones. Months later I discovered that the tattoo of the three dots means *mort aux vaches*, a statement of protest that loosely translates in the vernacular as "kill the pigs" (although *vaches* is actually "cows") or "fuck the world." [2] Back in the States in the fall, I saw the same tattoo in Aaron's shop. He said that it's common in southern California, and in the language of the streets it means *mi vida loca*, or "my crazy life." When I asked a Mexican friend what he thought of that translation, he said that it did not adequately communicate the meaning of the phrase. "It's about freedom," he said.

The tattoo mystique carries something of this street code of freedom, of living outside the norm—the gypsies, the odalisques of old, the seamen who carried tattoos all around the world, artists and musicians, the wanderers and warriors who have always refused to dance to Caesar's fiddle . . . What secrets might they hold for those who are interested in sacred art as tattoos?

This is a book about the alchemy of transformation through the specific medium of sacred art tattooed on skin. Alchemy is a classical aspect of the great spiritual traditions around the world, from shamanism to Taoism; it is found in tantric Hindusim and Buddhism, in esoteric Christianity, in the Fourth Way of G.I. Gurdjieff, in hatha yoga, and in Sufism. With the help of a true guide and a true path, that which has alchemical effects can be found in many places—like tattoos. To endure such an alchemy requires many of the same qualities, transposed into the context of spiritual transformation, that one might find in those who have always been the "tattooed ones"—the tribal people, the gypsy clans, and even street gangs: steadfast loyalty, warriorship, strength and commitment of purpose, the ability to endure hardship, a passion and capacity for life's pleasure and pain, and perhaps especially, living outside the expectations and regulations of society's norm.

I went to Tattoo Revolution to get sacred images tattooed on my skin, to enter into a relationship with one of the most ancient languages known to humankind—Sanskrit, considered a living deity in its own right and brought into this world through ecstatic, mystical revelation by the ancient *rishis* or seers. There was a definite thread of continuity between my vision of skin art and this particular tattoo world, where the artists make their path through life by a completely different means than my own. I loved it that Aaron and the other guys at the shop were simultaneously tough and gentle, friendly and cool, living by a certain code of integrity, not looking for anybody's approval. Aaron does what he loves to do, and he brings real integrity to it—that alone lends his actions the power of sincerity, a genuineness of being. This is the *dharma* (the Sanskrit word for the cosmic law, or that which is virtuous and ultimately good) in action.

The world of tattoos is really no different than any other theatre on life's stage, where the commitment to an all-inclusive vision shines in any one act of integrity. In the same way, an act of generosity or human warmth may be all it takes to make a difference in someone's life, for it is those moments, when we have reached out to another person and bridged the gap of our seemingly separate experience, that we become truly human.

Happily ensconced in a tattoo shop in a strip mall in Redlands, Aaron and his friends were no new age pretenders to spirituality, and it was this quality of realness, toughness, trueness that lent strength and power to my own experience of sacred art as tattoo. Through them, I discovered that I could not write this book without expressing in full measure my appreciation for the legacy of the traditional tattoo world in the West as it has existed over the years and the contemporary tattoo art and artists who have made this incredible medium of expression available to me and many others.

The sacred and the profane are everywhere we look. It is one of the great epiphanies of life when we truly understand that we cannot judge "the book by the cover" in terms of what is sacred and what is profane, because they are ultimately one and the same. In that moment of realization, the dichotomies of good and bad are dissolved into connectedness, unity, life in all its glory.

What we find when we dive into an exploration of objective art, such as that found in the Eastern religious traditions represented in this book, is that those images that are the most profound contain higher or deeper octaves or expressions

of both dark and light, sacred and profane. We find a certain transformational darkness in the image of the goddess Kali, for example, and yet everything about that image is employed in the service of that which heals and harmonizes in ultimate terms.

Arriving through the auspices of the creative imagination, the images in this book come from the deepest revelations of the human soul. They represent a small part of the vast possibilities of sacred art as tattoo. The sheer joy of that which is beautiful opens the heart and causes us to rejoice in moments of freedom, and so it is my great hope and wish that the reader will find inspiration in these pages, whether you choose to be tattooed or not, because simply reflecting on these images communicates a certain benevolence to the observer.

Finally, a book of this nature cannot be properly introduced without stating the wish: May all beings prosper and be happy from the efforts and results of this endeavor.

# Truth, Beauty & Tattoos

# Truth, Beauty & Tattoos

What is it about tattoos that strikes the human imagination with such a resounding blow that the reaction is rarely lukewarm? We are usually either magnetically drawn to their mysterious power or repelled. Regardless of our attraction or repulsion, *tatouage*, as the French call it, is not only a current fad but an ancient art that has arrived, finally, full-blown in the West. Long associated with cultural taboos, tattoos are now gaining recognition as an art form that is changing the fabric of how we see ourselves and our potential as human beings.

The "tattoo revolution" of current times has made it common knowledge that tattooing exists globally and in widely diverse cultures. Tattooing customs are found across the Far East and among the Polynesians, Africans, Peruvians, Maori, Mayan, Incan and Aztec peoples. The Greeks, Persians, Arabians and Egyptians tattooed; in old Europe, the Celts, Gauls, Norse, Danes and Saxons had tattoos. Julius Caesar wrote in *The Gallic Wars*, "All of the Britons colored themselves with woad, which produces a blue coloration . . . . in this manner they are frightful to look upon in battle." He was referring to the fierce tribal Picts of the ancient Celtic world, who used tattoos in part to terrify their enemies in warfare.

Like Caesar and many others, Charles Darwin was also struck by the power of tattoos, commenting, "Not one great country can be named, from the polar regions in the north to New Zealand in the south, in which the aborigines do not tattoo themselves." Most archeological sources agree that evidence of tattooing goes back to 12,000 years B.C.E. Other scholars claim that body modifications of all kinds are traceable as far back as over a million years.[1]

*Tattoos combine art and craft. As in any applied art, technical skill, along with creativity and vision, is required of the artist. Tattoos are an art form both spiritual and secular. Cultural anthropologists believe that tattoos actually serve society by bringing ritual to cultures that lack communal rites. That's just one reason why tattooing is so popular in America today. Our culture suffers from a decided lack of traditions, combined with a latent desire for both spiritual and secular rites that bind people to each other or to a larger group. A tattoo is a commitment. And it's been that way for centuries. In the past, for example in Borneo, certain tattoo patterns on a woman's forearm indicated her skill as a weaver, and accomplished weavers were highly prized "marriageable material" . . . . Getting a tattoo is a ritual, with the tattooist as a "shaman" who offers the "magic." Rituals, whether personal or societal, bond a person to the heritage and traditions of the past, while carrying them into the present and future. Tattoos clearly do that.*[2]

Tattoos in the ancient world have had many different purposes: warding off evil, designating an individual's skill or particular place in the tribe, and carrying spiritual or magical affiliations. The use of the tattoo ordeal as an initiation into warriorship or into the secret religious life of the tribe—indeed, the vast importance and efficacy of tattoos for their spiritual, aesthetic and apotropaic value—has arisen in the origins of cultures everywhere on our planet, giving tattoos an archetypal significance as a shared event of the human imagination. The sacred nature of Maori, Native American or Polynesian tattoos is obvious to the discerning eye, and yet these same tattoos have been considered pagan and therefore taboo or "the work of the devil" by the majority of Western culture. If tattoos are found in the ancient cultures of every continent on the globe, then how did they become taboo in the West? To set a proper context for the sacred tattoos that are presented in this book, this is a question that must be explored.

# Tattoos: Sacred and Profane

The love/hate relationship with skin art in the modern Western world really began when the famous explorer Captain James Cook arrived in Tahiti in 1769 with his men on the ship *Endeavor*. They discovered that the Tahitians had an ancient custom of dipping a sharp comb into the sooty juice of a burned candlenut, then beating the comb into the skin with a mallet to leave indelible marks that had great importance to them. Ship's artist Sydney Parkinson wrote, "The stain left in the skin, which cannot be effaced without destroying it, is of a lively bluish purple, similar to that made upon the skin by gun-powder." He and several of the sailors on board had tattoos made on their own skin, becoming the first known modern Europeans to wear what has become the insignia of the seaman ever since—the tattoo, so named because that was the way Cook's crew heard the native Tahitian word *tataow*. Interestingly, the Tahitians used this same word to describe the words inked on paper by the crewmen of the *Endeavor*.[3]

As the Englishmen got to know the Tahitians and their social order, there was a mutual exchange of cultural and religious ideas. It was through this now famous interaction that the word "taboo" entered the English language, taken from the Polynesian word *tapu*, which was the intricate system by which Polynesians "ordered the world into sacred and profane."[4] Tattoos became linked with the profane by Europeans who had a deep-seated religious bias against marking the skin. It is well known that in Judaism and Islam, tattooing is considered a sin—a form of self-immolation (deliberate sacrifice or killing of one's self). In the Old Testament we find perhaps the root of the Judeo-Christian tattoo taboo in Leviticus 19:28, which says, "You shall not make any cuttings in your skin in memory of a dead soul, nor make any marks on you, nor incise any writing on you." This is a translation made directly from the original Hebrew text; interestingly, later versions of the Bible simply use the word "tattoo" to describe "marks" made upon the body.

To complicate the situation, what Captain James Cook and his crew found in Tahiti was an ancient tribal culture with practices of human sacrifice to primal gods and goddesses and a free flowing, joyful relationship to the human body; the sexuality of the Tahitians was shockingly unfettered by religious or social injunctions. Cook's description of a public Tahitian sexual rite involving a twelve-year-old girl and several grown men was widely popularized in writings about his explorations in Polynesia. The girl was being prompted and coached in a ritual sexual act by the older women of the tribe, although, as Cook reported, she didn't seem to need or want their instruction. These highly misunderstood and sensational stories spurred a flurry of condemnation by English churchmen and those who attempted to repress so-called "pornographic verse."[5]

Captain Cook later discovered that the Tahitian participants in this outrageous ritual were *Ariori*, the members of a religious sect and fertility cult who devoted themselves to performing erotic songs, dances and ritual sex. Nonetheless, he was moved to write of the Tahitians, "Both sexes express the most indecent ideas in conversation without the least emotion and they delight in such conversation behond [sic] any other. Chastity indeed is but little Valued."[6] The stories of the Polynesian natives that the shipmates of the *Endeavor* brought back to "civilization" rocked the staid, puritanical world of colonial America and a devoutly Christian—and sexually repressed—England and Europe.

Many modern Westerners still have to penetrate the cultural prohibitions around tattoos that linger on from the time of Captain Cook's adventures. The relationship to the human body and the mysteries surrounding sex and death in cultures of antiquity was radically different than the constrained, problematic relationship to those domains of experience found in Christendom. The connection between societal attitudes toward primal experiences of life (sex and death) and the tattoo ritual is made clearer when we consider that all three of these involve a *bodily* experience of ecstasy that includes both pleasure and pain.

This fact is found to be true not only in primitive, "pagan" societies like that of the Tahitians, but in polytheistic and animistic cultures with highly developed arts and sciences such as architecture, metallurgy, mathematics, astronomy, agriculture and so on. For example, in the highly developed cultures found in the East—most notably in India, Japan and China, where a premium is set on higher philosophy, aesthetics and an idealized form of warriorship—the primal realities of life are elevated to very lofty heights. This viewpoint, which is both practical and philosophical, creates a culture in which the relationship to the body, sexuality and death can be extremely refined, as illustrated in the following succinct glimpses into the world of Eastern *tatouage*:

*"How can I draw a beautiful woman on your chest," asked the third emperor's impudent Tattoo Master, "when the only woman worthy of you is tattooed on mine?"*

*On the breast of the geisha Tsieou Kin, an expert hand had drawn a golden bee that sucked from her roselike nipple. Evidently, this caused the downfall of the second governor of the Minamoto family.*

*Before leaving for war, the shogun of Nara had his wife's flawless abdomen engraved with the shadow of a terrible dragon. It seems that during the extended Gempei conflict the lady of Nara took pleasure in imagining a samurai who discovered she was unprotected from the rear.*

*The ruthless shogun Ieyasu is credited with this warning: "You can engrave whatever you'd like on the bodies of the geishas, but you must respect the stone of the public statues."*

*Softly, with the voice of an autumn wind, while hiding distraught behind the pearl screen, the young but widowed empress, when asked by her eunuchs to agree to marry again for the good of the empire, unsteadily replied, "I will agree, but my new husband must wear the serene smile of my dead husband tattooed on his chest."*

*The Parchment Master of the Great Court was executed in Kyoto in the thirteenth century for producing a malicious tattoo on the chest of the shogun Kamakura, and for inciting the drawing to assassinate, as it did, its owner.*

*In order to engender the perfect child, Madame Tai tattooed an angel over her womb.*[7]

These short juicy tales paint a picture that is free of moralistic taboos and fear of the body. The definitions of sacred and profane are all a matter of worldview: for the Tahitians, their sexual rituals were sacred; for the captain of the *Endeavor*, those same rites were profane in the extreme (although it was reported that some of the shipmates participated in them). How quickly our ancestors forgot that their European heritage was built upon the philosophy, religion and culture of Greece and Rome, where sacred prostitutes and temple priestesses also enacted a divine fertility rite—called *hieros gamos* or the sacred marriage—

for centuries. Those very sacred prostitutes were most likely decorated with tattoos of religious and mythical significance! From time immemorial cultures have enacted fertility rites such as the sacred marriage, not only in Greece and Rome, but in great cultures such as those in Egypt, India and across Mesopotamia (the Sumeria of antiquity). Like tattoos, these customs were banished in the West; it was a trend that would follow Western imperialism and colonialism across the world.

## A Reign of Terror and Taboo

The climate of religion and politics in Europe developed over the centuries under the yoke of the Roman conquerors, beginning with Julius Caesar, who invaded Britain in 55 B.C.E. He was the first of many Roman conquerors whose rule and influence would prevail in Europe for centuries to come—particularly as they foisted their new religion, Christianity, on the people they vanquished. As the dogmatic theology of an orthodox Christianity took over, archaic customs like tattoo rites and sacred prostitute traditions disappeared, while many established religious traditions were persecuted and oppressed: the Dionysian cults and other ancient Greek mystery schools, goddess worshipping in all forms, the Gnostic Christians and arcane Western alchemy, to name a few.

Eventually these traditions either died out completely or had to "go underground" in order to survive the five hundred year Inquisition that raged throughout Europe from the Middle Ages through the Renaissance. The general populace—many of whom were still connected in some way to the pagan traditions of the Celts, European tribes or the old pantheons of Greece and Rome—were forced to convert to the religious doctrines of Christianity if they wanted to live. Even the Knights Templar, the mystic warriors par excellence of early Christianity, were extremely persecuted, with countless of their numbers burned to death as heretics.

The Inquisition was a particularly virulent form of Judeo-Christian fundamentalism that essentially waged a war against everything that honored the natural capacity of the human being to experience the divine directly, through the mystical and ecstatic states of the individual. Much of the ideological conflict boiled down to the fear and loathing of the human body that is found at the core of the Old Testament doctrine of original sin.

The difference between a theological premise that the human body is profane (an obstacle to the life of the spirit at best; the vehicle of the devil at worst) and one that considers the human body to be a sacred temple of the immortal soul is a chasm that seems impossible to breach.

During the centuries that the Inquisition ruled life in Europe, everyone who believed that God is present in life as it is, without the intermediary of the priesthood and the dogmatic creeds of the church, was subject to the most heinous forms of torture and death. One of the countless historical examples is Pierre de Bruys, who was burned to death in 1126 for openly stating, "God is no more in the church than in the market place; the forms and ceremonies which to so many folk replace true religion are utterly useless; the Cross should not be prayed to . . . . The priests lie in pretending that they made Christ's body and give it to people for their salvation." [8]

This deadly struggle proliferated in a most malignant way in the tribunals of the Inquisition, wherein hundreds of thousands, probably millions of people were brutally executed, burned at the stake, forced into suicide or tortured to death as witches and heretics because they posed some form of threat, real or imagined, to the prevailing orthodox fundamentalism of Christian Europe. These people were healers, teachers, sages and saints, artists, storytellers, writers, historians, craftsmen and women, midwives, thespians, singers and musicians, deeply religious folk of many different faiths—including "heretical" Christian sects like the Cathars, who were exterminated—and anyone with arcane knowledge such as alchemy, cabala or astrology. The statistics of mass burnings and barbaric executions are staggering and mostly forgotten except by a few hardcore scholars. The fact is that anyone with a tattoo (and surely there must have been many who still carried such "marks of the devil") would have been among the first to be burned.

The devastating holocaust of the Inquisition effectively severed the link between the West and its original pagan or tribal roots. Even after the Inquisition was abolished by Pope Pius VII in 1816, its insidious fanaticism was transferred to Protestant countries and carried over into the witch trials in the United States.[9] The underlying attitudes and dogmatic beliefs of the Inquisition—fear of ecstatic or mystical experience, fear of the body, fear of polytheistic, magical or animistic religious traditions—have continued as a strong undercurrent within modern Western culture. Human beings do not easily recover from such a sweeping and pervasive long-term reign of terror. It lingers on as a shared memory, deep in the collective unconscious of the race. The Inquisition was a collective nightmare, the effects of which are still operative at a profound level as race karma that rumbles beneath the fabric of our comfortable techno-society.

The convergence between European and Polynesian cultures in 1769, after which Captain Cook and his crew re-introduced tattoos to the Western world, was a serious clash of not only religious and social mores but of entire worldviews, coming as it did on the heels of such a violent history of repression. However, by the late eighteenth century the winds of freedom were blowing with a little more force than they had been two or three hundred years before; the American Revolution brought independence from England in 1776 and the French Revolutionary Wars followed quickly, beginning in 1789.

At the same time, this meeting of two radically different cultures was an exchange that altered the world in numerous ways, perhaps not the least of which was that the mystique of the tattoo spread like wildfire among the sailors of the world, and from them to the docks, the port streets and the prostitutes, artisans and merchants they met onshore. Marginalized social groups, renegades, heretics, those not constrained by the creeds of a privileged class and rank in society, found tattoos mysterious and exciting, sensuous, even frankly sexual, and more resonant to their own way of life, and it was in this fertile soil that tattoos took root and proliferated. To the rest of the religiously moralistic West, tattoos were considered taboo—a legacy that persisted for another two hundred years.

## From Marginal to Mainstream

Under the shadow of a puritanical climate until recently, tattoos in the West have been a telling mark of anyone who wanted to declare his or her status as a deviant from religious and social injunctions. That included, maybe even especially, the malcontents and marginalized population—those who lived on the sharp edge of accepted cultural norms. For many years tattoos were mostly found in abundance at every biker tavern or rally, among the grifters and drifters, in working class bars, in the ghettos and seaports.

Prisons are another place where tattoos have thrived as an

important part of inmate culture. Tattoos are so popular among inmates that prison authorities cannot keep their proliferation under control, even though they are against the law. Tattooing in prisons is forbidden because it is a threat to the absolute control of the institution over the prisoner's life. When a person is incarcerated, the warden gets a full description of the prisoner, including birthmarks, scars and dental records. When that same prisoner gets a new tattoo, it alters the landscape of the body; his or her description has been *changed*. Prison authorities regularly go to great lengths to confiscate all tattooing equipment, but typically, within a week, everything is back in place and new tattoos are cropping up.

It's fairly easy to understand why the tattoo is tremendously important to prison inmates: when all other freedoms are taken away, one can still alter one's identity by irrevocably changing the body. Tattoos define one's gang affiliation, rank within the gang and personal power. The "blood in, blood out" code of the gangs has a primal resonance with the whole tattoo experience. The black and brooding skulls, demons, spiders, skeletons, swords, flames and wraiths are the symbolic emblems—however shadowy they might be, a topic that will be explored later—of a powerful warrior, perhaps of one who has faced death many times, whether through physical combat or through the dark arts of sorcery, and is not afraid.

On the other hand, tattoos among prisoners are sometimes a paean, a poem in image, to the individual's religious or familial and ancestral roots: the bleeding heart of Jesus, Christ on the cross or with the crown of thorns, portraits of wives, sweethearts, mothers and family names abound as well as Oriental, African, Mayan, Incan and Native American designs and deities. Other common symbols involve power or totem animals: tigers, dragons, snakes, lions, eagles and so on. Some sources say that cobwebs are commonly understood in the language of the streets as a symbol that the wearer has committed murder. In the mythical sense they may represent fate or karma, understood in the East as *maya*, which is spun for each person.[10]

While tattoos have remained a constant element of these environments for many decades, they began to draw attention from a different quarter in the late sixties during the cultural revolution of rock & roll, free love and psychedelic mind expansion, when rock stars and a few hippies started getting their skin inked. At the crest of this wave were major counterculture icons like Janis Joplin, whose life and art became a potent symbol of breaking free to reclaim the repressed and largely forbidden ecstasies of the human body. Still, like graffiti art, tattooing was illegal in many places, and carried a certain danger with contaminated needles and the threat of hepatitis. Of course, as a forbidden fruit, tattoos also carried a certain thrill of high risk, which added to their attractiveness for many rebels and iconoclasts.

Over the next decade counterculture interest in tattooing began to slowly and then quickly seep into the mainstream culture. A new wave of interest in tattoos as art was introduced to the public in the early 1970s and promoted by well-known tattoo artists like Lyle Tuttle and Don Ed Hardy. Lyle Tuttle, tattoo artist to Janis Joplin, Peter Fonda and Joan Baez (to name a few) and curator of the Tattoo Art Museum in San Francisco, became the first tattooist to capture media attention with his pioneering vision and social commentary on the relevance of tattoos in modern culture.[11]

Music and dance have been the domains of ecstasy and mystical experience since the appearance of human beings in this world, and it was only natural that the rock & roll world—rife as it is with rebels and high levels of creativity—quickly took tattoos to its heart. Today we find that images inked on skin abound at any rock concert. With the punk rock explosion in the eighties, tattoos became de rigueur for rockers and their hardcore fans. Celebrated pop music idols with fan bases as diverse as David Bowie, Gregg Allman, Mary J. Blige and Sean (Puffy) Combs have tattoos on their skin—to name only a few. New tattoo technology made it more hygienic, beckoning more and more into the growing ranks of those who get tattoos to mark a major life passage—the death of a parent, the birth of a child, a divorce, recovery from a serious surgery.

Who would have guessed, twenty years ago, that tattoos would be the gypsy who came for dinner and ended up marrying into the family? Today we see tattoos springing up everywhere in the West. Skin art, small and large, peaks out from blue jeans and T-shirts, spreading over curves and planes of the body. Ankles, legs, necks, faces, ears, fingers—no surface is left out as a possible canvas. Tattoo conventions are now held regularly all over the U.S., Europe, Canada and the U.K., where hardcore tattoo addicts and cognoscenti gather with curiosity seekers and dabblers to view the handiwork of tattoo artists.

This is refreshing in many ways, but at the same time, tattoos

have become a way for people to appear to have street cred when they really don't—like wearing a badge of coolness that now has mass appeal and cultural relevance. The group mind of the masses, manipulated by the governing bureaucracies in any given society, has a way of co-opting that which erupts from the fertile grass roots of more radical subcultures. While this is unquestionably an unconscious urge in the case of tattoos going mainstream, the result is not at all unlike that sought by the Romans, who knew that if they assimilated the art, ritual and myth of the conquered culture into their own, they would have total control over its citizens.

At the same time, clearly there is a difference between those who have one or two tattoos and those who are committed to the world of tattoos in a very different way: the *tatoués*. For many tattooed people, wearing art on one's skin is a way of life. In some ways it is a revolutionary way of life that is, in effect, marginalizing. A person with highly visible, multiple tattoos no longer has the option to live "safely" within the walled compound of the established conventional society. Nonetheless, within this profusion of variety, purpose and meaning—different kinds of people with many different kinds of tattoos for lots of different reasons—there is a thread of continuity. We might well ask: what does the tattoo really signify in the postmodern West?

For most contemporary people, tattoos are fundamentally a symbol of individual freedom. Regardless of how conscious or unconscious the impulse toward freedom may be, this significance holds true on the streets of inner city America, in prisons, in the barrios, in the ghettos, in rock & roll culture and even in hip enclaves where middle-class people dabble in skin art. Tattoos as status symbols have been elevated to even greater heights by sports stars and popular film icons who sport tattoos—like Angelina Jolie, Billy Bob Thornton and Johnny Depp, to name only a very few who are often celebrated for their iconoclastic, freewheeling, rebellious lifestyles. Now we are seeing tattoos that reflect spiritual values and aesthetics; these kinds of tattoos, like those in this book, are becoming more and more visible, particularly among those who are involved in the Eastern traditions or philosophies. They also represent a bid for freedom, but a freedom of another kind.

Tattoos have arisen with an amazing force in the global consciousness of the world and continue to evolve toward a greater expression of the universal human urge toward art and beauty—those archetypal forces that have been aligned with the liberation of the human spirit from time immemorial. Interestingly, the popular tattoo culture of Europe is exactly like the tattoo culture of America, precisely because tattoos speak to that in us which rebels against the stultifying effects of cultural decay in the West. *Tatouage* is a distinct turn toward ancient customs and cultures and the wisdom or sanity they may have to offer us.

## Icons of Freedom

In the past fifteen years a new wave of interest in tattooing as an art form has proliferated, and yet tattoos are still considered taboo to the uninitiated majority of Americans and Europeans. Prejudice against people who have tattoos is alive and well in the upper echelons of our society. Although a few undoubtedly sneak in, tattoos are typically not found at the country club, or at the meeting of the board of directors, or on Wall Street, or in the church Sunday school class, or in Ivy League academia. Even with the current fashion-driven interest in tattoos, it is most likely that over time they will remain, by and large, symbols of freedom and authenticity—a mark of the rebel, the heretic, the iconoclast, the radical visionary.

What does the visionary see? Once the man behind the curtain in the Land of Oz has been glimpsed, we cannot fool ourselves: we live in a world that is driven by the motive for absolute power, brutally wielded. What power does the individual have in the face of this? The power to be internally free from false identities, free from illusion, free from the biases of the culture in which we are born. That people with tattoos are showing up everywhere cannot be called a revolution in the literal sense, but it can be viewed as a kind of guerilla warfare waged against the negative socio-political trends of our era. Those stout-hearted individuals who seek a road that is not traveled by the average person have a lot in common with those who are drawn to the tattoo experience, not just once, but many times over.

In many ways the current passion for tattoos in the West is the visible vanguard of the counterculture's protest against the upheaval and desperation of our times, in which we are experiencing the death of that which is true and real. In our rush for personal comfort *at any cost* we have given away our power to live, love and experience—in a conscious way—the inevitable

joy and pain that is encountered during a lifetime; in the process, as a culture we have lost our ability to find our way on the road of truth. It is the human birthright to be free to live in the largest sense, free to discover our divine underpinnings and the "primacy of natural ecstasy"—the truth of our own innate existence—in the time and way that is right for the individual.[12] In America, leader of the "free world" since World War II, the vast majority of people don't even realize that they are having their basic constitutional freedoms slowly taken from them, and they have already foregone the essential right of being free in thought, free in feeling, free in bodily sensation. We live in an era in which the truth of the body—the innate wisdom and bone deep creativity of the human being, which engenders all true art, science and philosophy—is being systematically repressed in insidious ways that are perhaps more subtle than the terrorism of the Inquisition, but just as deadly to the individual.

These statements are not really so radical, and they certainly aren't new. As a culture, we simply have not been listening to the visionaries in diverse fields who have been trying to tell us the truth over the years: Aldous Huxley, D.H. Lawrence, Albert Einstein, Nietzsche, Carl Jung, Wilhelm Reich and many others—writers, artists, philosophers, filmmakers, the neo-physicists and the whole of the deep ecology field, to name only a few. The saints, prophets and spiritual teachers of all times and movements have been telling us exactly the same thing in a different way. Creativity and mysticism are inexorably linked within the human soul, and the visionaries among us bear witness while the death of the soul itself is furthered by abuses of technology and science. The result of this dilemma is that our psychological aberrations and addictions have festered and proliferated to an epidemic level of mass insanity.

As the misuse of technological power spreads like a toxic mushroom cloud and our planet becomes more and more poisoned, our instincts, perceptions and feelings are deadened, and we are ushered ever more deeply into a collective trance. We are being distracted and manipulated by the double-dealing influences of consumer trends, with cell phones and the worldwide web divorcing us further from our instincts and from human relationships. We are the byproduct of devitalized and genetically manipulated food sources, now owned and controlled by vast corporate monsters of profit and greed; of the stultifying effects of television, media and advertising; of polluted land,

oceans and rivers dying from the effluvia of a decadent techno-culture. All this is inextricably woven together with falsehoods promoted by the strange but familiar bedfellows of religious fundamentalism and right-wing politics.

All in all, we seem hell-bent on destruction through a collective psychosis of grand proportions. As Nietzsche once said, "Madness is something rare in individuals—but in groups, parties, peoples, ages it is the rule." [13] A diehard iconoclast with a penchant for misogyny, Nietzsche was nonetheless a brilliant visionary who was highly critical of social conventions. He conceived of the essential human life as being entirely natural rather than defined by social norms, dogma, regulations and prejudices. He wrote: "Life such as I conceive it may quite possibly be that of the 'savage,' and may only be realized fully or brilliantly in the 'natural state' or in that primitive state, with its loosely organized societies that is sometimes referred to as the natural state. In the end, it is the social invention itself that stands against me." He also wrote: "Who wishes to be creative must first destroy and smash accepted values." [14]

## Getting Real

There is a place where philosophy and mystical traditions meet: for example, the tantric path in both Hinduism and Buddhism teaches that the natural state—pristine and awakened to reality as it is—is where the greatest wisdom is found. The Sanskrit term *sahaj samadhi* refers to a state of open-eyed, fully aware, ecstatic awakened consciousness. In this awakened state there is no separation from the whole of life in the ultimate and immediate sense. This experience gives rise to that most coveted way of living freely as the *sahaj manus*: the natural or spontaneous woman or man who lives by her or his own *svadharma*—the truth of the individual, or the right way to live a life of virtue in harmony with the whole of life.

At its best, the tattoo experience wakes us up. It is a moment of heightened awareness, a transient moment in which we make a small self-sacrifice in an act of consciously bearing pain. Such a conscious action may place us well on the road to re-discovering the sacred thread of *svadharma* within ourselves. The tattoo experience is an empowerment of the individual, not of the masses, that can be a vital way of accessing real feeling, and it is real feeling that makes us sane and forges a path of return

to that which is true. It is only that which can be viscerally felt or directly experienced in the human body that empowers the dawn of truth and freedom within the individual and makes the natural man or woman possible.

Contrary to the conventional point of view in which tattoos are taboo, inking one's skin may represent an individual choice to move away from self-destruction and hopelessness, back to the native roots of humankind and simultaneously forward toward a new vision of what we may become. The tattoo act, entered into with awareness, can cultivate inner strength, resilience, or a dimension of individual warriorship that can be dedicated to a greater good. It should come as no surprise that in the eighties and nineties tattooing, multiple body piercings and scarification became the rebel's new frontier and a passionate way of life for a whole segment of young adults in the West. The decision to alter the body significantly thrusts the individual into a lifestyle that marks them permanently as being *different*. It is a statement of rebellion against the degenerate world we have inherited, where the "freedom" we are offered by the state and organized religion is a prison of the most treacherous kind.

Once we have pierced the illusions of our cultural conditioning, then we can turn and face the greater question of ultimate freedom from illusion: the illusion that we are separate, isolated beings in an existence with no purpose. When this illusion falls away, with all of its subsidiary karmas, or patterns of cause and effect, then we are left with life as it is: the fact that we exist in a spontaneously arising, endless, divine and intelligent field of being that people over the millennium have called by many names: ultimate reality, the divine or the absolute. The theists simply refer to this ultimate reality as God, Allah, Ram, Krishna, Shiva, Brahman or Jehovah. As interdependent creatures existing within this creation, we have a responsibility (even an obligation) to the natural reciprocity that exists between everything within it. The concept of freedom, then, takes on a vaster, deeper meaning, as does one's purpose in the act of engraving the skin with images of power and sanctity.

That the tattoo experience rings a clear note of resonance with those who are serious about liberation in the spiritual sense is understood in the East as well as in tribal societies, and yet, the path to awakening is surely a road rarely traveled, as all the great spiritual traditions of the world quite openly state. Some people are magnetically drawn to a spiritual path in life from a very early age, due to the fruition of past karmas and a natural mystical bent; others come through political activism fueled by an acute awareness of the suffering of others. Most ordinary people come to the spiritual path through an epiphany of some kind, or perhaps a great loss or earthshaking event in their private lives that inflames the longing of the heart for that which is enduring, incorruptible and real. When this happens we are no longer satisfied with shadows, mists and empty illusions, including the influence of mass movements that can manipulate and control our minds; only that which carries the taste of truth will satisfy. Regardless of how we arrive at the crossroads, when the light of clarity shines within, we begin to see through the layers of veils to the core reality of ourselves and everything around us.

## The Sanity of Sacrifice

We discover some very interesting things when we investigate the fascination, the magic, the unexplained pull of the tattoo image, and the sheer exultation of getting tattooed. It's true that tattoos are about personal change, identity, empowerment and freedom, and yet the question—"What is the value of tattoos?"—can be investigated further, until what is discovered at the heart of the tattoo experience are two universal urges of the human spirit: sacrifice and beauty. In other words, the answer to this question is found primarily in the archetypal potency of the image as an expression of beauty, made even more powerful by the sacrificial act of engraving it on the skin, so that a transformational alchemy is engaged. Getting tattooed is a primal experience of pain and blood, willingly entered into by the individual who must relinquish control for a period of time. In the expansion of consciousness that can occur through such an experience, involving the entire body/mind complex, we are changed and possibly even transformed in some mysterious way.

The traditional wisdom of all folk movements and great spiritual teachings tells us that nothing of value is gained without effort and sacrifice of one kind or another. Life itself operates on the principle of sacrifice: one example of this is that the plant world is sacrificed to the animal domain, while animals are sacrificed so that the human world may flourish. In some spiritual traditions it is said that the human world is sacrificed for the angelic world, or the world of higher beings. Native American traditions refer to this principle as the "giveaway,"

which is found in all spheres of life; to serve the greater good, the buffalo and the deer willingly give themselves to the hunter's arrows. Sacrifice is most powerful in the human domain, where it may be made a conscious act: the power to sacrifice one's self for a vision of something greater.

The word itself—"sacrifice"—comes from the Latin *sacrificium*, which is a combination of the words *sacer*, or "sacred," and *facere*, "to make." To sacrifice is "to make sacred." Sacrifice, as idea and custom, has been around from the beginnings of human culture. Often when we hear the word "sacrifice" we think of Abraham and Isaac of the Old Testament, when human sacrifice as still part of the Judeo-Christian heritage, but humanity has had many opportunities to evolve since that time. The custom of human sacrifice, which is commonly found in many ancient cultures, is a primitive and shadowy expression of this archetypal urge; war itself can be viewed as another shadowy expression of this same impulse within the collective psyche.

As humanity evolves, the principle of sacrifice is expressed in ways that are more resonant with obvious cosmic laws: "Thou shalt not kill." Everyone is moved by heroic sacrifices that are made in extreme circumstances—by soldiers, firemen or ordinary men and women who act selflessly to rescue, protect or save the life of another person. Such acts of self-sacrifice, made for the right purpose, elevate the human spirit and bring sanity to our lives in very basic ways. Seemingly small, unsung daily sacrifices build character, resilience and forbearance and develop within us a capacity to serve others. One simple form of sacrifice is to give up our own gratification for the welfare of another person, like a child.

For thousands of years yogis, fakirs, shamans, charismatics and mystics, the *brujos* and *curanderos* and medicine men and women, have known that personal sacrifice in ordeals of the body are a sure way to expand or awaken consciousness and induce highly sought after states of clarity, mystical union and prayer. When one seeks spiritual power it is a personal sacrifice and transformation that must be entered into, and in this case ordeals of the flesh are of the greatest efficacy, because the body itself is sacred. One example of this is found in the Native American sun dance, in which the mystic warrior enters into a tremendous self-sacrifice in a ritual of pain, endurance and hardship. In order to purify himself and bring blessings to the tribe, even to the world, he fasts and chants, then is partially suspended by hooks from the skin of the chest and hangs dancing, sometimes for days, sometimes until the hook breaks through the skin.

Spiritual transformation requires that we learn to suffer consciously—that is, to fully experience ordinary or extraordinary pain, which may be physical, psycho-emotional, spiritual or all of those, in a way that releases and activates the innate transforming power of the experience. The passion and crucifixion of Christ is the most obvious enactment or religious symbol of conscious suffering and sacrifice at a cosmic level. Similarly, the Buddhist bodhisattva vow is a sacred oath that binds the awakened individual to sacrifice his or her own enlightenment—forever, if necessary—to work for the liberation of all sentient beings. These are profound examples of an ultimate, ontological "good conscience," that, when rendered into basic, practical, here and now terms, calls ordinary people to acts of kindness and compassion in which we put the welfare of others before our own. Acts of conscience have the power to change us as individuals and to change those with whom we interact. Everyday people encounter poignant examples of the need for good conscience in relationship to others on a regular basis. Even in small ways, self-sacrifice changes us and builds this deeper conscience, or the capacity to suffer consciously.

The tattoo experience has the potential to tap the archetypal power behind acts of sacrifice, undertaken either unconsciously or consciously, and yet the reality of sacrifice as an aspect of modern tattooing is minimal when compared to the tattoo ordeals of ancient or indigenous cultures. Getting a tattoo in India, for example, is a significantly more painful and dangerous experience; the ink is laboriously pounded into the skin with a hammer struck against a flat wooden stick or small board with a needle or nail protruding from one end. These kinds of archaic tattooing technologies endure to this day in places like India, Samoa and Burma.

In Thailand, Buddhism is combined with the ancient animism of the tribal culture. In some places the original religion of the forests remains, and there are cults of monks who tattoo themselves with combinations of semi-divine animals, anthropomorphic deities, mandalas, sacred texts and diagrams. Thai Buddhist tattoos are made by repeated piercings of the skin with six-foot-long swords dipped in black ink. Tattooing at a distance of six feet is one of the extraordinary aspects of this art form; the intricacy of detail that is achieved is marvelous. To

endure this horrendous ordeal, the monks go into a deep trance state, sometimes twitching or dancing.[15]

Such a sacrificial rite is an unimaginable feat of courage and commitment, especially for Westerners who have the luxury of getting tattooed with the comparative ease and antiseptic cleanliness of modern equipment. Nonetheless, in the Western rite of *tatouage* there is pain and quite often blood involved, for it is impossible to repeatedly pierce the epidermal layer of the skin and go deep enough to deposit dyes in such a way that a whole picture emerges over a spread of flesh without a significant edge of discomfort, and in most cases, a good dose of pain.

## Beauty

Although tattooing was originally developed for magical purposes, it has evolved as an aesthetic calling, which gives rise to the consideration that the beautification or enhancement of the human form can also have a higher purpose. Most notably, the Japanese have evolved tattoos as a pure art form—known as Irezumi—to a significant degree, incorporating many Buddhist motifs and singularly beautiful representations of mythical creatures and the natural world. Tattoos are naturally attuned with creativity, but beyond tattooing as an aesthetic form, there is a possibility of getting a beautiful tattoo because of the spiritual value of beauty, a purpose or idea that is distinctly different than ordinary egoic vanity. This requires a strong intention, because it is intention that brings the inherent reality—the very realness—of a beautiful image to life.

Beauty, as an objective principle, is said to be one of the faces of God. Beauty interacts with our senses in a way that is healing and enlivening. That which is beautiful nourishes the soul and uplifts the heart. Its fleeting touch melts our hardness, fills us with awe and wonder. Sometimes an encounter with beauty gets us through the darkest nights of our lives, because beauty, even in small things, opens the heart for the moment. It has been said that beauty does not show us the road to truth; beauty allows us to endure the truth.

Chilean filmmaker Alejandro Jodorowsky once said, "I cannot know truth, but I can know beauty." It is in the depth of our own direct experience of life that we discover the truth of that statement. Our rare human contact with ultimate truth is as mysterious and unfathomable as the endlessness of the midnight sky, whose starry spread points us, once again, back to the rampant, breathtaking beauty that exists throughout the physical universe we inhabit. It can even be said that beauty *is* the sacred; beauty is God's mercy made manifest in the perfect symmetry and asymmetry of life, in chaos and order, in darkness and light, in the vast grandeur of the universe, the intelligent perfection of our galaxy and solar system, in the intricate tapestry of mineral, plant and animal life on this most benevolent planet.

This is a tattoo book that has a lot to say, especially in its pictures, about the principle of beauty, specifically in its appearance in the milieu of sacred art. It's important to consider that art is not the only place where beauty is found; beauty actually pervades our lives. Beauty is life's gift to us and can be found everywhere, but we have to slow down our hectic pace to not only notice but actually receive its healing power. Beauty is found at its most thrilling peak when it is fleeting: even the stars, which last forever in a relative sense, will sooner or later burn out and pass away. This transient quality of beauty abounds in nature—in the passing of seasons, the cycles of life, the blossoming of flowers and trees, in the face of a child—and teaches us the truth of impermanence. All things pass, and eternity is found when we allow ourselves to appreciate the transitory joy of the present moment.

Beauty is found in equal measure in both the newborn and the elder, even moments from death, for death itself has a certain beauty in it. This is an important point: beauty is not only that which is sweet or apparently pleasing. To see beauty requires that we open our perceptions beyond our restricted conditioning to see what is real, because there is always beauty, in one form or another, in what is real. As a principle that informs life, beauty has a wrathful, thorny side that may seem out of control or wild and awesome in its power—like a hurricane or a pride of lions on the hunt. Beauty is found in destruction as well as in creation; who has not been moved to wonder and awe at the fierce power of a tornado or volcano or at the bloody, raw power of birth? In the same way, tattoos run the gamut from the benevolent to the beastly.

Sacred art as tattoo is an expression of the divine principle of beauty in its deepest and most profound expression, captured by the images that follow in these pages. Yet, before we consider further the value of irrevocably tattooing ink into skin as a celebration of the beauty that surrounds us, let us take the time to explore the background reality of the tattoo image: archetype and symbol.

# An Archetypal Reality

The archetypal world as Plato described it is the foundation of everything that exists in this world of form. In his famous works *The Republic* and *The Phaedo*, Plato articulates his theory of ideas or forms as the immutable archetypes of all temporal phenomena. According to Plato, the archetypes or ideas are objective and therefore real, while the physical world possesses only relative reality. It is the archetypal forms of objective reality that invest our world of constant flux with order and intelligence.[16]

Similarly, Carl Jung described archetypes as "primordial images" of the collective unconscious—like divine instincts that exist within the world soul of humanity. Jung wrote: "The archetype is an element of our psychic structure and thus a vital and necessary component in our psychic economy. It represents or personifies certain instinctive data of the dark, primitive psyche, the real but invisible roots of consciousness."[17] Archetypes, or the "invisible roots of consciousness," can be understood as a priori cosmic forces or principles that inform all of life and creation itself. An archetype carries particular qualities or characteristics and is the unconscious "cause" behind a trend that manifests in form.

One of the obvious ways that human beings communicate with the archetypal world is through the language of symbols—the metaphorical "twilight language" of poetry, fairy tales, dream images and artistic vision. The archetypes are found at play everywhere we look, even in movies, media and advertisements—and in our own neuroses and complexes as well. They are most obviously encountered in the symbolism of classical mythologies where we find the same archetypal patterns repeated again and again: the warrior or hero, the mystic, the communicator or messenger, the lover or beloved, the wise old man or woman, the golden child, the great mother (goddess), the great father (god), the artist, the healer, the teacher, savior, sage or guru.

The nature of an archetype is that it is clothed in many different ways that vary from universally recognized symbolic forms to those that are specific to a particular culture or an individual; for each symbolic representation or form, the archetypal origin is the same. The archetype of the Great Mother, for example, is represented in many different images that have visible similarities: in Christianity there is Mary, the Mother of Jesus; in Buddhism we find Tara and Kwan Yin; in Hinduism there are a plethora of goddesses who represent these same qualities, including Parvati, Ganga, Shri Devi and Lakshmi. In ancient Greece she was called Hera, Demeter or Gaia; in Sumeria and Mesopotamia she was Inanna, Ishtar and Astarte. Once we learn to identify archetypes at work and to speak the language of symbols, the archetypal roots of mythic images from different cultures can be easily recognized. As we become more fluent in this language, we can begin to see the archetypes as basic, universal structures that reveal themselves in the patterns of life.

For Jung, the archetypes are of the psyche and of the spirit, for they transcend the empirical world of time and space.[18] The archetypes are living forces; they can be understood as facets of the divine—or as deities that represent facets of the divine—and are easily perceived within the pantheons of the great religious myths. An archetypal image transmits the qualities of the archetype and also activates those qualities within one who interacts with it. When we work closely with archetypal images we are literally identifying with the deity or the divine—transforming the mind and soul through the alchemical vehicle of the body. Interacting with such a deity through the power of its image is like gardening: we are sowing the seeds of that being's qualities within the soil of our own being. This is why many spiritual paths instruct us to meditate upon the images of deities, a practice that is prevalent in Buddhism and Hinduism, where there are numerous images of the divine. Even in monotheistic traditions such as Christianity and Islam there are contemplative images: the crucified Christ on the cross and the written name of God (Allah), respectively.

There is a vast range of nuance in this twilight language because, depending on the degree of clarity and trueness of the medium through which an archetypal energy is expressed, the image will appear along a continuum: from the subjective, murky dimensions of the shadow, to the clarity and wisdom of the objective self. When the archetype is being expressed as the shadow, the images are populated by underworld elements and tell a story of rebellion and obsession that appears in many passionate forms: hatred, pain, rage, betrayal, cruelty, selfishness, possessiveness, jealousy, vanity or pride. Even nostalgia and sentimentality are neurotic expressions of something real.

When the archetype is reflected through a higher octave of being in which its characteristics are clear or crystalline, then it expresses the true nature of the deep self and tells a story of grace, valor, courage, ferocity, strength, dignity, harmony, wholeness,

peace, compassion, mercy, splendor or unconditional love. These archetypal images have the power to uplift or transform by direct interaction with the imagination of the heart. It is said that laughter is divine, and so we also find a trickster quality at work in higher octaves of expression, wherein humor also plays an important role.

It is the interaction between cosmic opposites—the primordial, ultimate archetypes of the shadow and the self, or dark and light—that engenders the great play and drama of life. Fairy tales abound with images that reflect this interplay. Often there are combinations of both the shadowy expressions of the archetype and the positive, life-serving side of the archetype at work in the same story. As an example, in *Cinderella* we have a wicked, cruel stepmother and stepsisters (representing the shadow side of the feminine) alongside the heroine, Cinderella, who is so naturally humble, kind and good that she attracts the attention of a fairy godmother (a benign feminine force) who bestows a boon with her magic. *Sleeping Beauty* is another fairy tale that depicts these opposing forces of the archetype, with dark and light juxtaposed and interacting in such a way that sparks a creative alchemy. Three good fairies and one evil witch vie for the soul of the innocent Sleeping Beauty. In the end Beauty is awakened from her (symbolic) sleep to discover the Prince, a noble expression of the masculine principle, which results in a play of masculine and feminine forces that join in an alchemical wedding.

Archetypal motifs are found time and again in the world's great religious myths and stories, like the Hindu *Ramayana*. Once again it is a feminine being, Sita, who is captured by a terrible demon, Ravana, and must be reclaimed by the kingly and noble Lord Rama, her husband. Rama's loyal brother Lakshmana and the great archetypal devotee, Hanuman (an anthropomorphized divine monkey), join in the effort to free Sita, who in the meantime has remained pure and untouched in her noble love for Rama despite Ravana's best attempts to seduce her. After a great battle in which Rama and his cohorts rally their forces as only divine warriors can, Sita and Rama are reunited and the order and harmony of cosmic masculine and feminine forces are restored to a state of balanced interplay.

When we are able to bring a greater awareness and intention to our choice of image, the potential of the image to affect a more profound transformation in our lives becomes activated.

Nonetheless, images have innate powers at their various levels of meaning, even if the image is secular, mundane or extremely dark. Those images that draw us magnetically are mirrors of the soul—they tell us where we are at any given time, or perhaps what we are longing for. The language of the soul is symbol, metaphor, image, myth—the messengers of archetypal reality.

## The Language of Symbols

Set against a basic understanding of archetypes and the images that represent them, we can better appreciate the current popularity of tattoos. Tattoos have proven their timeless value; it seems they are here to stay, in one form or another. From marginal outcasts to rebels, pop icons, street sages, celibate monks and ordinary people, tattoos are gaining ground as magical emblems of life on Earth in our millennium. What are these fabulously creative manifestations of the collective inner world trying to say to us?

Tigers, lions, eagles, bulls, bears, serpents and other ferocious or sexually potent creatures abound in the tattoo world. Native peoples understood these as totem or spirit animals, beings that embody specific desirable qualities: strength, the wisdom of the body, the power to see far on the wing, the power to endure, to fight off one's enemies, the power to procreate. They are symbols that speak of reclaiming the primal life of the human body—an affirmation of incarnation and life on earth. For example, birds are universal symbols of freedom and the unfettered soul, and so we find many tattoo images of graceful cranes, powerful eagles, hawks, bluebirds, peacocks or sparrows that carry and communicate nuances of meaning.

However, these are the more standard and accepted interpretations of animals as symbols or metaphors. Tattoos are a lot like dream images; we may have a conscious idea about the image in mind, but they remain very mysterious. James Hillman, renowned Jungian analyst, philosopher and archetypal psychologist, cautions us against applying too much of the rational mind to any symbolic image:

*Since I prefer not to consider animals as instincts inside us, I do not use the hermeneutics of vitality for responding to their appearance in dreams. Here, I am trying to move away from the view that animals bring us life or show our power, ambition, sexual*

*energy, endurance, or any of the other* rajas, *the hungry demands and compulsive sins and vices that have been put upon animals in our culture and continue to be projected there in our dream interpretations. To look at them from an underworld perspective means to regard them as carriers of soul, perhaps totem carriers of our own free soul or death soul, there to help us see in the dark. To find out who they are and what they are doing in the dream, we must first of all watch the image and pay less attention to our own reactions to it . . . . But no animal ever means one thing only . . . .* [19]

Mythological creatures abound in the world of tattoos. Phoenixes, winged horses, unicorns, dragons, snow lions, valkyries and sirens, mermaids, fairies and elves, gorgons, semi-divine, half-human heroes and heroines, winged lions, garish creatures, gargoyles, angels and demons of every kind—all of these have a communication to make. As spiritual protectors, some of these have the function of warding off negative influences, or they are emblematic of elemental nature and creativity. Like the sirens, many of these kinds of creatures have trickster-like qualities or are communicating the shadow side of an archetype.

A brief tour through any tattoo magazine yields an abundance of images reflecting the vast range of human experience from sacred to profane. One woman has her entire back tattooed with themes from Van Gogh's paintings, including "Starry Night" and "Irises." Another tattoo image depicts a city in flames overshadowed by an angel of doom, holding a flaming sword in one hand while the other holds the scales of justice; beneath this scene are the words: "Your actions bring great consequence." Another tattoo, on the whimsical, humorous side, is a luscious and dripping piece of cherry pie, placed in the choice location of a woman's lower belly. [20]

Tattoo art typically contains strong juxtapositions of symbols: red roses in full bloom with knives piercing the center or roses entwined with skulls, which speak of the relationship between beauty and impermanence, and the irrevocable fact of death. Angels mixed with demons are another common theme. The province of *tatouage* in the West has been largely populated with these kinds of images, which are distinctly different from the stunning tribal designs of a religious nature—representations of archetypal forces that have been extremely stylized, based on the specific sense of aesthetics of the particular culture. Many tattoo images are associated with the dark, dangerous side of

human nature—black magic or criminal activity. Images of the underworld abound in that traditional tattoo milieu: devils, demons, seething inchoate darkness. The chaos of what the ancients called "the underworld" and what today we might just call "hell" are often reflected in popular skin art. Some of it is tasteless, while some of it is quite excellent and paradoxically sublime as art in its genre.

Tattoo images are a form of communication; they are the collective unconscious speaking to us. When the images are extremely dark, demonic and troubled, they speak of the contents of the unconscious spewing forth its pain, rage and sorrow. This eruption in the form of tattoos found all over the world is a mirror into which we must peer; it is necessary to face our Medusa if we are to have any hope of transforming her back into the goddess of her origins.

## The Shadow Speaks

Many of the tattoo images that are arising today are expressions of the suffering in the world—they speak of war and terror, of tortured souls and abusive childhoods still seeking redemption in adult life. Looking at a tattoo magazine at a soiree in Paris, a woman took one look at the images and murmured vehemently, "Quelle horreur!" What a horror! Tattoos that speak of private horrors—like those of the woman whose breasts and nipples are crisscrossed with tattoos of barbed wire, while at the center of her chest is a heart emitting roaches and bound with barbed wire—are mirrors of the heartbreak in our world today. [21] We live in a time of urgent need, of global, individual and familial crisis. For most people childhood is a gestalt of painful experience in which, as individuals, we are not seen, heard or acknowledged. Instead, the child suffers some form of emotional, psychological, sexual and/or physical abuse. Repressed, shut down, split apart by falsehoods, hypocrisy and cynicism and brainwashed to believe that he or she is an island apart from all others, the child is often doomed to a bare, brutal, spiritually dead subsistence in an uncaring world.

People recoil from a great deal of tattoo art, but how can we separate ourselves from the suffering of others, whether it is through war, natural disaster or personal, psychological pain? When we refuse to face our connection to the world soul, the *anima mundi*, we refuse to be responsible to each other as human

beings. As individuals who seek to think and feel consciously, troubling images found in tattoos or other art forms can engender a response of compassion or insight rather than revulsion. We need to feel into our interdependence and interconnectedness with others, even though (and especially because) to do so will inevitably cause us to feel, with the other, his or her pain. "Love thy neighbor as thyself," a great teacher once said. This is one of the most fundamental teachings of all great traditions: to have compassion is to know intimately what the other feels.

Because tattoos can be a way of telling a story that needs to be told in order to release its hold on us, they have the potential to help resolve personal pain. Many people get a tattoo for very specific healing purposes: to cover a mastectomy scar, to honor a loved one who has passed away or to work with grief or loss in some other way. The events that have occurred in our lives cannot be changed, but we can become free of the emotional chains that bind us in unhealthy ways. To access the full possibility of healing that a tattoo may offer, one has to become conscious of what he or she is doing. Emotional and psychological energy that is bound up in the body can be unleashed by such an act of power, if one has the right intention. A case can be made for tattoos as a form of therapeutic bodywork, although such a possibility would require a profound intention on the part of the individual and a willingness to confront the angels and demons of the unconscious. In order to do this, we must come to know that we need the darkness of the shadow so that we can find and embrace the light.

## Crossing The Great Divide

Western culture has a history of denying and repressing the archetypal potencies of the unconscious, which contains upperworld and underworld, mystic and monster, eros, ecstasy and thanatos—that is, death and transformation. As Rainer Maria Rilke once said, if we cast out our demons, then we cast out our angels also; this wisdom of the ages has been rejected by Western society, which has developed instead a relationship of conflict and repression to the dualities of existence.

The Judeo-Christian heritage that pervades Western philosophy and religion is founded upon the belief that the natural polarities of life are at war with one another: spirit versus body, good versus bad, life versus death, man versus woman.

The dichotomies continue with our dogmatic beliefs about day/night, sun/moon, mother/whore, God/devil, heaven/hell, rational/irrational. This scenario of conflicting opposites sets up a paradigm of separation and alienation, "us versus them," in which war—between nations, states, individuals, genders, religions, ideologies—is the outcome.

In the ancient teachings of Hinduism and Buddhism there is a nonlinear understanding that the divine has both fierce and merciful aspects that co-exist as dimensions of a whole, reflected in the prolific art and iconography that has arisen in these traditions. The wrathful side of the divine is found in those deities that bring about the destruction of that which needs to be destroyed in order for the ongoing process of creation to take place. This is depicted as ferocity or severity, the shocking penetration of illusion, annihilation of identifications and forceful taming of the ego. It is the active wisdom that reveals our darker motives, like the drive for power and control over others.

At the same time, the wrathful deities play an important role as protective and guardian spirits—they are, in effect, guarding the treasure of the inner life:

*In Nepal, the deities that are especially worshipped are the ones that repel and instill terror. This is based on the general idea that the more wrathful and horrifying a deity looks, the more effectively they can protect against danger. Because they are as easily placated as they are insulted, they instill their followers with a sense of trust.*[22]

Similarly, the benevolent images of the divine are found in a myriad array of expressions: peace, grace, splendor, magnificence, light, clarity, compassion, mercy, longing and the nectar of divine moods in many flavors of sweetness. These images are uplifting and emancipating; they resolve paradoxes and commune with the heart. These are living metaphors that whisper of the beloved and the possibility of a personal divinity; they remind us that we are essentially good, and that divine grace and abiding love is our ultimate human birthright. In this sense these images are also guardians and protective agents.

As human beings we must become big enough to embrace the whole of life in these natural pairs of opposites and end the war on all levels. While shadowy images seem to dominate popular tattoo culture, at the same time tattoos that are clear statements

of a higher aesthetic or spiritual urge—devotional images of deities, symbols of protection or blessings, pristine natural or mythological landscapes, universal symbols of impermanence, death and beauty—are becoming more and more visible. The images in this book are about realizing the inherent unity between these dichotomies and celebrating the wisdom of their interplay in life, which is abundantly found in sacred art.

## Art as Agent of Change

Art is a universal human urge, the importance of which cannot be overestimated. Art has the power to change not only individuals but culture at large. There are countless examples of artistic movements that have literally swept across cultures, effecting millions of people. The music of artists like Bob Dylan and the Beatles are good contemporary examples of this, but clearly the works of individual artists—Shakespeare, Leonardo Da Vinci, Beethoven, Bach or Picasso to name only a few, not to mention the anonymous writers of the Vedas, Upanishads or the Bible—have had undeniably powerful, far-reaching positive effects on the consciousness of humankind.

It's not uncommon for new forms of art to be greeted with fear and suspicion at first. The blues, for example, was taboo in white mainstream culture for a very long time before it was accepted as an art form, and only then at the cost of great hardship to many black artists who forged the path to that acceptance. Rock & roll, the illicit love child of the blues, is an art form that had to break through cultural taboos. When Elvis Presley first hit the scene, bringing black roots music and an earthy sensuality to a white mainstream audience, people were scandalized. The Beatles, whose original music spoke to the unconscious need for a revolution of the spirit within a whole generation, created a similar stir of resistance at first. The music of Bob Dylan, the Beatles and a whole wave of rock & roll that came after them revolutionized the contemporary landscape, finally gaining worldwide acceptance and respect. Looking back at that time from our current era of much greater decadence and darkness, the reaction to the Beatles in 1963 seems absurd: a breath of fresh air after the stifling decade of the 1950s, the Beatles were gifted with a boundless creativity that enriched our culture in extraordinary ways.

Tattoos, graffiti art, rock & roll and hip hop are good examples of art forms that have sprung out of the grass roots of modern culture and have historically verged on the taboo. At the least, all of these were originally considered controversial, unacceptable or just in bad taste by polite, well-heeled circles of society. Why has so much art been banned or censored over the years? It is difficult for "Caesar" to accept these creative forces that erupt so potently in our culture because art is the agent of freedom. Indeed, a great deal of authentic art is frightening to the linear thinking mind, which relies on controlled environments and a strategically limited awareness to keep its illusions in place. It is the power and profit echelons of society that benefit from maintaining the status quo of under-educated masses, caught in the web of an oppressive system. Lulled to sleep by the soporific of consumerism, we become willing victims. We are so addicted to our petty pleasures and comforts that we too are complicit in the drama, refusing to see the underbelly of an elitist culture whose privileges are rooted in the suffering and deprivation of others.

Because so much fine art is owned and controlled by the elite, we often forget that art is of and for people; it is meant to be appreciated and absorbed by the five senses—to be heard, seen, read and deeply felt. Art is the upwelling urge of humankind toward that which is liberating. The arts—including music, poetry, literature, film, theatre, painting, sculpture and dance—are an ecstatic expression of the human spirit. That is why art plays such a vital role in our world: it has the potential to keep us not only awake, but truly alive. This is the importance of a movement like graffiti art, which should be celebrated and honored, not persecuted. Art is an expression of inner freedom, and at its best, art is alchemical. It has the potential to catalyze change and the evolution of the individual.

A great deal of art does this by speaking for the shadow, which inherently seeks the light in a process of integration and becoming. Investigating more deeply we find that the demonic, found in art forms like tattoos and rock & roll, may be understood as an unconscious or shadow-like expression of the wrathful or severe face of an all-inclusive divinity. They are exactly those transformational elements that could, if embraced and made conscious, bring about revolutionary changes—in the individual and potentially in the world. The images that communicate a certain trickster quality, which shocks our mundane sensibilities, are exactly those that shake us up and actually free us to think for ourselves. Salvador Dali is an example of another controversial

artist who blends sacred and profane in his work in such a way that one is shocked, momentarily, into a different awareness.

The urge behind our collective obsession with images of suffering is found in many art forms. Picasso's famous depiction of the Spanish Civil War, "Guernica," is one classic example, while contemporary movies are another way of telling the tale of experiences that seek to be finally heard and seen in a conscious way. Real art has the effect of locating one firmly in the body, because real art catalyzes feeling. Art has always had an essential healing element—in our art, we can tell the truth.

Tattoos gained momentum as an art form in the more sophisticated developments of Sailor Jerry Collins (1911–1972), who was responsible for the profound influence of Japanese art in American tattoo culture, beginning in the early sixties. But in the tattoo world, the potential of art as agent of change is even found in simplistic flash art. Speaking of the cartoon aspect of tattoo art, Nara commented, "To really appreciate flash art you have to appreciate the world of kitsch. Some of it even has a certain innocence. It's the court jester of the arts. It thumbs its nose at the sensibilities of the rest of the art world. It celebrates as much as it ridicules consumer trends." Much of contemporary tattoo art—as "court jester of the arts"—has this trickster quality at the level of the mundane. It confronts our more effete tastes and turns reality on its head. And yet, as James Hillman points out, an overly intellectual analysis of archetypal images will, by necessity, fall short of what the image is really all about. The power of an image and how it communicates its meaning remains a mystery. Tattoo artist and subculture icon Don Ed Hardy wrote:

*Tattoos generally function as psychic armor. Often a marker of a state of mind or events, meaning is accrued with time; the bearer explains the mark's significance and the story of how and where it was acquired. Much of the symbolism or meaning cannot be articulated and is private to the wearer, as is any artwork to its creator or collector. By willing it to be placed on the body the tattoo collector literally becomes one with the art. While the art may arguably have a more profound or long-term effect than a painting or sculpture, which can be put away or sold, daily exposure over a lifetime erodes awareness. In the end, the tattoo functions as a social barometer, revealing far more about the viewer than the person wearing it. Ultimately no one else's business, the projections, intrusions, judgments, or appreciations it triggers are indications of*

*the viewer's perceptions and received social notions. Tattooing will continue to provide rich fodder for the dissecting tables of academia, but at core its power defies absolute classification. At best, it fulfills the enduring role of all art: to emphatically affirm the irrational and to celebrate life itself.[23]*

Kitschy tattoo art, very much like the trickster side of rock & roll or hip hop, has its own meaning to those who love it and tattoo it on their bodies. All art—the good, the bad and the ugly—has archetypal power. Even the most ordinary flash art has fundamental symbolic meaning. A rose speaks of unfolding beauty, the nectar and perfume of life. A star speaks the twilight language of the heavens; it hints of the heights, the unattainable, of inspiration, the highest possibilities, and also of fate, karma, destiny. However, there is a big difference between a star drawn by a five year old child and Van Gogh's "The Starry Night." Which one moves us in the most profound way? Are we more deeply touched by caricatures of women with bobbing breasts, sailor costumes or mermaid tails, or Sandro Botticelli's "The Birth of Venus," where the divine woman emerges nascent and dripping from the primal salty sea, delivered to an exotic shore on the half shell? If the shocking images of our worst nightmares have the potential to be healing, then what great power the magnificent images of grace and harmony must carry, particularly the incredible genre of spiritual art that has appeared, as if in rare flashes of light, throughout the ages.

# The Transforming Power of the Image

The mythic image as archetypal symbol has the power to transport us. Symbols are living metaphors that literally transport us from one realm to another. In one sense symbols are the messengers of a greater reality, while in another sense they are transpersonal transformers that have the ability to imbue us with the very reality that they represent. This is what Carl Jung referred to as "the transcendent function of myth." As with all great movements of folk art, the symbolism of tattoo images crosses many different boundaries and can take us to a plethora of destinations. Certainly bluebirds of happiness, Betty Boop and the ships and stars of old school flash art take one to a different destination than a delicate, hand-painted watercolor of the Tibetan deity Green Tara or a beautiful rendering of

the agony of Christ in shades of black. In between these two dimensions of image is a vast vista of possibility.

The Hindus have known for thousands of years that the image of a deity or a great spiritual realizer has the power to transmit grace or blessings to one who gazes upon it. Great Indian masters such as Ramakrishna, Meher Baba, Ramana Maharshi and more recently, the revered South Indian beggar saint, Yogi Ramsuratkumar, have instructed their disciples to contemplate the image, or *murti*, of the awakened master to invoke grace and divine remembrance. In centuries past, the master would often have his image carved into stone and left behind as a *murti* or *vigraha*—an image that is empowered with the very essence of what it represents—with the power to bless ongoing generations of seekers and practitioners. In Vajrayana Buddhism, as in tantric Hinduism, worship of the image of an *ishta devata*, or chosen deity, is one of the most fundamental spiritual practices, employed as a means of purification, gaining wisdom and liberating the mind from illusion.

In India, tattoos—in most cases, Sanskrit mantras, prayers and deities—are used by certain obscure religious sects and cults. They are also found in tribal areas where tattoos are sacred symbols or clan initiations. The image or Sanskrit name of the deity is considered so powerful that it should be tattooed only on specific parts of the body or sides of the body, and never below the waist. To tattoo the image of a deity on the wrong part of the human body could incur serious negative karma; to tattoo a deity of the right-hand or left-hand (tantric) path on the wrong side of the body is considered another serious transgression. Because of the painful nature of the ordeal, one was supposed to gain spiritual merit in the process of getting tattooed; these sacred tattoo images are so potent that they could then be "traded" in "heaven" for better karma.

The Hindus aren't the only ones with this understanding of the power of the image. The great shaman Lame Deer speaks of tattoos in his classic book, *Seeker of Visions*:

*From birth to death we Indians are enfolded in symbols as in a blanket. An infant's cradle board is covered with designs to ensure a happy, healthy life for the child. The moccasins of the dead have their soles beaded in a certain way to ease the journey to the hereafter. For the same reason most of us have tattoos on our wrists—not like the tattoos of your sailors—daggers, hearts and nude girls—but just a name, a few letters or designs. The Owl Woman who guards the road to the spirit lodges looks at these tattoos and lets us pass. They are like a passport. Many Indians believe that if you don't have these signs on your body, that Ghost Woman won't let you through but will throw you over a cliff. In that case you have to roam the earth endlessly as a wanagi—ghost. Maybe it's not so bad being a ghost. It could even be fun. I don't know. But, as you see, I have my arms tattooed.[24]*

The gypsies of Europe, whose origins are found in India, have a similar understanding. In the tiny village of Saintes Maries de la Mer, on the Mediterranean Sea in the Camargue in the south of France, the statue of Saint Sarah, patron saint of the gypsies, beckons from her crypt in a thousand-year-old stone church. As an archetypal image of the Great Mother, Sarah is very likely the most alive spiritual icon in all of Europe. Like the Hindu Kali, her skin is black and glistens, like her eyes, in the light of many candles that burn continuously beside the offerings that have been made to court her blessing. Countless miracles have occurred there, evidenced by the crutches, shoes and garlanded plaques giving names and dates. The deity impacts the senses in a total way; standing in her presence, there is no question that Saint Sarah is a manifestation of the sacred in the world today.

The gypsies understand a very important secret of life. They love this deity so much that they journey to Saintes Maries de la Mer every year in May en masse, as many as a hundred thousand at a time, to carry this archetypal image, a *murti* in every sense, to the sea for her annual ablution in the maternal waters of the Mediterranean. Sarah is the *ishta devata* of the gypsies, the chosen deity, and through her image, they find the divine within themselves.

The powerful magic of an image is not meant to be understood by the rational mind; it cuts closer to the bone, blood and heart of the matter. As Don Ed Hardy wrote, "At best, [tattoo art] fulfills the enduring role of all art: to emphatically affirm the irrational and to celebrate life itself." This statement applies to all tattoo art, and as indefinable as the link of interaction between the image and the soul of an individual human being will remain, the power of the image is undeniable. All mysteries appear to be irrational from the limited perspective of the human mind.

# Science Speaks

Despite the misuse of technological breakthroughs that are so apparent in our world today, science can and should be applied judiciously toward the dawn of wisdom; when it is, we often find the affirmation of the "irrational" and "magical" in fantastic ways. For example, there have been studies recently made in Japan by Masaru Emoto, a doctor who was deeply inspired by the work of Dr. Lee H. Lorenzen, a pioneer in water studies. Emoto was profoundly moved by what he began to discover about the properties of water, the principles of which applied exactly to the workings of subtle energy (*chi* or *prana*) and consciousness in humans.

Dr. Emoto discovered a new method of evaluating water, which is a substance that changes rapidly and is inherently unstable. He experimented with highly polluted water as well as clear water from springs, rivers, lakes, marshes and rainwater from all over the world, submitting it to sound (in the form of music and spoken words) and light (in the form of pictures and written words placed over the water). In order to determine how the state of the water might have changed after exposure to these influences, he took samples of the water and placed them in Petri dishes in a freezer for two hours. He then magnified the water crystals that had formed by two hundred to five hundred times in order to see the infinitesimal detail in the structure of the crystals.

Using high-speed photography to capture the images of the water crystals, Dr. Emoto made an extraordinary discovery; water responded to all influences by forming crystals that reflected the characteristics of that to which it had been exposed. When the words "I hate you" were spoken over water or even held over water in written form, the ice crystals were misshapen, hideous and dark. The water crystals could not take form in their natural six-sided shape, but were almost unrecognizable as crystals and appeared as dwarfed, stunted, warped versions of how they appeared under benign influences. When the words "You are beautiful" were spoken over water, or simply held over water in written form, the crystals became lovely, intricate and delicate. When the water was exposed to pictures of deities or mantras were chanted over it, the water crystals became sublime in their breath-taking coalescence of beauty in a perfect six-sided symmetry. [25]

The parallels to the human body are obvious, since the body is composed primarily of water. Every person knows in him or herself how different the internal response is to kindness or cruelty. The salt or sugar of our speech and actions do make a difference; the fact of this does not need to be explained but remains a fundamental of human experience. When we are treated with dignity, exposed to beauty, grace, kindness, generosity and compassion, the best is brought out in us. Emoto's research is most poignant when applied to how we raise our children; the words we speak to them are, on a daily basis, creating the adults they will become.

Similarly, one of the fundamental premises of this book is that engraving the human body with potent images, including the sacred written word, has the power to effect change and even radical transformation. Dr. Emoto's studies shed a very bright light on the supposition that sacred art tattoos have a physical effect on the human body and an alchemical effect when engaged with awareness and intention. And further, it places tremendous importance on the symbolism of the images we choose to populate our lives, whether in skin art engraved on human flesh, or in the art that we bring into our lives at any level. This includes painting, literature, sculpture, movies, theatre and in human interaction—for relationship with other human beings is an art form in and of itself. These impressions, across the spectrum from gross to subtle, are literally a form of nourishment or poison, depending on what they are.

# The Agony: Pain and Pleasure

Because it is a process of change and creation, of bringing something to life, the tattoo ritual has something in common with birth and death—times in which we are in contact with the intangible dimensions of being. Many who have been present at both the births and deaths of loved ones comment on the similarity between these two experiences, when one can feel the primal energies and potencies that are unleashed while the doorway into the invisible worlds is wide open. The tattoo rite has something of this intensity in it but to a lesser degree: the image itself is brought to life when it is put on living flesh, and there is a small death and rebirth because, once tattooed with an image, we have been changed.

Every tattoo experience is unique. Each time remains an unknown, and even for those who have gone under the needle

many times there is some fear and excitement. When sacred art is combined with a higher intention for the purpose of the tattoo, there is also a strong felt sense that we are entering into a serious commitment as we are brought into direct contact with a mystery that will be revealed to us over time in living with the tattoos we have gotten.

It takes some courage to get a tattoo, because for many people the pain is not an insignificant part of the process. Everyone deals with the pain of the tattoo rite in a different way. Many people distract themselves with music or conversation, while some cry, squirm or grimace. Still others will split off from the bodily experience and retreat into a state that is almost somnambulistic, which is distinctly different from staying aware and conscious. Others people pray all the way through their tattoo, saying, "Lord, get me through this." We could also respond with another kind of prayer: "Let the pain of this experience be dedicated to relieving the suffering of others. Let me have this pain that others may be free of it."

Our conditioned response to life is to be afraid of pain or to try to armor ourselves against it—to avoid it at all costs. When we choose to get a tattoo we have the opportunity to say yes to an experience of pain and remain conscious in it. Some tattoos may be much easier than others, but all of them are a confrontation to the limitations of the body and the fact of our fragile physical existence and ultimate mortality. Practically speaking, the bigger the tattoo, the more the pain and the greater the opportunity to realize that we exist beyond the five senses and the sensations of the physical body. There is a certain nobility that is developed within us when we discover that we are worthy of the challenge of the tattoo experience.

Every individual has to find his or her own relationship to getting a tattoo, but it is very powerful to realize that we don't have to talk about or dramatize the pain of it. The whole experience can be managed internally by turning strong feelings inward and containing them in a way that creates an alchemical crucible. The pain and our response to it becomes an internal heat that has both purifying effects and also amplifies the empowering aspects of the tattoo experience. One way to do this is to enter into a state of open-eyed meditation during a tattoo. Meditation, mantra, prayer or pranayama (breath) practice, or a martial arts practice that cultivates the ability to manage energies in the body and focus attention, can come into play during a tattoo.

The veterans of the tattoo world know that tattoos have a certain addictive quality (in other words, we keep going back for more), and that the first time one goes under the needle is going to be different than the fifth, sixth or seventh time. The very real, visceral, bodily experience of pain mixed with pleasure is an encounter that touches a primal chord of longing for many people. This meeting with the primal realities of the body is one of the great attractions of tattoos. Truly, for most people the tattoo sensation is a combination of agonies and ecstasies—like a raw lemon with sugar piled on top. The pleasure and ecstatic feelings are part of the process; it is a known fact that endorphins flow freely after a while during a tattoo experience. And there may be something of the forbidden fruit—of having broken through the taboo barrier to a certain freedom—that increases pleasure in the tattoo act.

There is the pain of the needle, the small losses of blood, the rawness of the skin and emotions, the feeling of having been purified in some way, and then there is the power of the image itself. The pain of the tattoo ordeal will be over as soon as the needle stops, although it takes a few days for the skin to heal completely. The image, however, will be with us permanently, from now until death, and the power of the image will make its presence known to us. The size of the image does not always make a difference in terms of its potency as a symbolic representation of a greater reality. Very small Sanskrit words are the greatest example of this because they carry tremendous spiritual force. The tattoo image itself is an irritant, like the grain of sand in an oyster that eventually makes the pearl. It reminds us of the pleasure and pain of existence. Because it is *always* there as a constant presence, it can incite our remembrance of the divine while also acting as a beacon that sends a message out into the universe—a constant prayer.

## The Alchemy

Sacred tattoos engender an alchemy that occurs in the medium or matrix of the human body, which is inseparable from the life force, spirit and soul that animate it. They are one way that we may invoke blessings upon ourselves and cultivate an inner environment of harmony and sanctuary, although any alchemical process catalyzes and invokes powerful forces that may shake things up in the internal landscape. Therefore, entering into any

process of alchemy demands a discriminating mind and heart and is best navigated with the help of a competent spiritual guide. Although this book is not intended to be a treatise or linear explication of alchemy or of any particular spiritual path (the detailed principles of which may be found in many other sources and books of wisdom), it is wise to consider briefly how this ancient science translates into the alchemy of sacred art as tattoos.

The aim of classical alchemy was to transmute base metals into gold and discover the elixir of life (longevity) or quintessence; taken both metaphorically and literally, alchemy is the process by which one undergoes a purification and dissolution in which the temporal body becomes transmuted, divinized or infused with the radiance of the divine. When we enter into the world of sacred tattoos, we are stating an intention to become purified and cultivate qualities such as kindness, compassion and surrender to higher principles. One does not engage sacred art as tattoo for purely aesthetic or academic reasons, but because deep in our bones we are ready to be changed in some way for the better. We are asking to have our character sculpted by divine means.

Any form of alchemy involves being undone from the individual egoic point of view—a process of deconstruction in which the structures of our psychological complexes and the superficial overlay that Jung called "the persona," or outer personality, are broken down to make way for a truer expression of self. There are stages in the alchemical process in which we are not being made grander, bigger, more eloquent or talented but smaller, deeper, quieter and simpler. This is the spiritual process in a nutshell as it has been given by all the major traditions of the world: Hinduism, Buddhism, Christianity, Islam or Sufism and Judaism.

In this process we are becoming surrendered to the natural laws of the cosmos as a totality. We are being stripped of those assumed conditionings that obstruct or obscure our true nature, which is innately clear to the point of transparency. Alchemy is a process of purification that involves inner fire and sometimes cataclysmic changes, many of which will only occur internally while our outer lives remains ordinary, with family, friends, work and service to others as the center poles of activity. As we change for the better, love in action becomes the theme of our lives. Over time we become radiant, clarified, purified of dross—like a glass of clear water.

This process of deconstruction of the outer personality comes into play as soon as we go under the tattoo needle and begin the ritual of working with the intrusion of needle, ink, pain and the raw feelings of ecstasy and discomfort. We have surrendered ourselves to pain for a few or several hours; in another way we have surrendered ourselves to this symbolic image, this tattoo, for life. Our skin is now not only our own, but exists as a constant invitation to invoke the indwelling presence of a divine being or a higher principle.

At the same time, the tattoo act makes us raw and vulnerable in ways that are actually empowering, because getting tattooed is the act of a warrior, requiring perseverance, inner fortitude, courage, strength of will and clarity of purpose. In very general terms, wherever there is friction between opposites, there is the possibility of sparking a creative alchemy. One of the hallmarks of a greater self-realization comes when we find ourselves experiencing continuity in the midst of opposing qualities—like being a tender-hearted warrior, or discovering the secret seeds of freedom and euphoria in the midst of pain, even for a few moments—because we have been brought closer to our original state of being, which is oneness with all that is.

The magnetic, steadying effect of sacred images exert an inexorable pull on the body toward that which the image or word represents; that is why it can be said that after the agony, there is the alchemy. Actually, it is not that linear, for as soon as the needle touches the skin, the process of alchemy has begun. Some say that it begins as soon as the image, words or mantra are chosen: in other words, as soon as we enter into a conscious relationship with the particular archetypal presence contained and transmitted in word or picture form. When we invoke the power of a fierce deity, we are asking for our illusions to be destroyed, which means that our personal, individual ego will become subsumed by a higher power.

If you ask (with enough sincerity and perhaps for a long enough period of time) Kali or Vajrayogini to sever your illusions, she will grant your prayer sooner or later. If you invite the divine lover, that blue-skinned flute player Lord Krishna, to break your heart and make of you a hopelessly-in-love lover of God, and you apply your prayer with a tender, vulnerable heart, sooner or later Krishna will call you to his *lila*, the divine games. In this metaphor of relationship to the divine, our longing is only another way of asking to be ruined to everything else but

the most gossamer touch of the beloved's kiss.

Even the blessings of the peaceful deities, like White Tara, will make demands upon you; the force of the deity will ask you to relinquish your pride, anger, shame, hatred, vanity, greed, arrogance, bigotry, violence and selfishness in any and all forms. As a cosmic force of peace and compassion, White Tara is the antithesis of these primal passions that, when unchecked, brood and multiply within the psyche then strike out against the world in our actions toward others. Even all of our grieving and betrayals must be transformed, for the great spiritual teachings tell us that the final frontier of the soul is one of gratitude, worship, prayer and praise.

The same is true when we use a sacred language like Sanskrit in tattoos on the body. The Sanskrit language, which is the language of the *Vedas*, is said to have two dimensions: the audible sound of its seed syllables and words, and the subtle, essential sound vibration behind those words, which is vibrant with the meaning natural to it. This subtle vibration is the real *sabda* or sound. In Vedic philosophy, the power of sound and light are the two original emanations of the Divine that create the manifest worlds. Sound, or Logos (also called the divine word), is that vibration which actually becomes the dynamic principle of Creation. The ancient Vedic goddess called Vak (Logos) was considered the Mother of the World.[26] By this same principle, all Sanskrit words are considered to be varied forms of the original sound, Om or Aum—the mystical syllable that is vibrant with the very Divine.[27]

Specific written Sanskrit words, used with conscious purpose, become prayers in and of themselves. For example, the Sanskrit seed syllables or actual names of God such as Krishna, Shiva, Kali or Durga have the power to invoke the presence of these aspects of the divine. The Sanskrit word *sraddha*, which translates as "faith," literally *is* the vibration of faith; the word *sreya*, which translates as "that which is good and auspicious," carries the essence of that quality. Sanskrit phrases are prayers that invoke blessings such as "She who shines with the power of a *crore* (ten million) of suns." The word of power and sanctity, engraved on skin, is a living vibration that exerts a steady subtle influence upon the malleable, restless waters of the human body—ruled as they are by the gravitational pull of the moon upon the planetary oceans.

Sacred tattoo art on the body of one who engages *sadhana*—

discipline and work on a spiritual path—becomes a testimony of the road one has traveled and a map of intention for the road ahead. In this sense it has the power to guide and mold our character and our lives. It is magic of the most subtle variety.

Sacred art as tattoos has the potential to alchemically transmute the very cells of the body and reveal profoundly deeper levels of meaning and possibility. To have the choice to change one's self according to a greater vision ushers in the potential for transformation—a word much bandied about in casual terms. What kind of transformation are we interested in? In asking this question, that which is really important comes into focus. Is it personal comfort we desire? A better self-image based on current fashions, a new house, a new car, more money, a better job, more status and power in whatever milieu we may find ourselves? Do we enjoy drawing attention to ourselves by shocking, repelling or attracting others? Or are we interested in the kind of irrevocable change that makes us into a human being who is a force of compassion, generosity and goodness in this world?

## A Splendor of Grand Design

The tattoos in this book are all images of traditional sacred art taken primarily from the great spiritual mythologies of the East. The transcendent function of myth is that the archetypal images or metaphors of mythology serve to connect us from microcosm to macrocosm; they make conscious that which is unconscious. The images that follow represent living potencies and forces of the divine that are multidimensional: they inhabit various levels of reality from subtle to gross. They are immediate and real in the here and now of physical life, yet also mystical and sublime.

When we focus on these images, we are nourishing their reality within our own being. The Eastern traditions understand that the multiple deities of their pantheons live within the human being; they are the archetypes of the human soul. Each one represents a very specific dimension of human experience; these are aspects of the divine manifesting in a world of myriad forms, each one expressing and celebrating the creator's creation. There is no conflict between unity and diversity in the great play, or *lila*, of the divine in this world of form. From this perspective, everything is holy—there is nothing that is not part of the fabric of life, a cloak of many colors and threads, woven into a seamless

whole by the ultimate reality which transcends all opposites.

All of these diverse anthropomorphic images of the divine lead us, sooner or later, to the unity of all beings in the absolute One. Modern quantum physics has proven to us that the microcosm and the macrocosm are inextricably intertwined; the vast universe is one continuous web of energy, eloquently described in Fritjof Capra's classic, *The Tao of Physics*. This is not news to the mystics of the human race. Hundreds of years ago William Blake wrote: "To see a world in a grain of sand / And heaven in a wild flower, / Hold Infinity in the palm of your hand, / And Eternity in an hour." Just as there is continuity between day and night, light and dark, there is continuity between the mundane physical world and the subtle mystical worlds, in the same way that there is continuity between the Earth, the Sun and the rest of the Milky Way.

Somehow in the midst of all this splendor, we can choose to embellish our lives with expressions of grace, harmony and clarity that reflect objective reality. The surprising works of original and popular art in this book, rich with many shades and nuances of color and form, touch us at deep levels because they are resonant to the human soul. They are not separate from us, existing in some heaven realm that we cannot imagine or dare to dream of, but living inside the human body, the sheath of the soul—in the core of our being. They are found in the human heart. They are expressions of our deepest longings, of even that which is hidden to our own awareness.

The phenomenal world exists by miracle alone. Why would our daily lives, held within the matrix of that miracle, be any less inexplicable and wondrous? There are still extant in the world today those spiritual traditions that rely, to a very great degree, upon the miraculous: Tibetan Buddhism, devotional and tantric Hinduism, tantric sects in India like the Bauls of Bengal and the Nath Siddhas, the shamanic traditions of Central and South America, the Hopis and Navajos. When we engage the alchemy of sacred tattoos we are entrusting ourselves to the wisdom of our ancestors, who knew that the world operates on the grounds of magic and miracle.

The intention of this book is to communicate in a universal way the essence of alchemical transformation in the images that are offered here. The magic of the image is that it speaks directly to the locus of imagination that exists in the awakened heart; it is a nonlinear transmission that bypasses the mind and goes directly to the soul. It is not necessary to get a tattoo to bring the influence of this sacred art into your life. Allow yourself to enjoy the beauty and sanctity of the images in the pages that follow. Take them to heart—absorb them through the eyes, breath and with the comprehension of your own heart—and they will reveal their secrets to you.

# The Tattoos

Brahman, Thou art One.
Though formless,
   through Thine own power,
   and for Thine own unfathomable purpose,
   Thou givest rise to many forms.
Thou createst the whole Universe from Thyself,
   and, at the end of time,
   drawest it back within Thyself.
O Brahman, Give us clear understanding.

Thou art Agni, the fire.
Thou art Aditya, the sun.
Thou are Vayu, the wind.
Thou art Chandrama, the moon.
Thou are the brilliant stars.
Thou art Hiranyagarbha, the golden womb of creation.
Thou art the cosmic waters.
Thou art Prajapati, the Lord of all creation.

Thou art woman,
Thou art man.
Thou art the youth,
Thou art the maiden.
Thou art the old man tottering along with his stick.
Having taken form, Thou facest in every direction.

Thou art the deep blue butterfly,
Thou art the parrot, green with red eyes.
Thou art the father of lightning.
Thou art the seasons and the seas.
Unborn,
   Thou art everywhere,
And all that is, is born from Thee.

Shvetashvatara Upanishad, IV.1 – IV.4

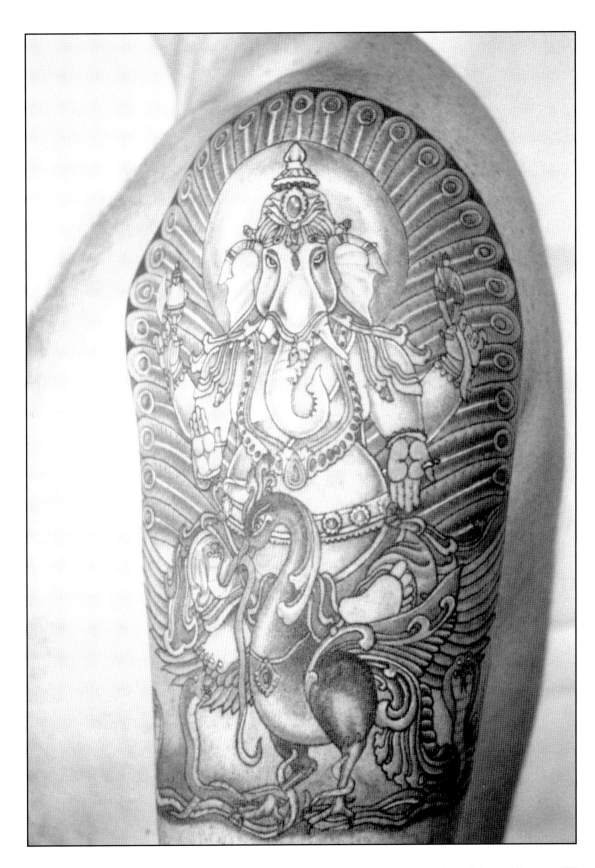

The Hindu god
Mayuresvara Ganesh
on his peacock mount.

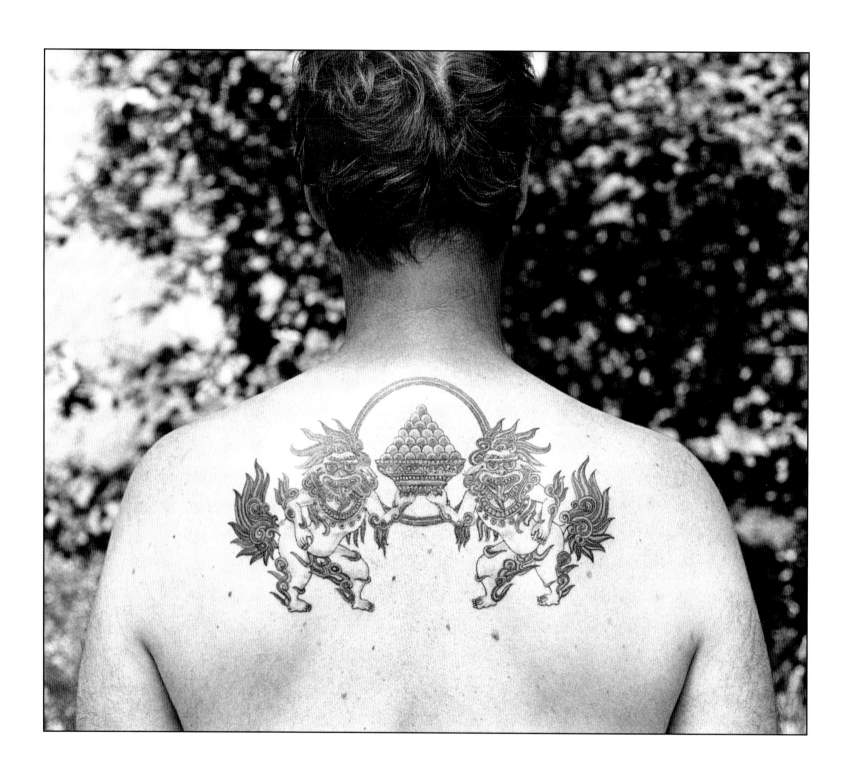

Rampant Snow Lions, holding offerings
of wish-fulfilling jewels within a rainbow aura.

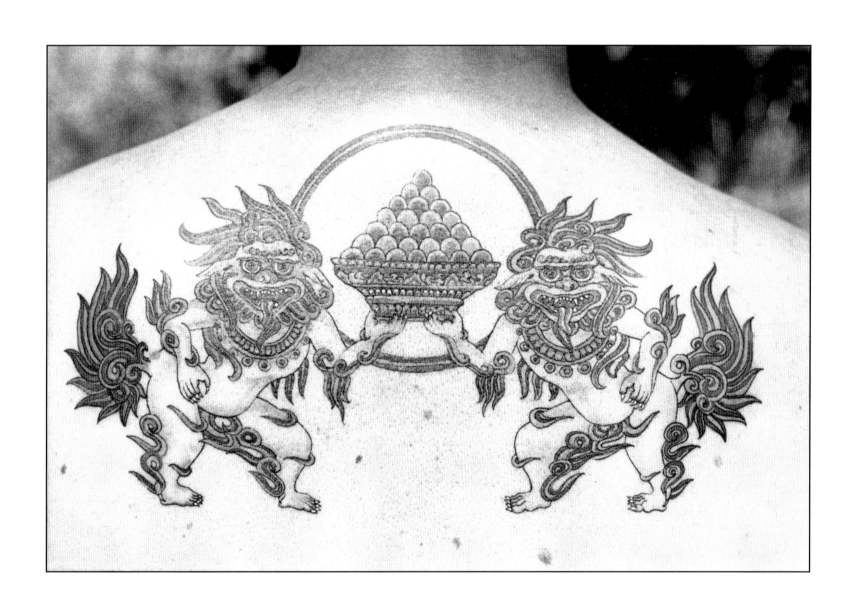

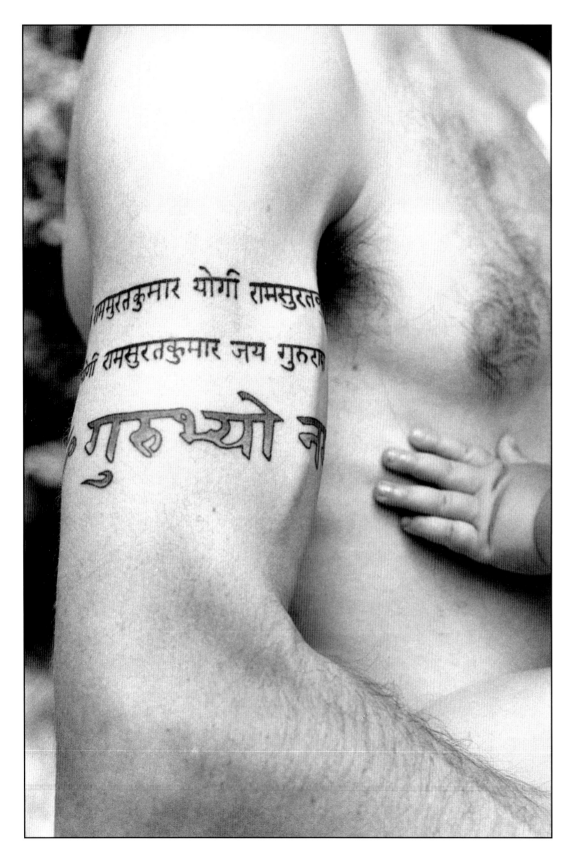

Sanskrit mantras.

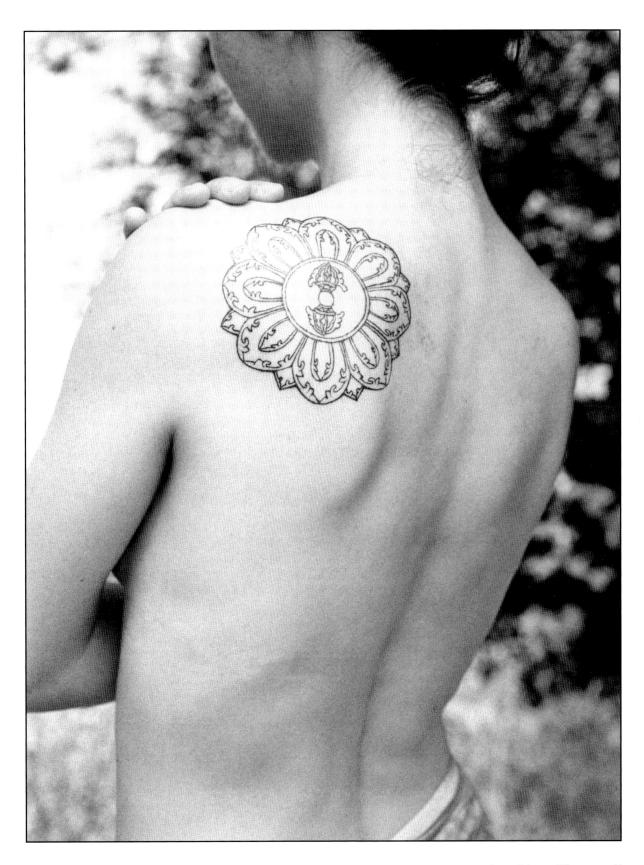

Vajra in
stylized lotus.

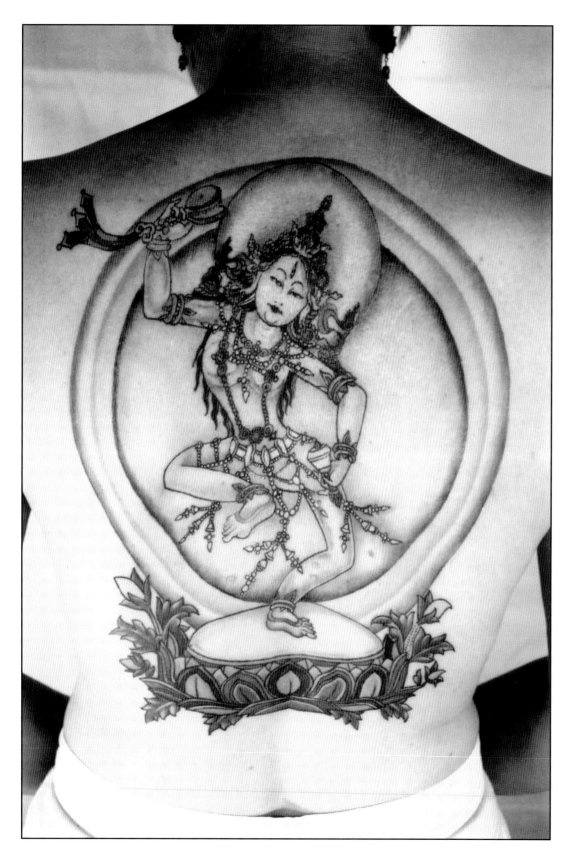

Machig Labdron (1055–1145), Tibetan female saint, dancing in the posture of Dakini Vajravarahi. Image interpreted from traditional Tibetan thangka art.

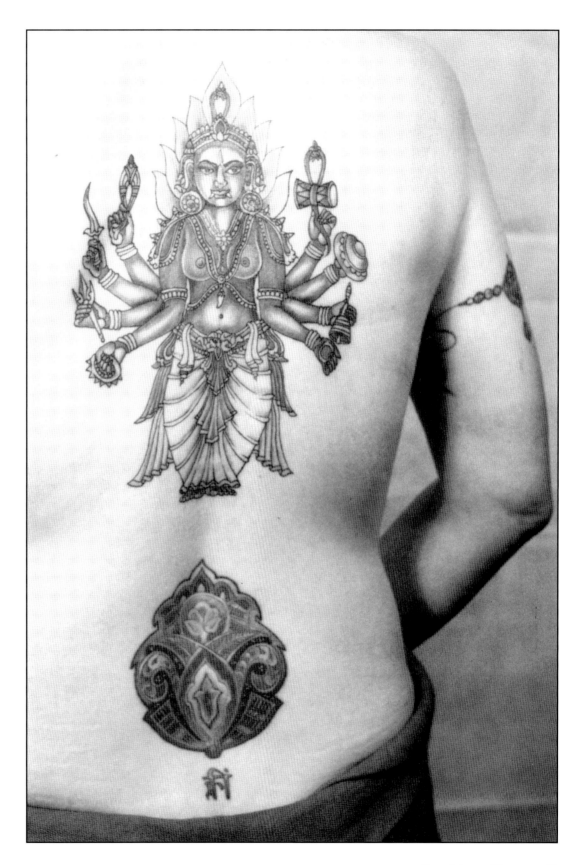

Hindu goddess
Om Kali above an
auspicious Persian
motif with Krishna
seed syllable.

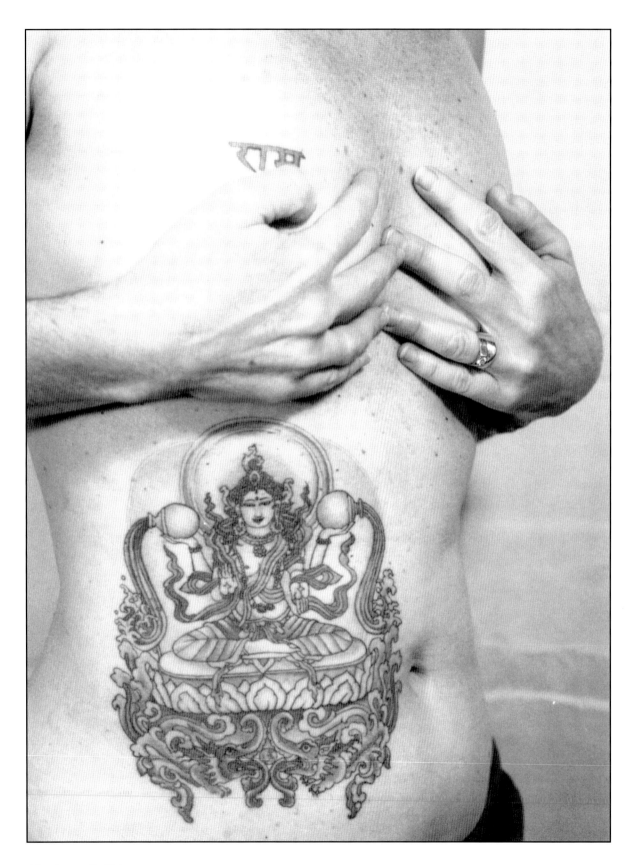

Newari goddess
Ganga below
Sanskrit "Ram."

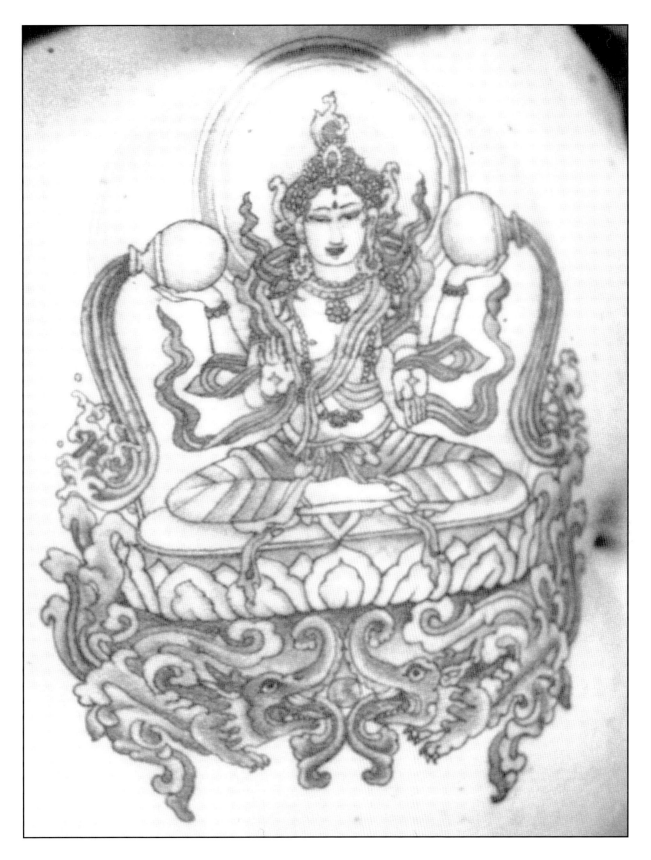

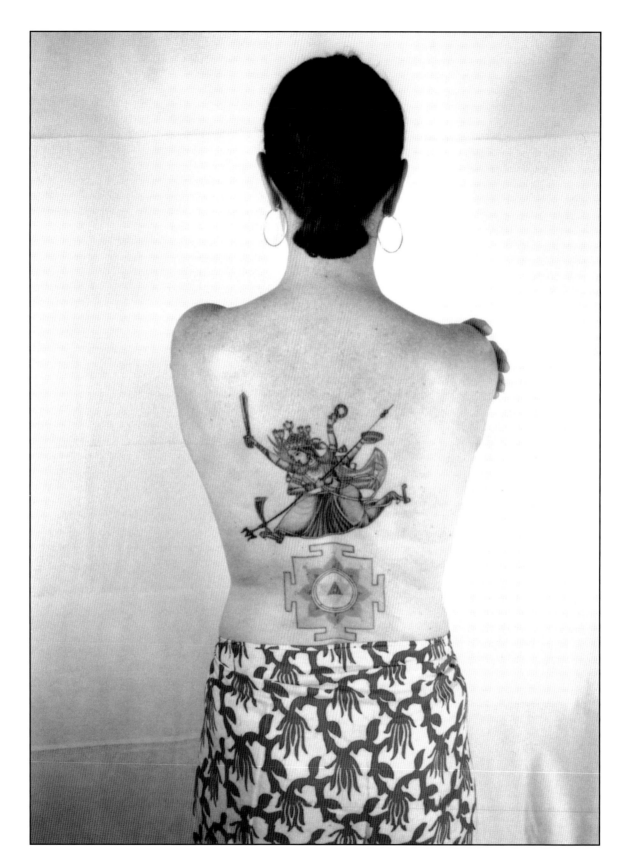

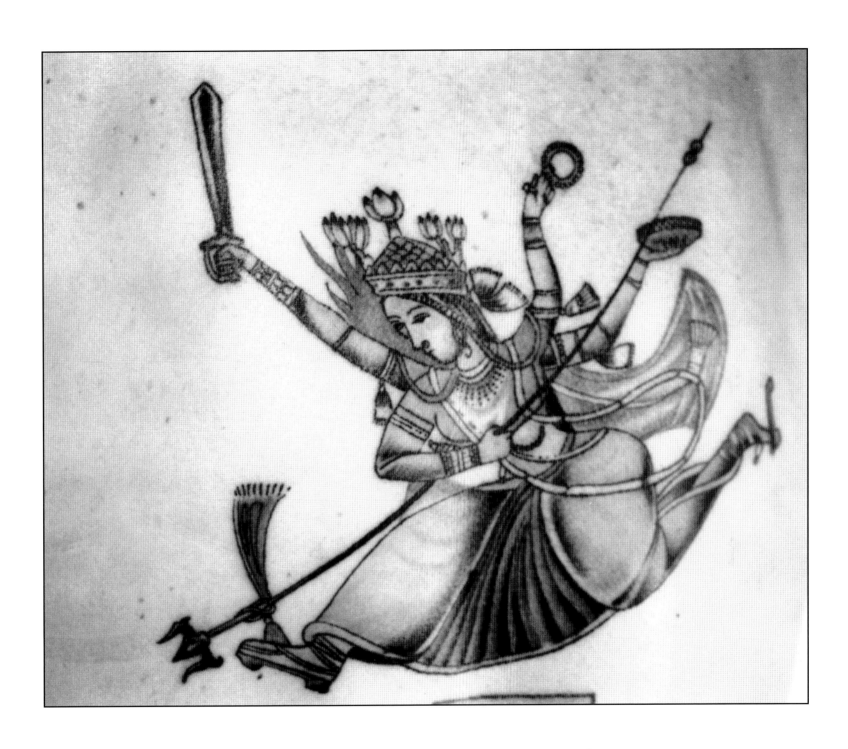

Opposite and above: Battling Durga with yantric diagram representing her energy. Popular image from India.

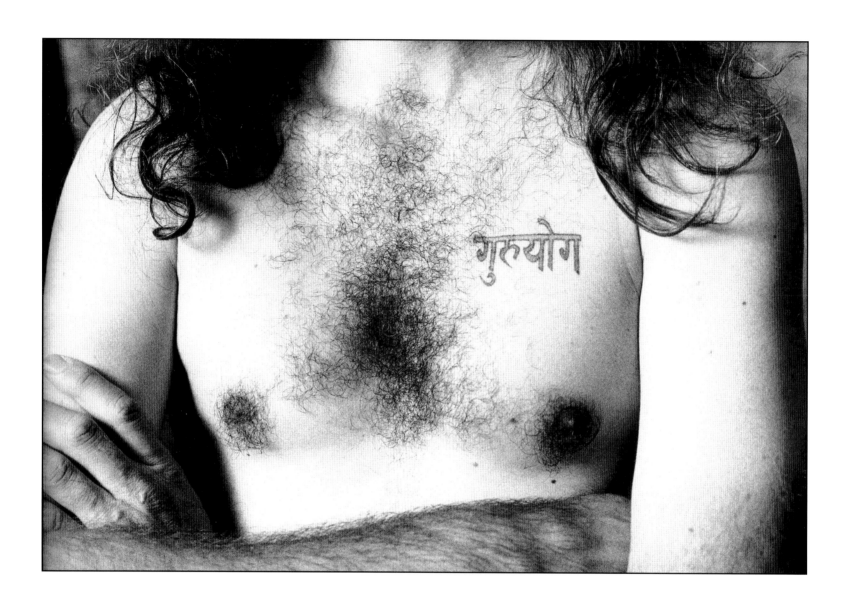

Mantric phrase in Sanskrit.

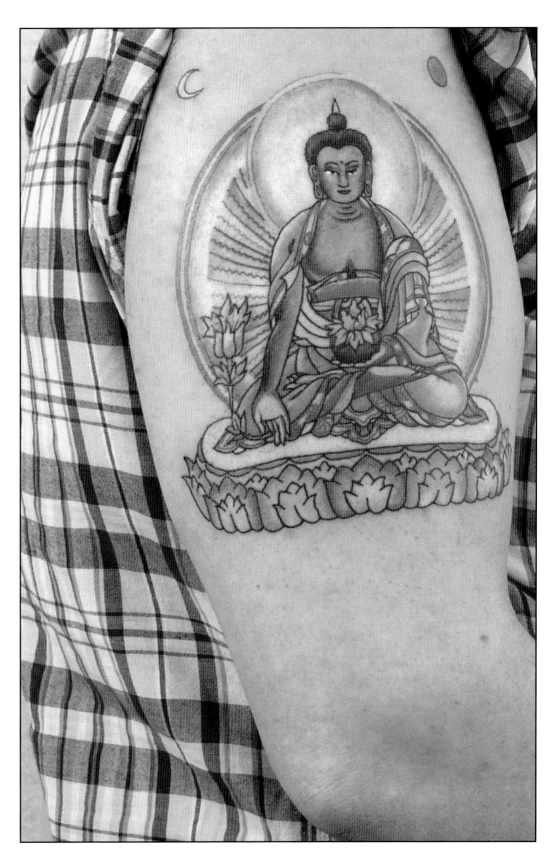

Tibetan Medicine
Buddha with
sun and moon.

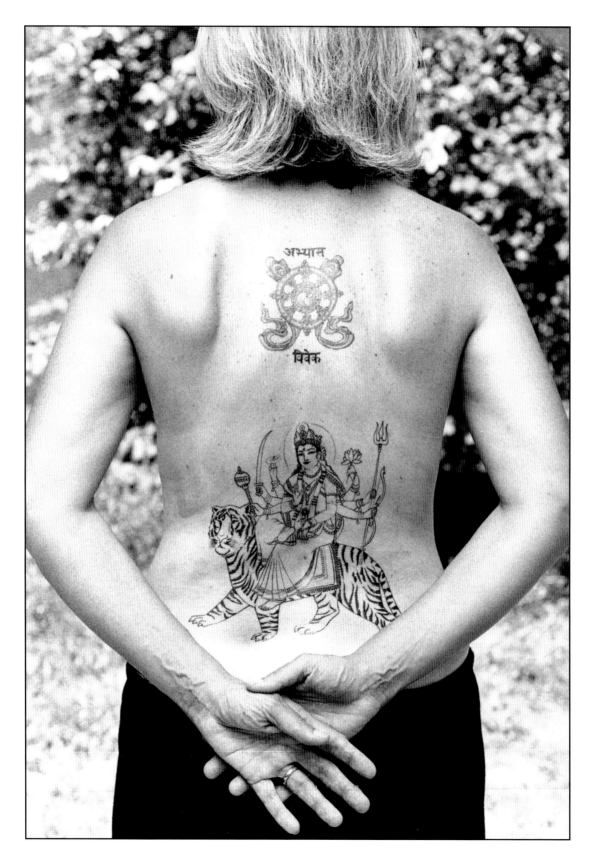

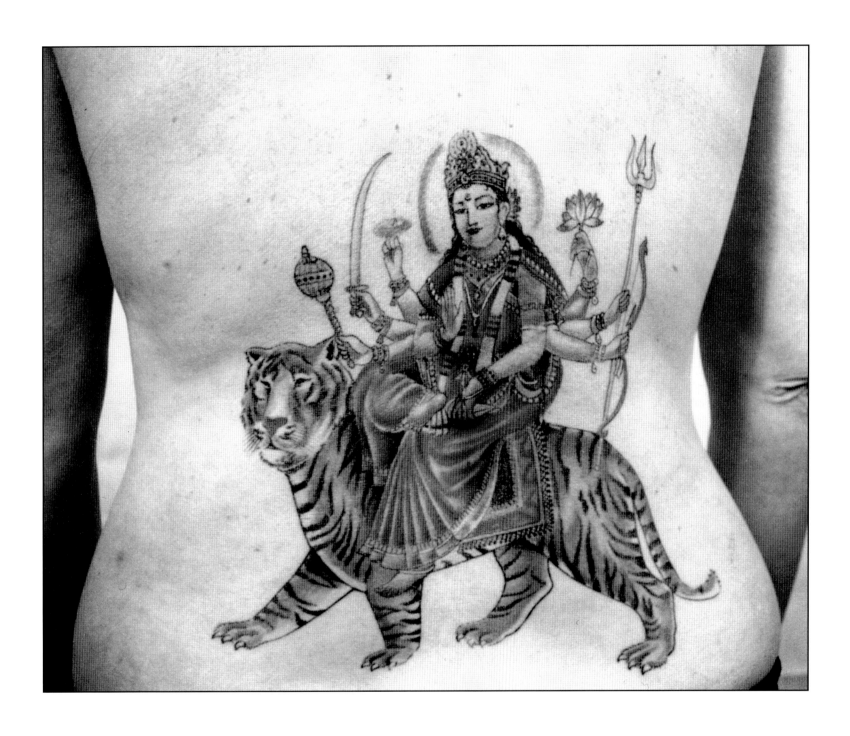

Opposite: Tibetan dharma wheel, drawing by Robert Beer,
with Sanskrit mantras above line drawing of the Hindu warrior goddess Durga
on her tiger vehicle, image taken from popular Indian art.

Above: Finished Durga.

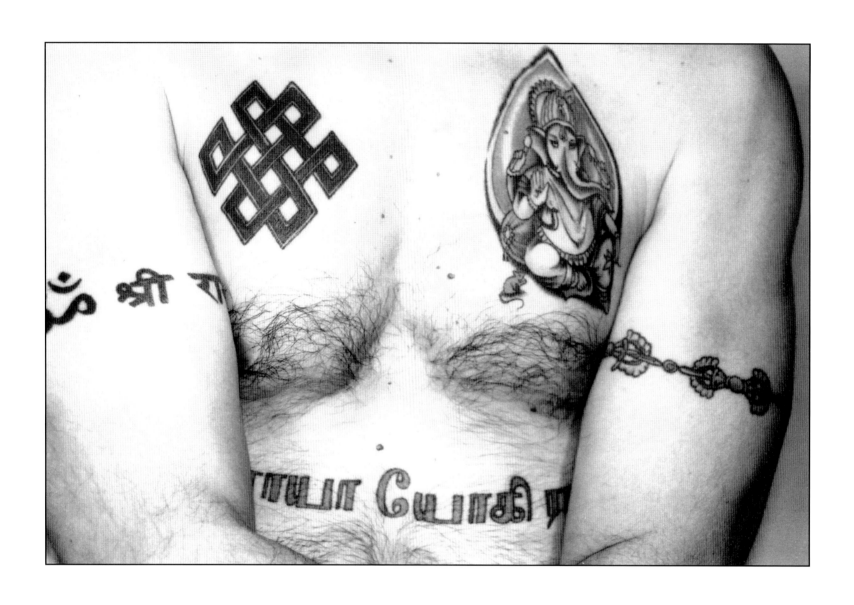

Above: Sanskrit mantra "Om Sri Ram Jai Ram Jai Jai Ram" on right upper arm; armband of dorjes (vajras), drawn by Robert Beer, on left upper arm. Popular image of the elephant-headed god Ganesh and Tibetan knot of eternity on chest.

Invocational prayer in Tamil circling the midriff.

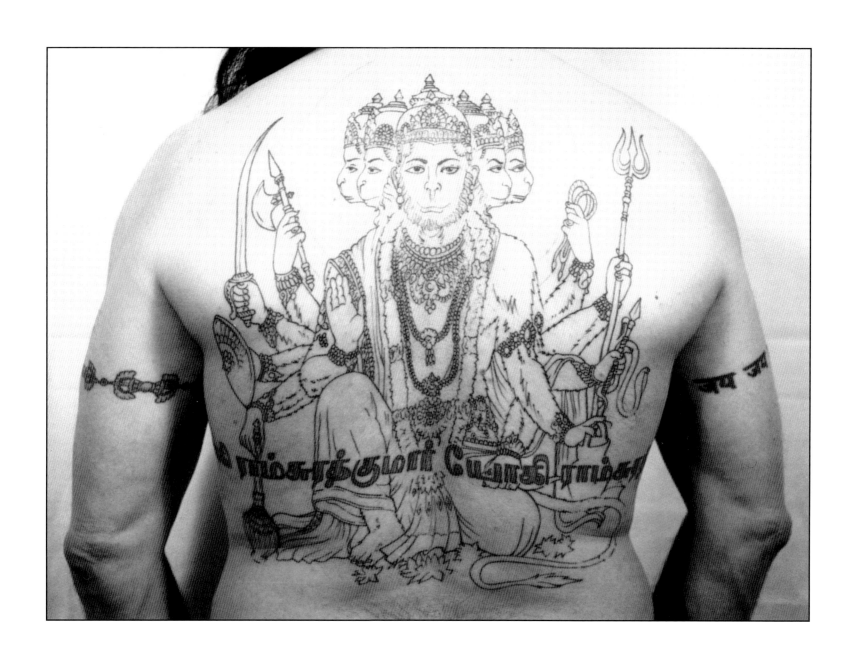

Work in progress: Line work of the Hindu god Hanuman in five headed
form added to Tamil prayer. Image taken from popular Hindu art.

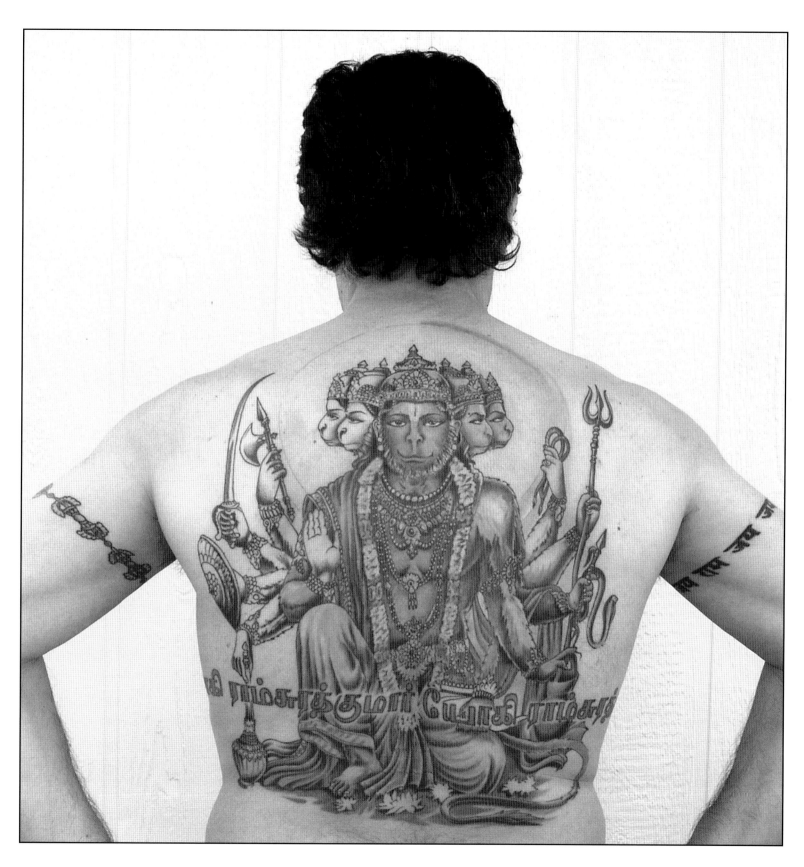

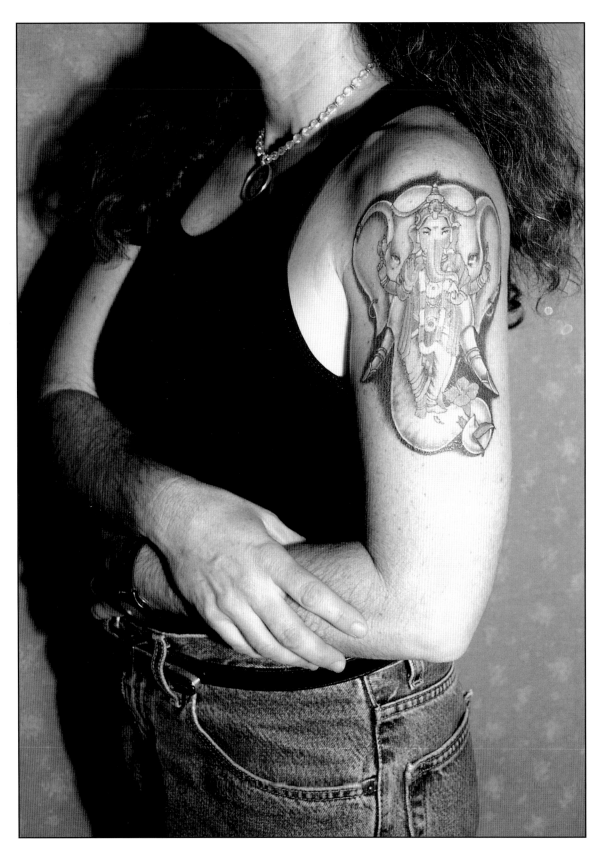

A popular image
of Lord Ganesh.

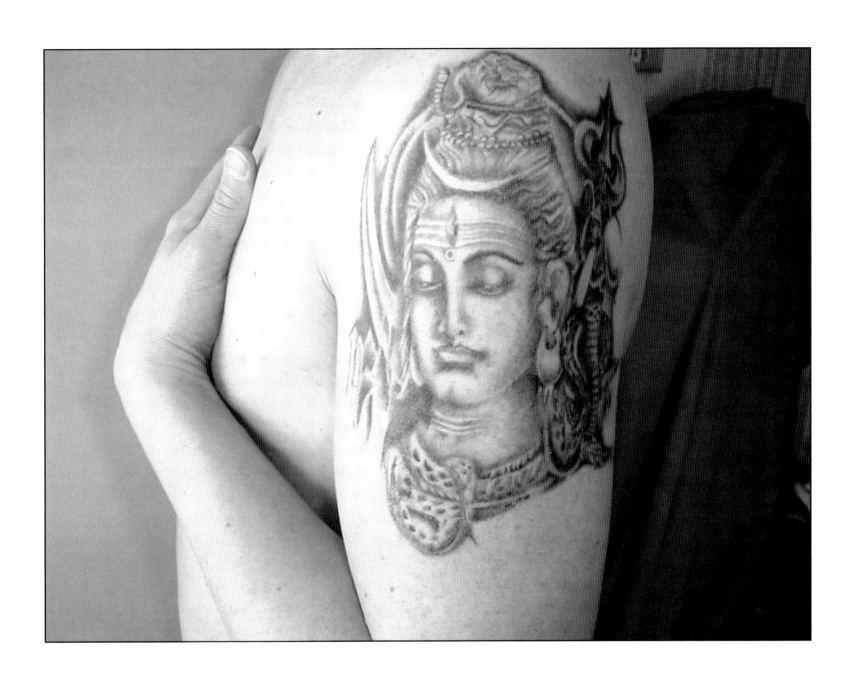

Lord Shiva, image taken from popular Indian art.

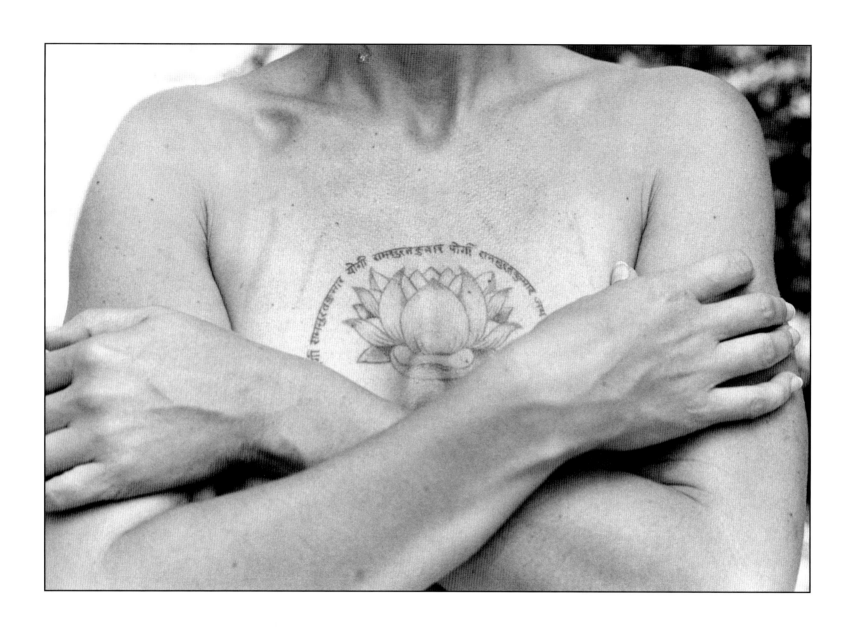

Sanskrit mantra with lotus.

Right: Flaming Durga
trident with protective
nagas (serpents) and
Sanskrit mantra,
Jnanananda Bhairavi.

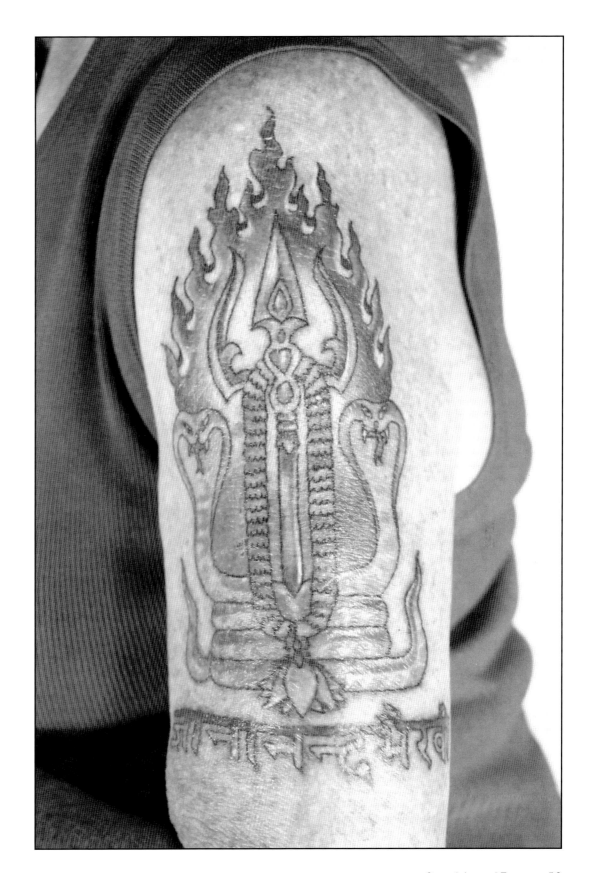

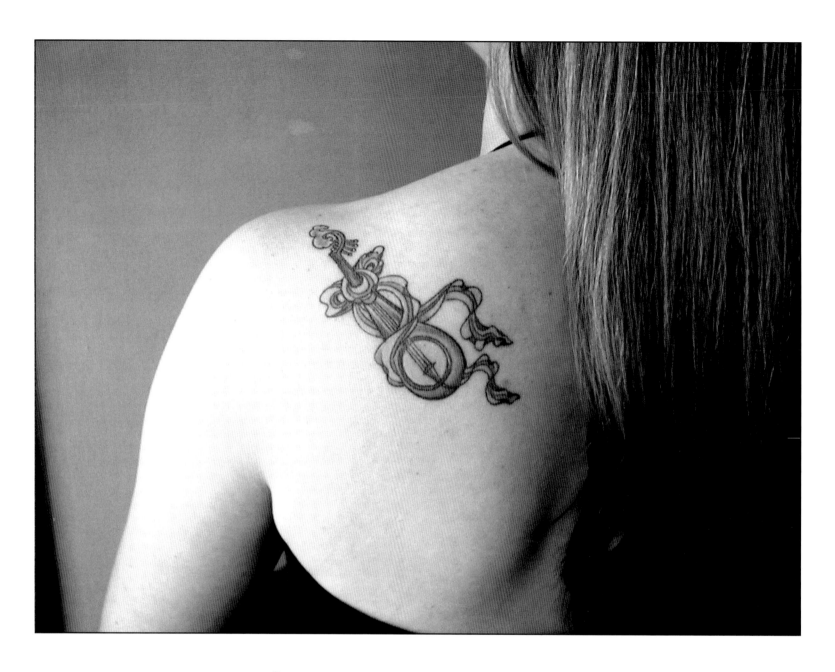

Ceremonial lute in silk offering scarves.

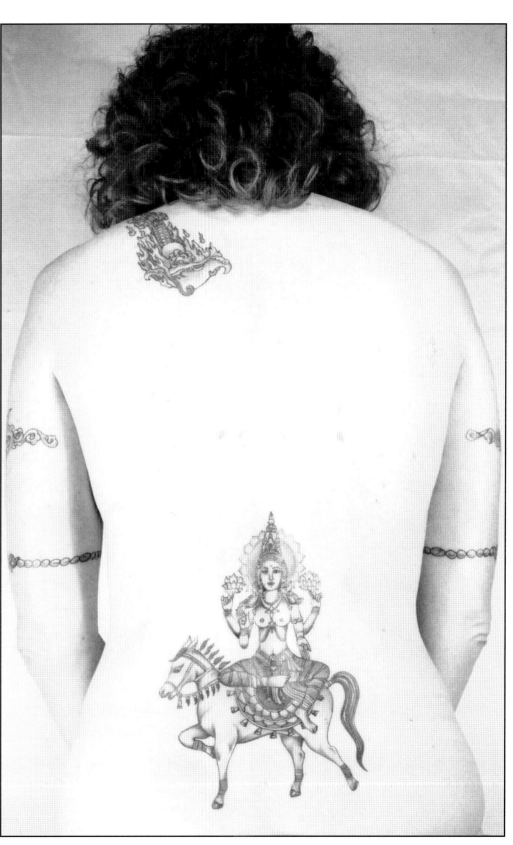

Left: The goddess Iswarya
Lakshmi below a flaming
ritual flaying knife
(close up) on shoulder

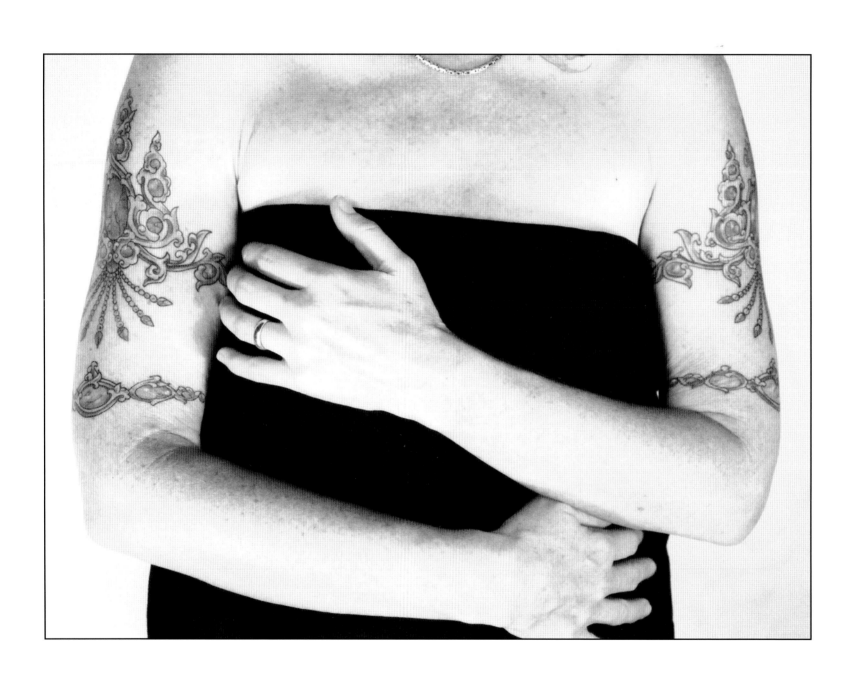

Tibetan-style gold and turquoise temple bazubands (see close up)
placed above smaller coral and gold armbands.

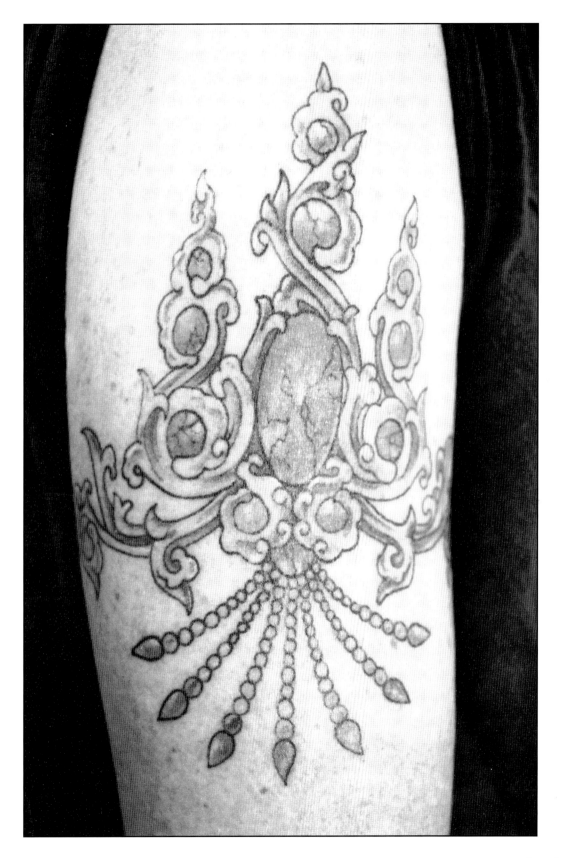

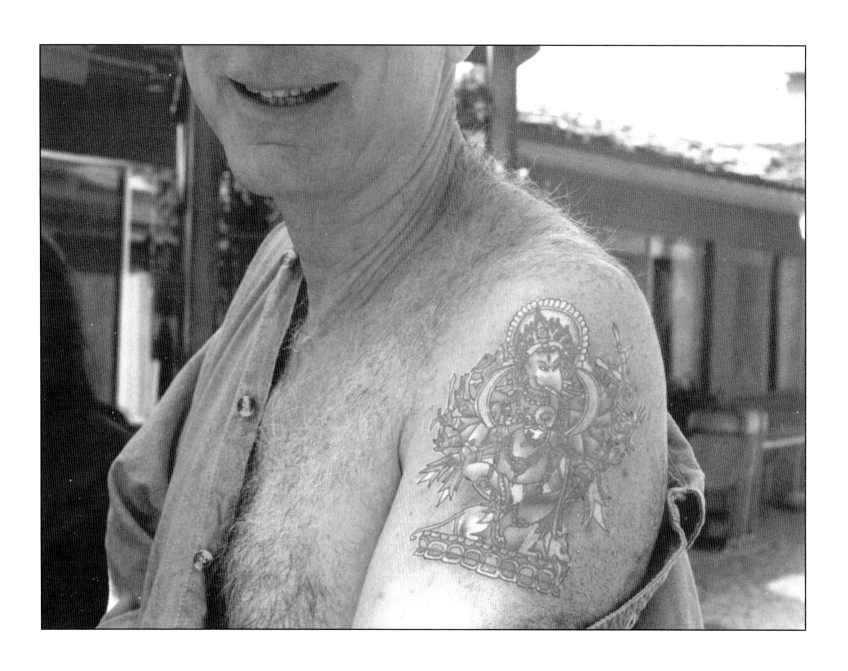

The god Ganesh in Nepalese style.

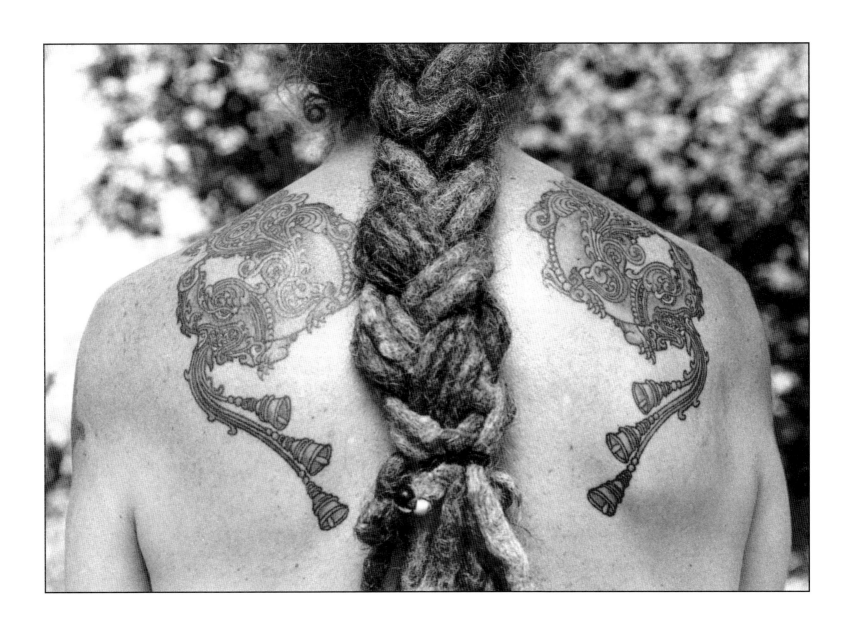

"Madurai Minakshi Makara," vomiting temple bells.

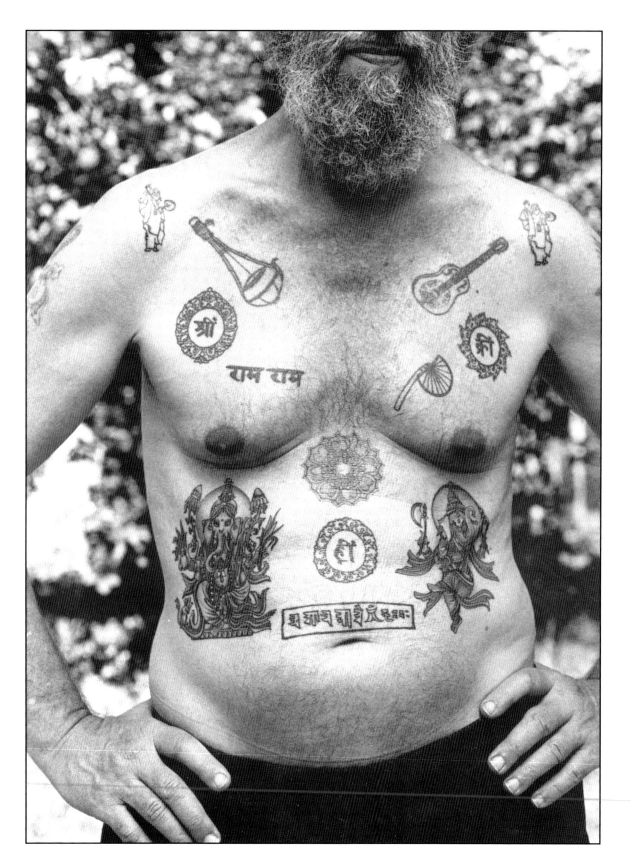

Two representations
of the Hindu god
Ganesh; Sanskrit
seed syllables and
lotus mandala.

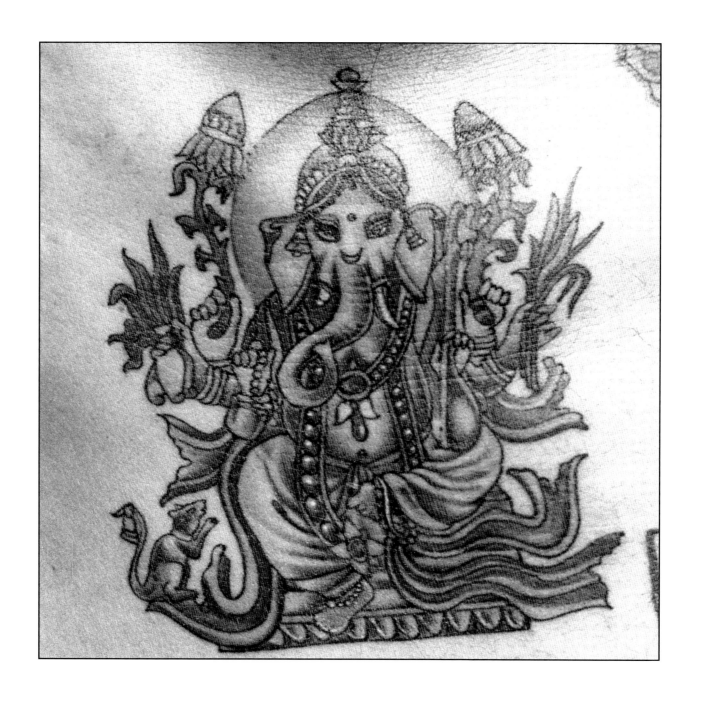

Ganesha.

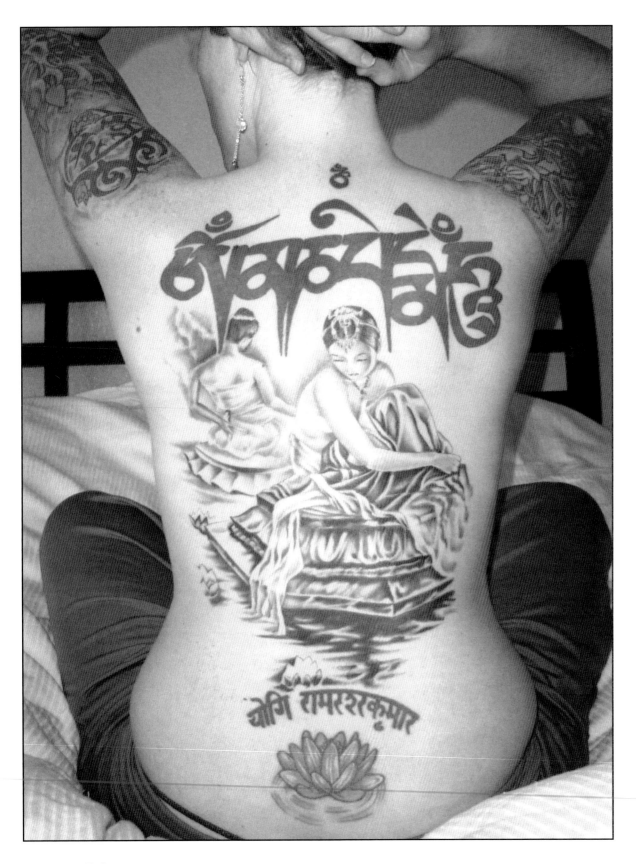

The Sanskrit mantra, "Om Mani Padme Hum," written in Tibetan script, which translates "Om, the jewel in the lotus, hum," and is an expression of compassion for all beings; Two women on stone pedestals at a lotus pool making prayers and fond wishes for loved ones who are deceased or far away; Sanskrit mantra above a stylized lotus. Art interpreted from popular sources.

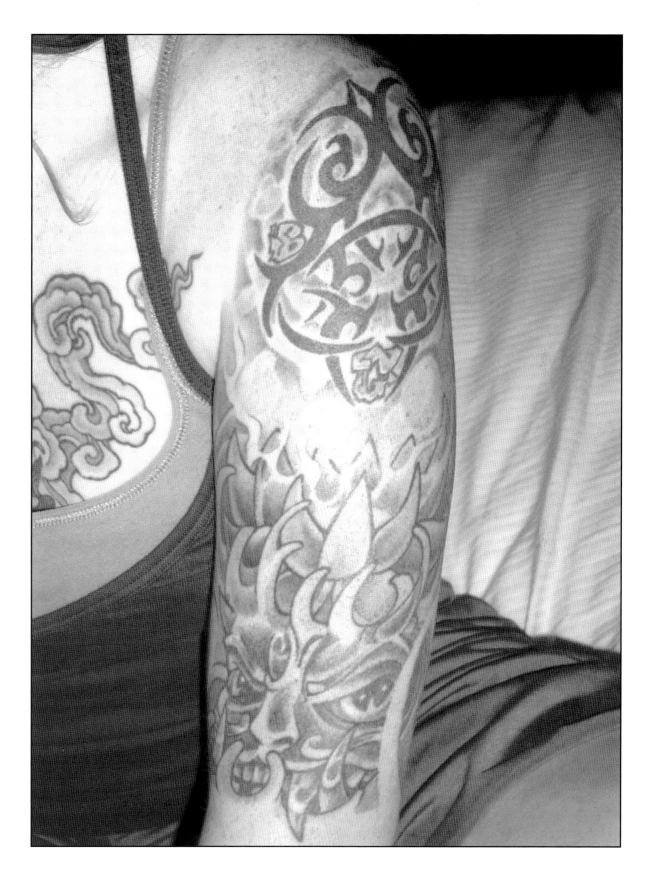

Half sleeve depiction of a Japanese Oni mask under a lotus. Original art by Aaron Funk.

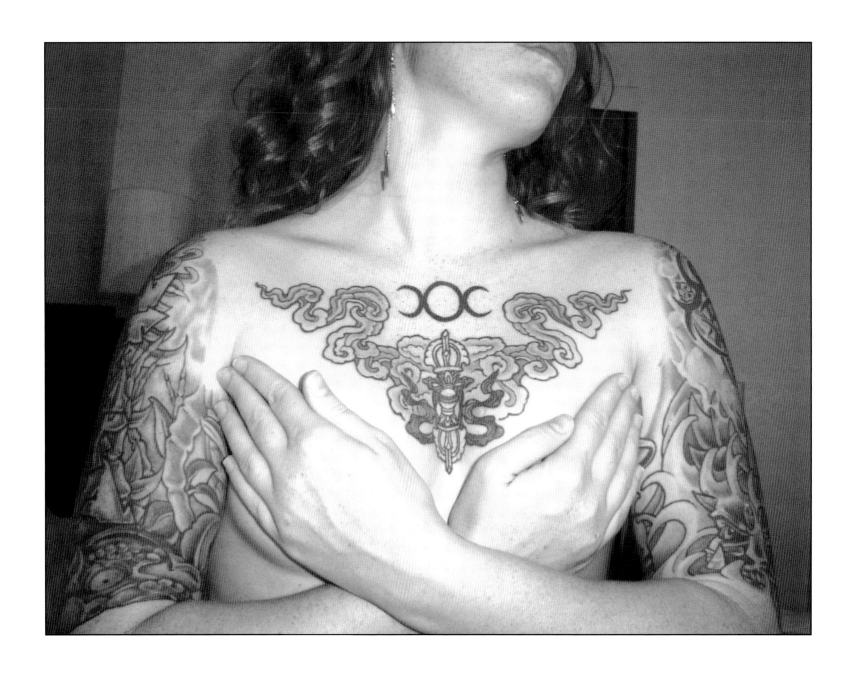

Popular symbol for the Celtic triple goddess and the
phases of the moon above a vajra resting in cloud banks.

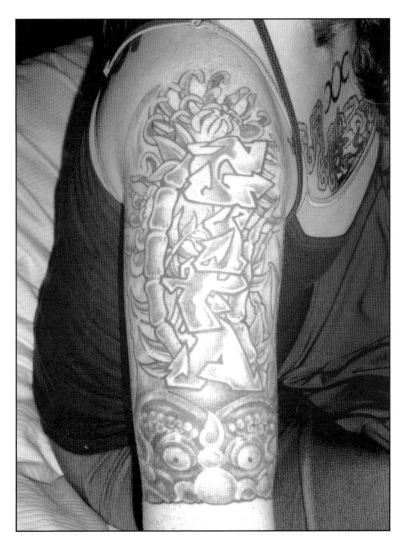

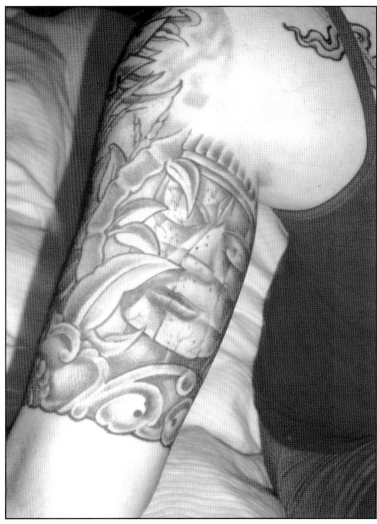

Above left: half sleeve images rendered from photographs of the stone ruins at Angkor Wat: Kala or Kiriti Mukha located on the north tower of the Preah Ko temple. Original art by Aaron Funk.

Above right: Inside arm images rendered from photographs of the stone ruins at Angkor Thom: Buddhist divinity found at the west entrance of Ta Som temple. Original art by Aaron Funk.

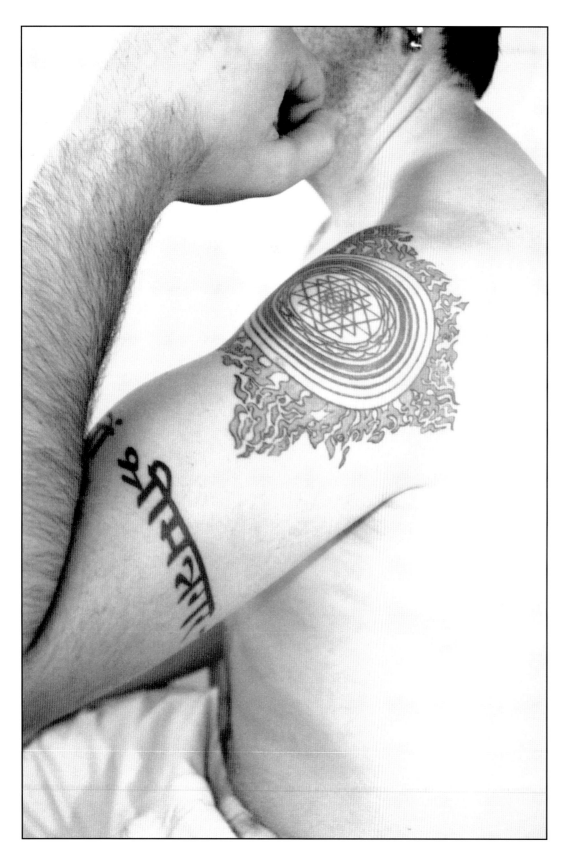

Yantric diagram
representing the goddess
Shri, surrounded by red
flames above Sanskrit
mantra: "Praise to She who
resides as the excellent
bindu, the central point,
in the Shri chakra."

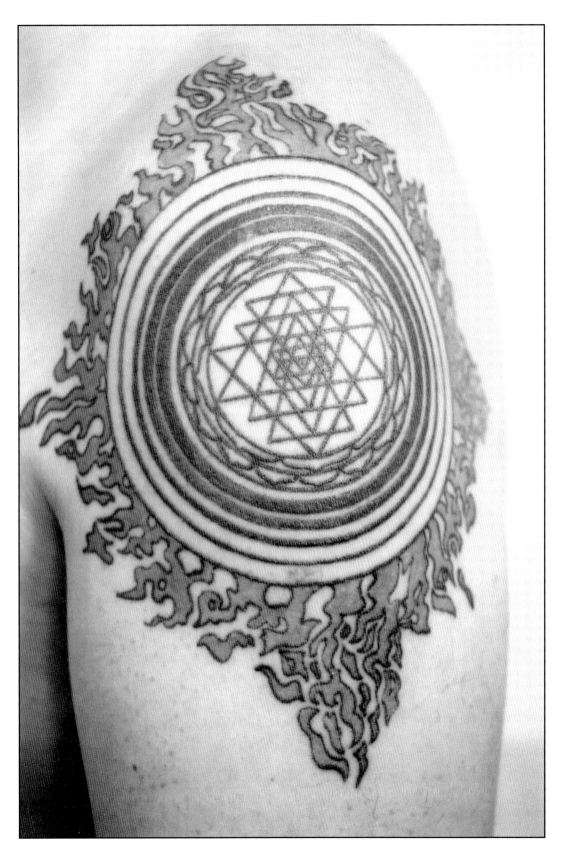

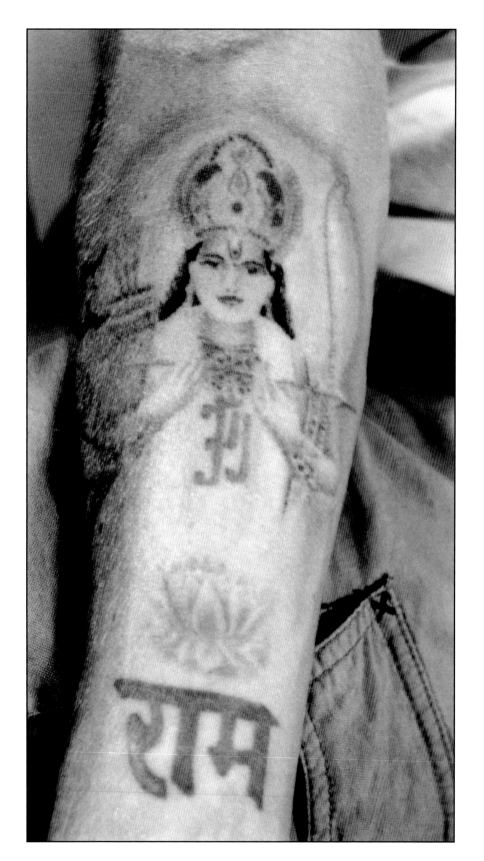

Hindu gods: Rama (left) with lotus and Sanskrit "Ram," and Narasimha (right) with his consort, Lakshmi. Designs adapted from popular Indian art. The image on the right is covering an old tattoo.

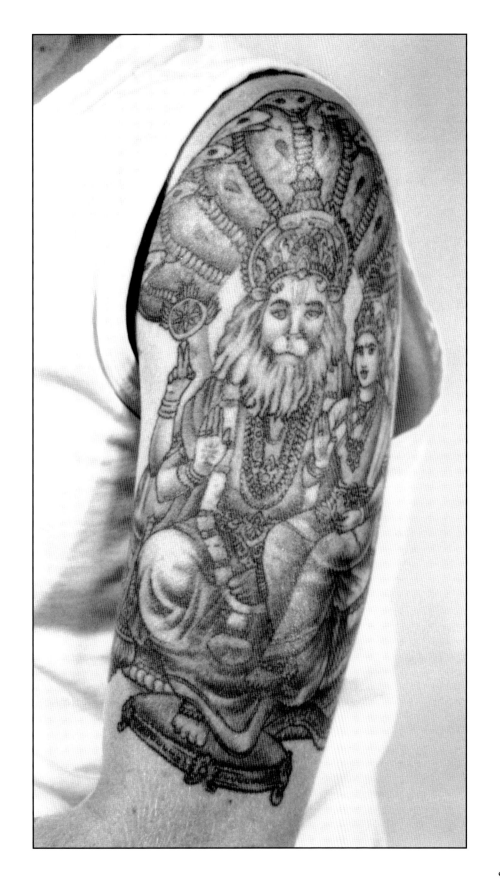

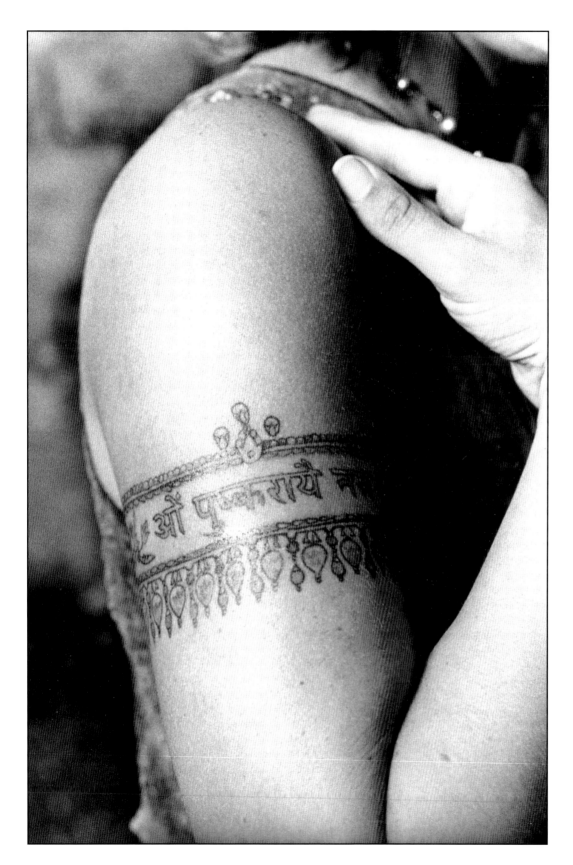

Traditional temple jewelry bazuband with Sanskrit mantra to the goddess Lakshmi: "Salutations to She who is like a lotus in full bloom."

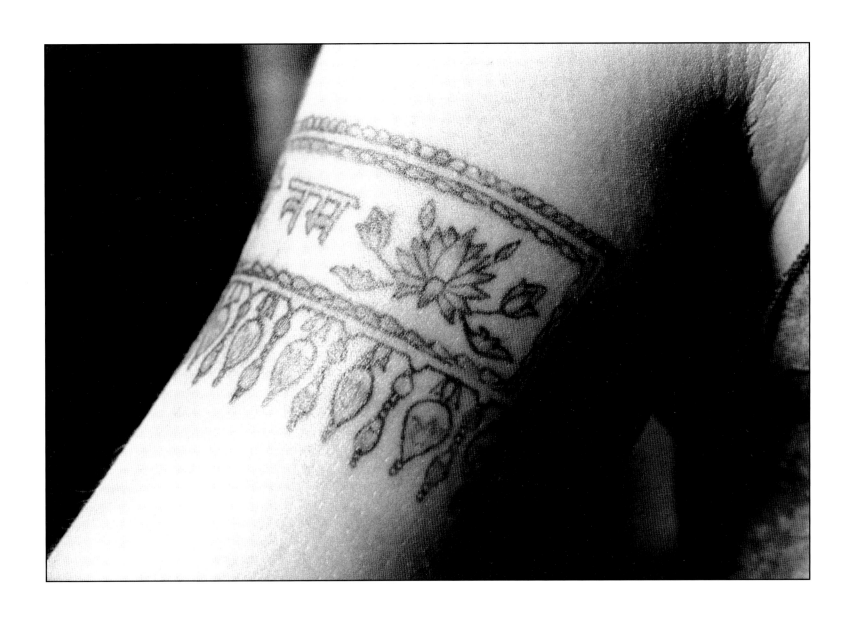

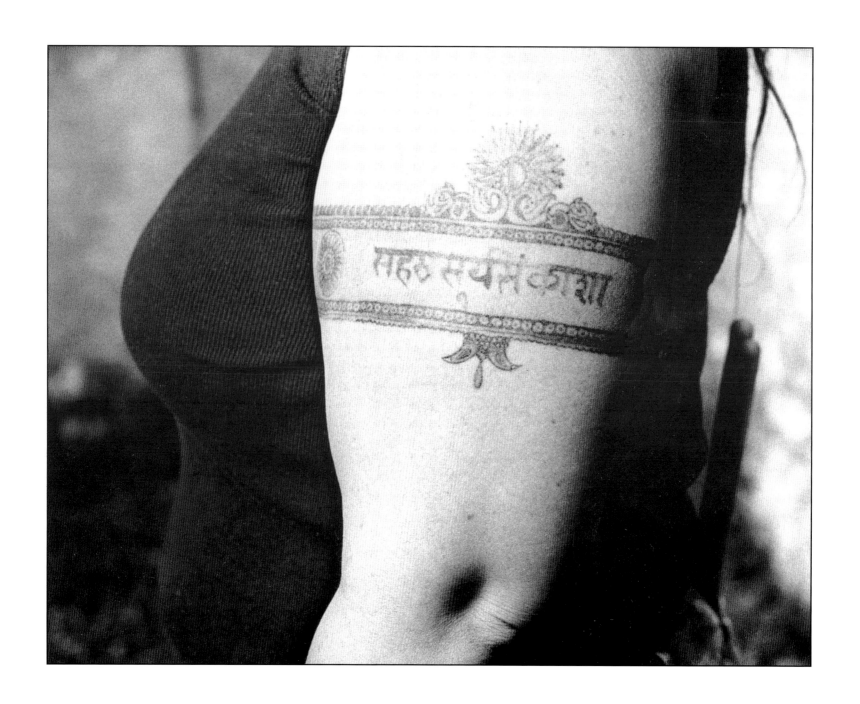

Solar ruby temple armlet with the mantra,
"She Whose Illumination is Like a Thousand Suns," to Sahasrasuryasamkasa,
one of the traditional 1008 names of the goddess Devi.

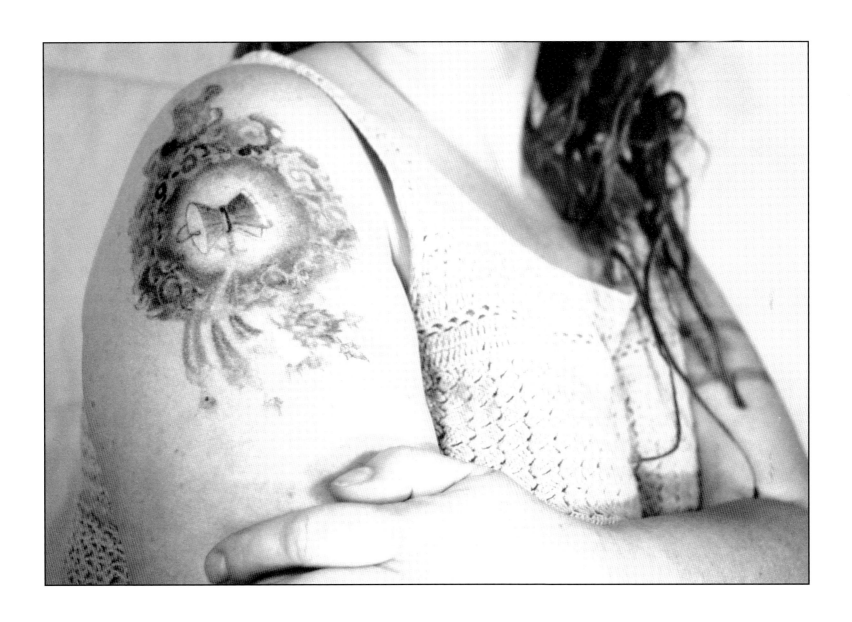

The Hindu god Shiva's damaru,
or cosmic drum, wreathed in flower offerings.

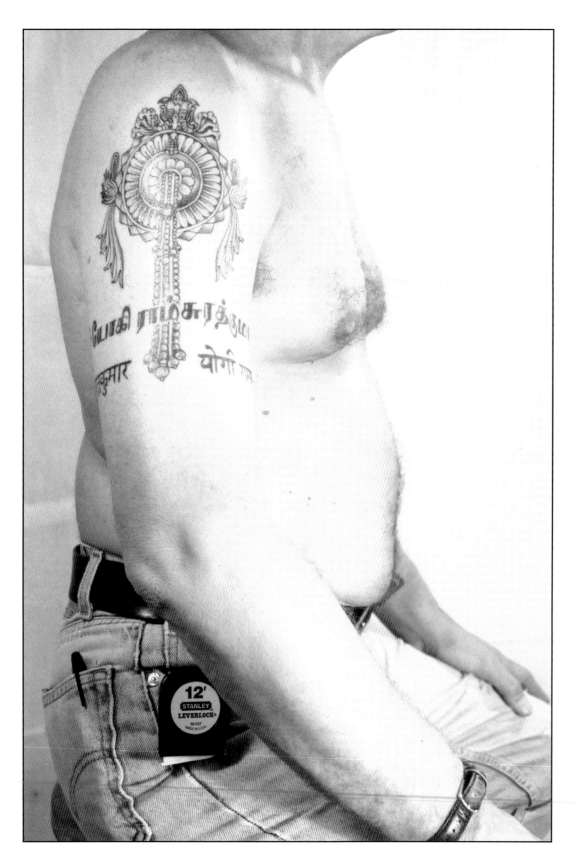

Sudarshan Chakra: the beautiful-to-behold solar weapon of the Hindu god Vishnu, with a Kiriti Mukha, or "Face of Glory." Tamil and Sanskrit mantra armbands.

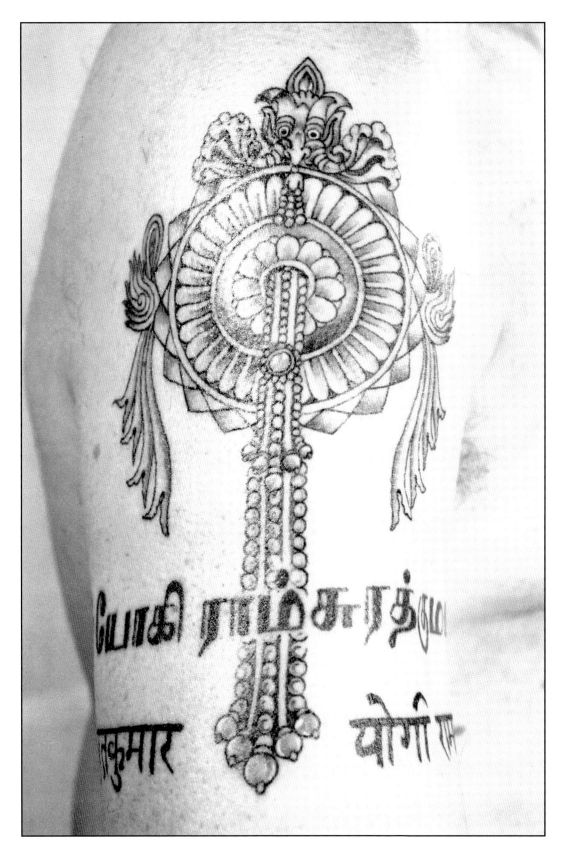

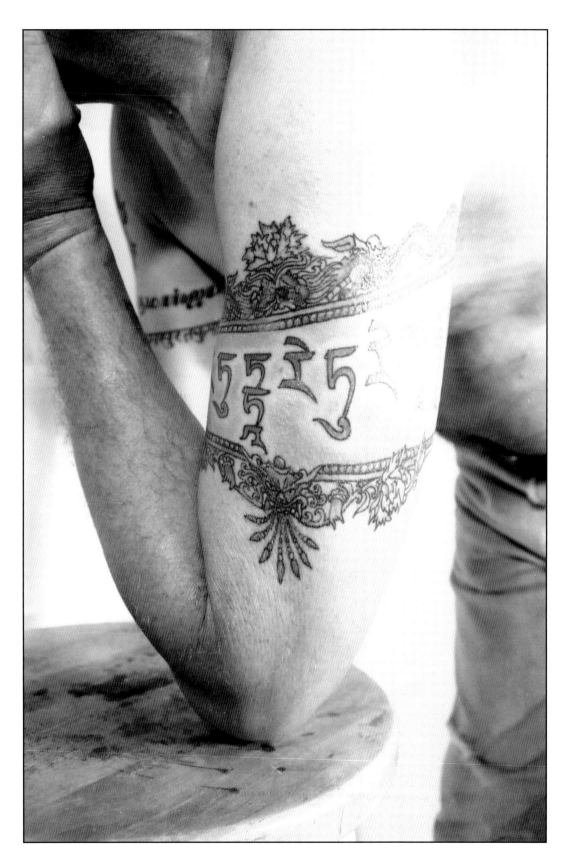

Green Tara bazuband:
Ornamental temple
armband imagined in
cloisonné enamel and
emerald.

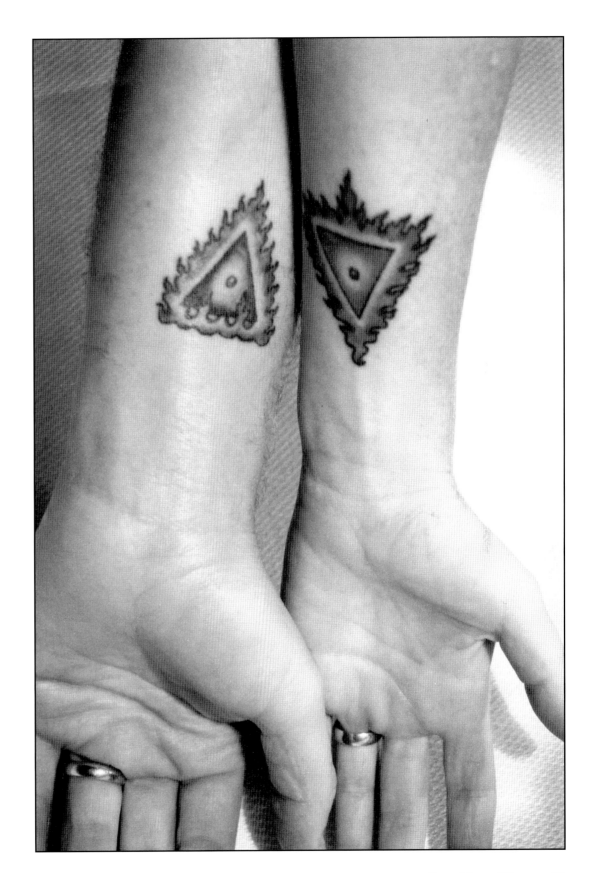

Triangles representing the Hindu deities Shiva (upward pointing) and Shaki (downward pointing). Interlocked, they represent the perfect interplay of masculine and feminine energies.

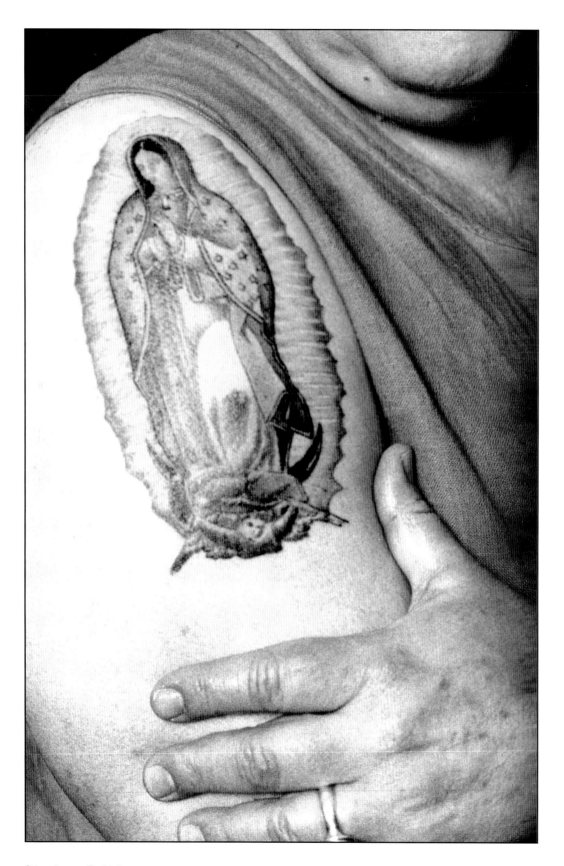

Popular image of the
Virgin of Guadalupe.

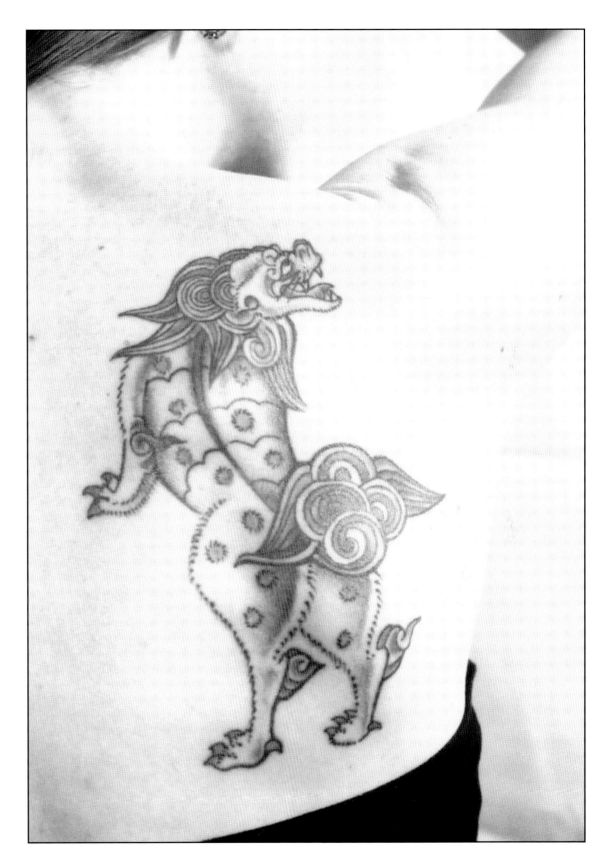

Chinese imperial
lion, popular image.

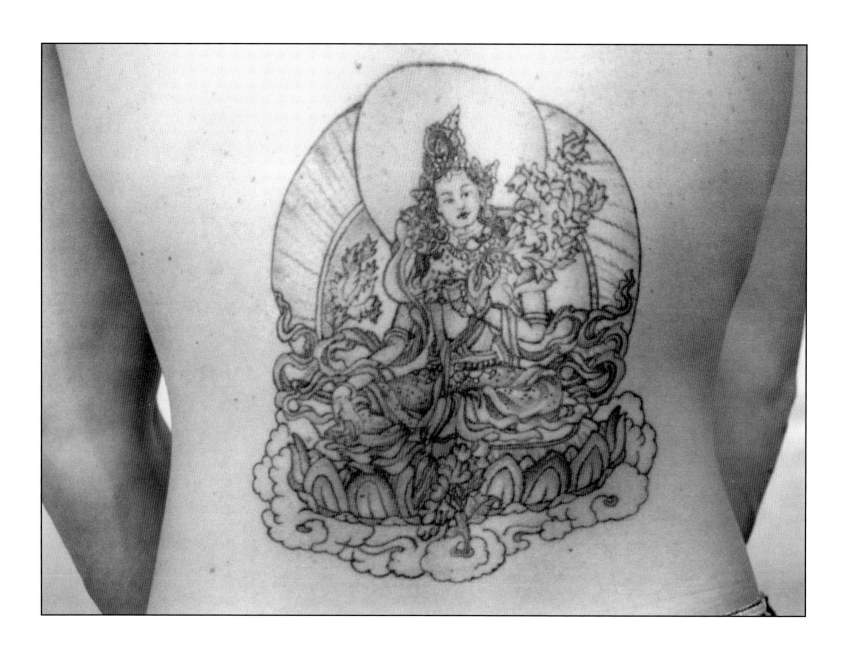

Green Tara, from a traditional line drawing;
color and additional background drawing by Nara.

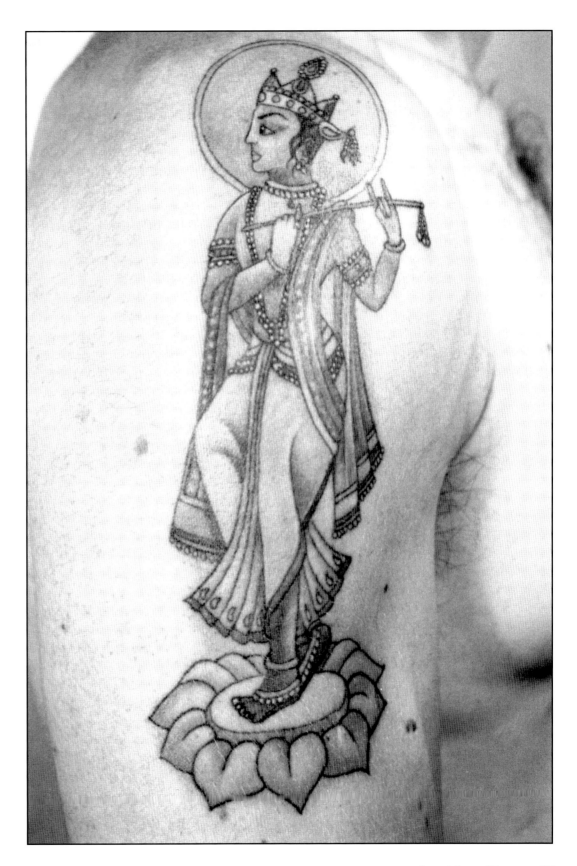

The Hindu god,
Lord Krishna,
incarnation of Vishnu,
with his flute, dancing
on a lotus throne.

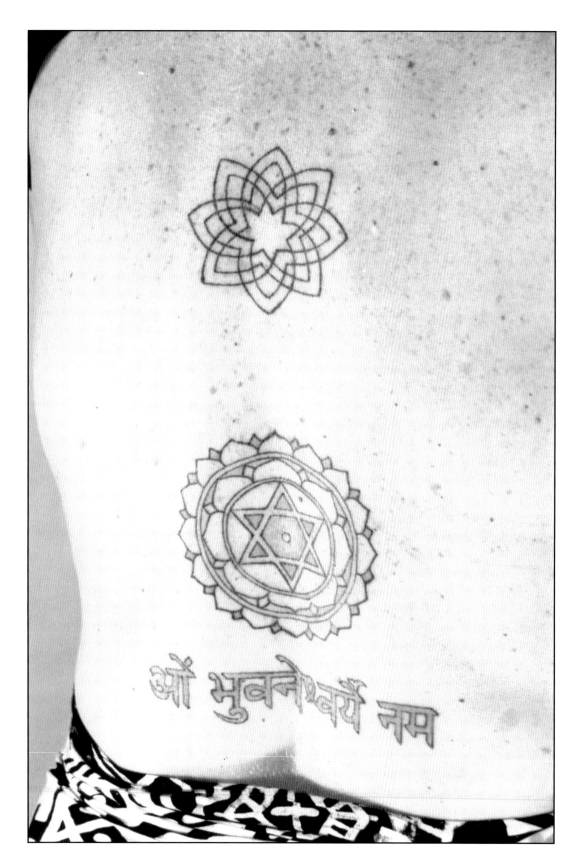

Hindu continuous line drawing above yantric diagram of Bhuvanesvari Chakra and Mantra: Queen of the Realms of Being—the Mother of the Sun; Om Bhuvanesvaryai Nama, "Salutations to She who is Bhuvanesvari, the soverign of the universe."

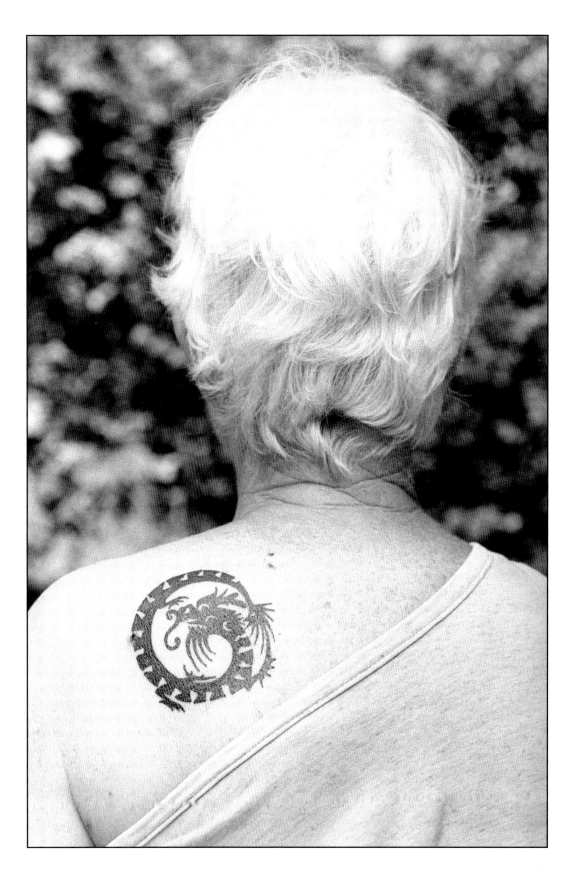

Alchemical dragon
of immortality
eating its own tail.

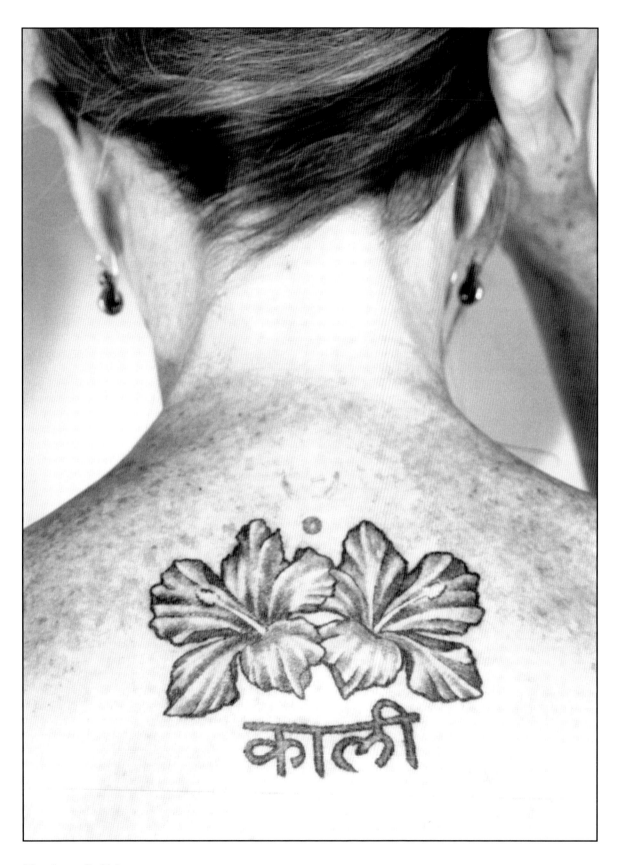

The goddess Kali's
hibiscus flowers
with moon,
bindu and
Sanskrit mantra.

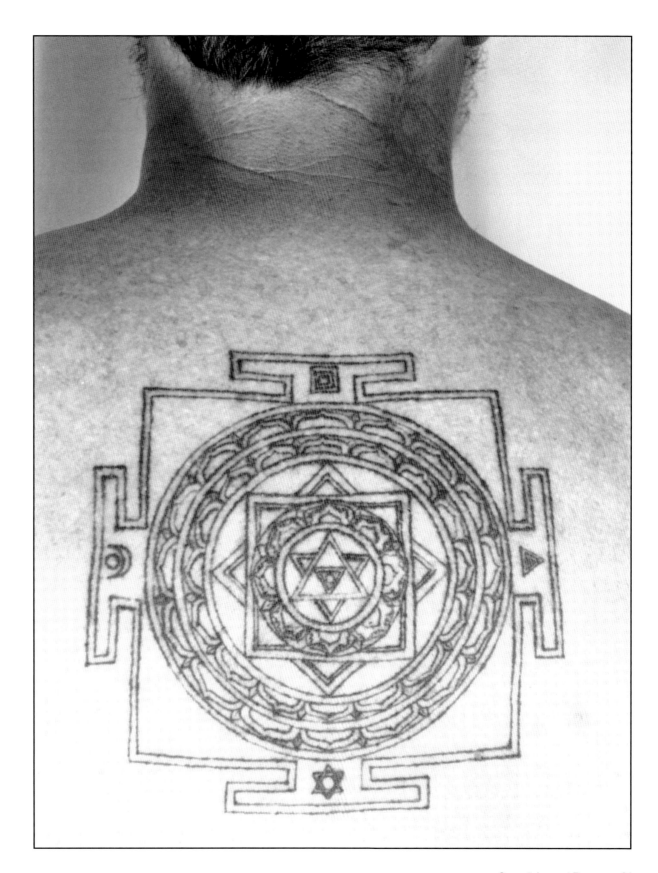

Hindu line drawing of yantric Shiva-Shakti diagram.

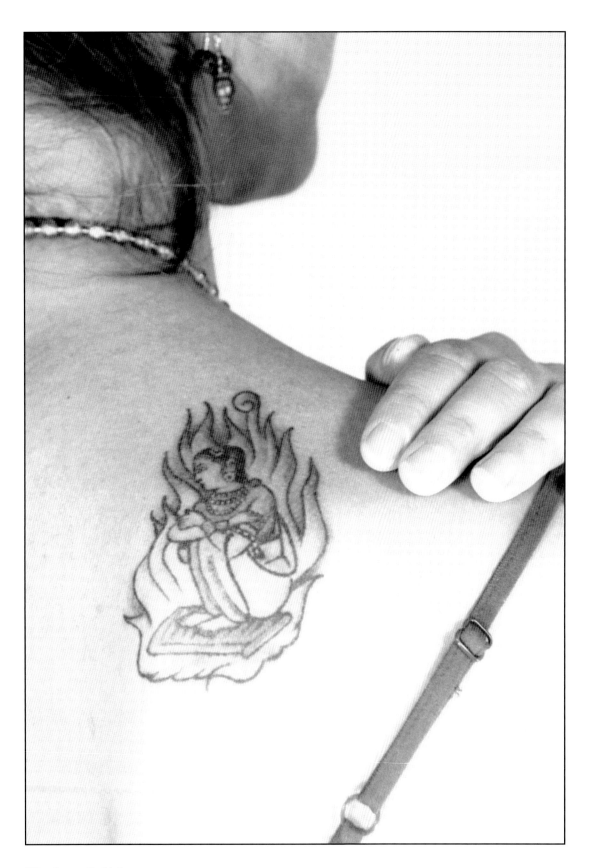

The goddess Sita, wife of the Hindu god Rama, burning in a sacrificial fire. From a popular Indian image.

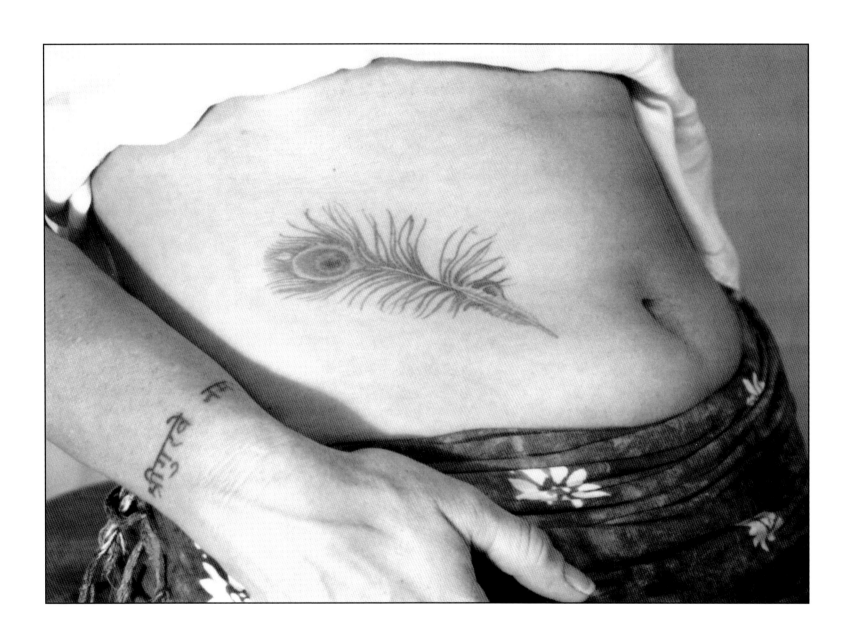

Peacock feather from Lord Krishna's crown and Sanskrit mantra.

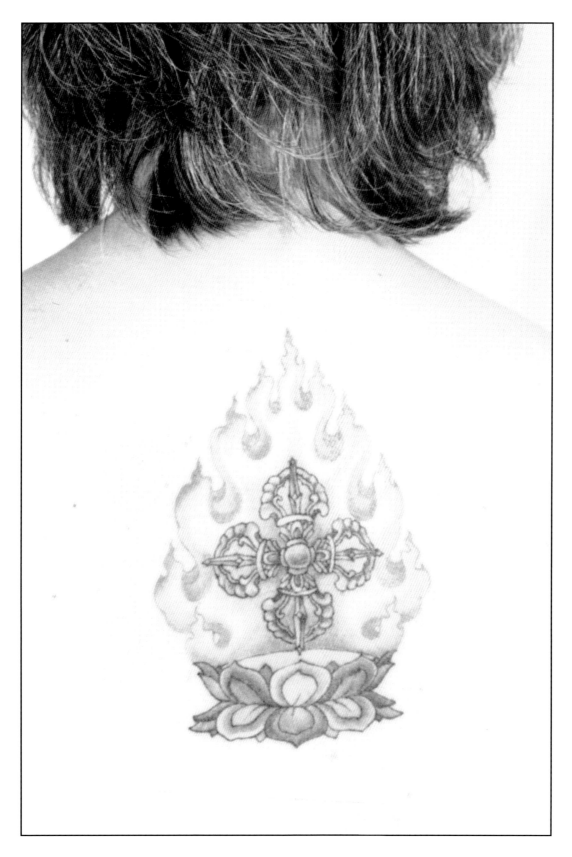

Double dorje on
lotus throne in
flaming aureole.
Line drawing
by Robert Beer.
Color interpreted
by Aaron Funk.

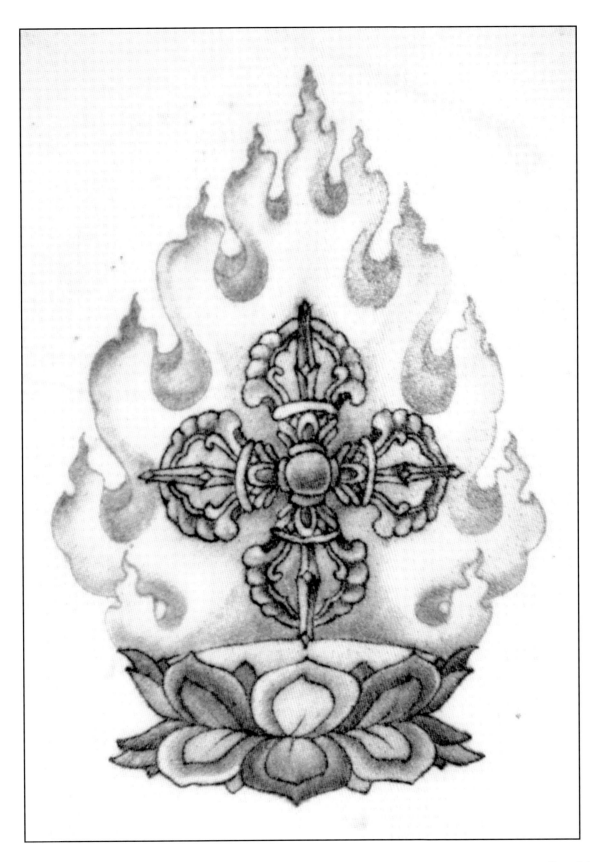

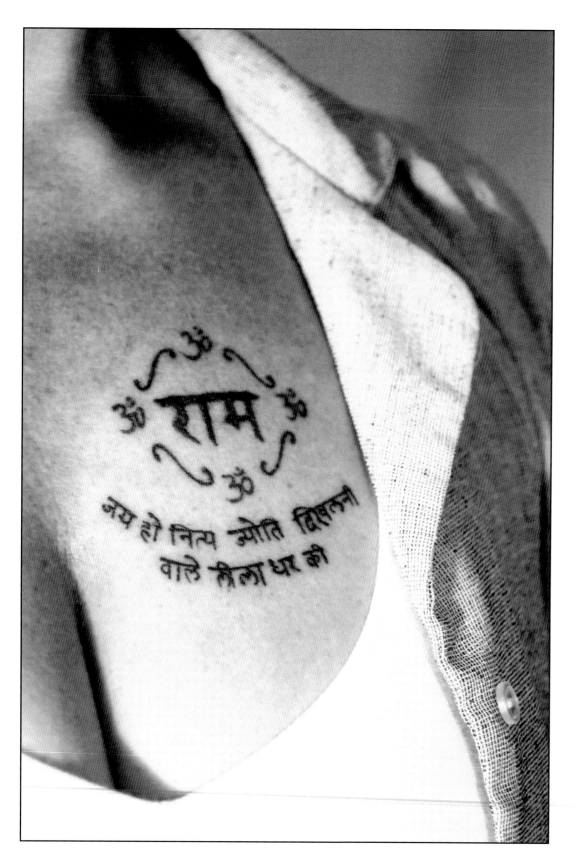

Sanskrit "Ram" framed by the word "Om" with a Sanskrit prayer: "Hail to the One who has revealed the eternal light and whose existence is a divine play."

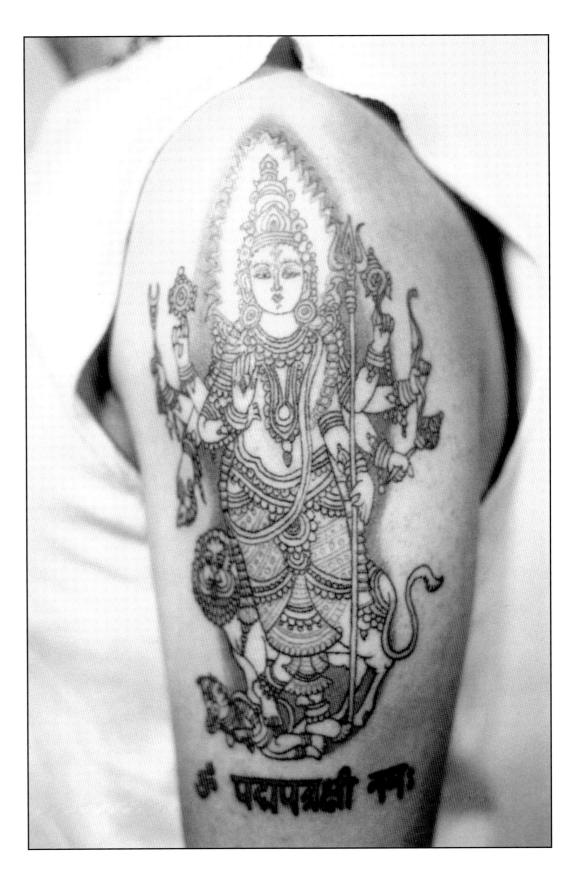

The goddess Durga, image taken from south Indian Kalamkari fabric art, with mantra.

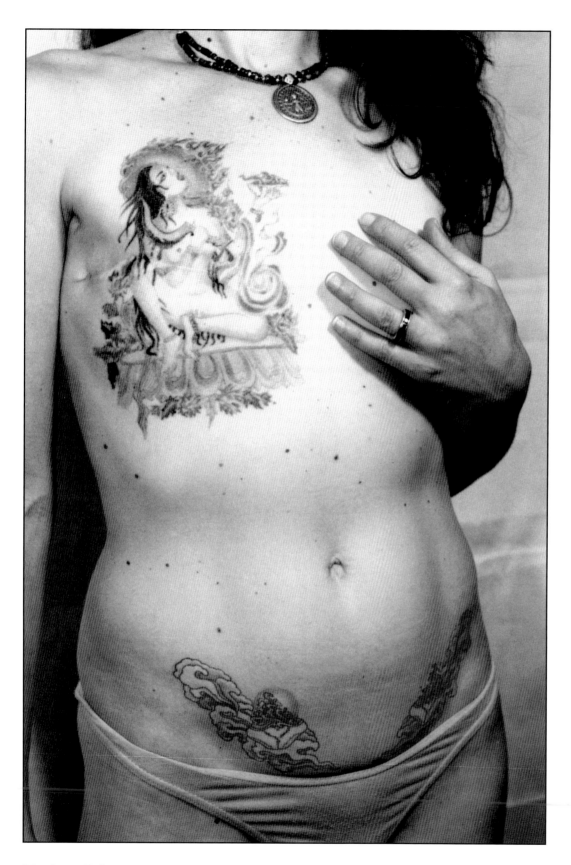

Yogini with skull cup offering of blood, covering mastectomy scar, above "Mother Tantra" skull cups filled with blood and nectar, resting on cloud banks.

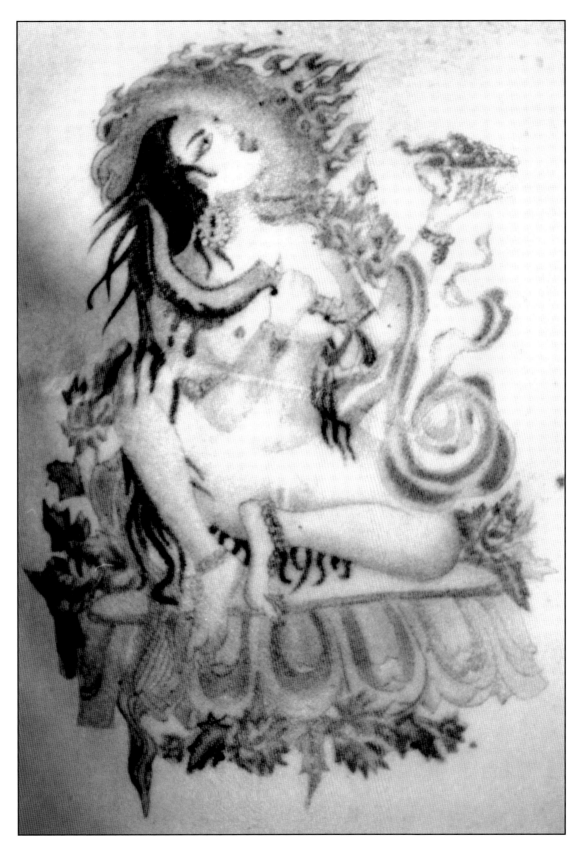

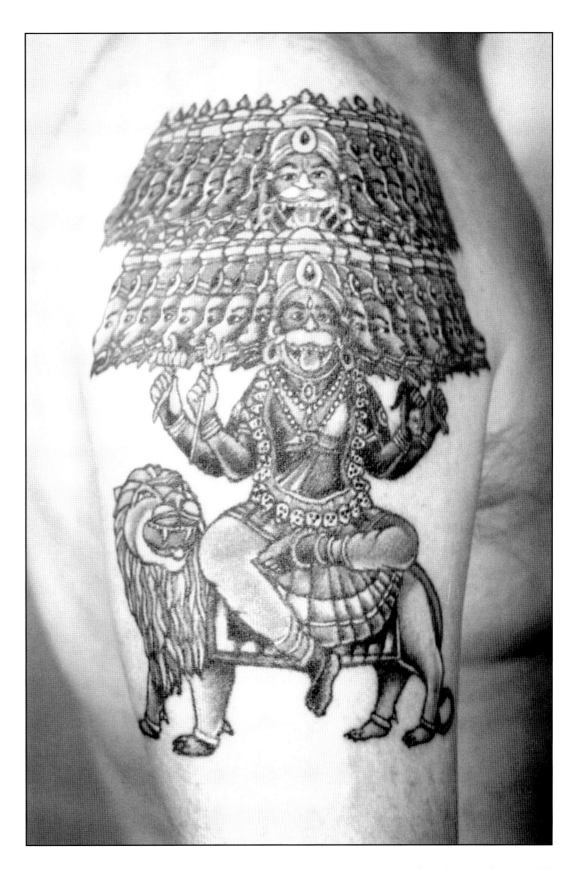

Mahapratyangiri Devi,
the consort of Shiva in
his form of Saraboowara.

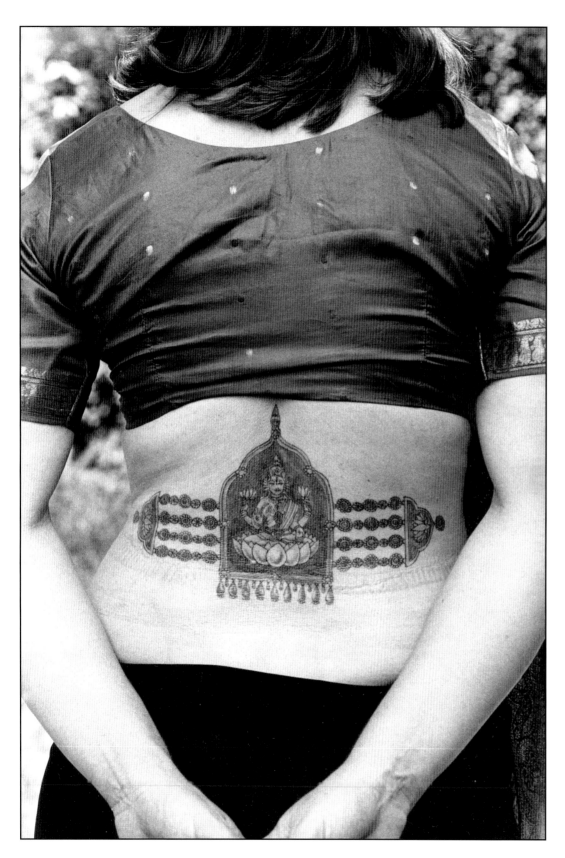

Temple jewelry: Gold, ruby and amethyst bazuband with the goddess Lakshmi seated on a lotus.

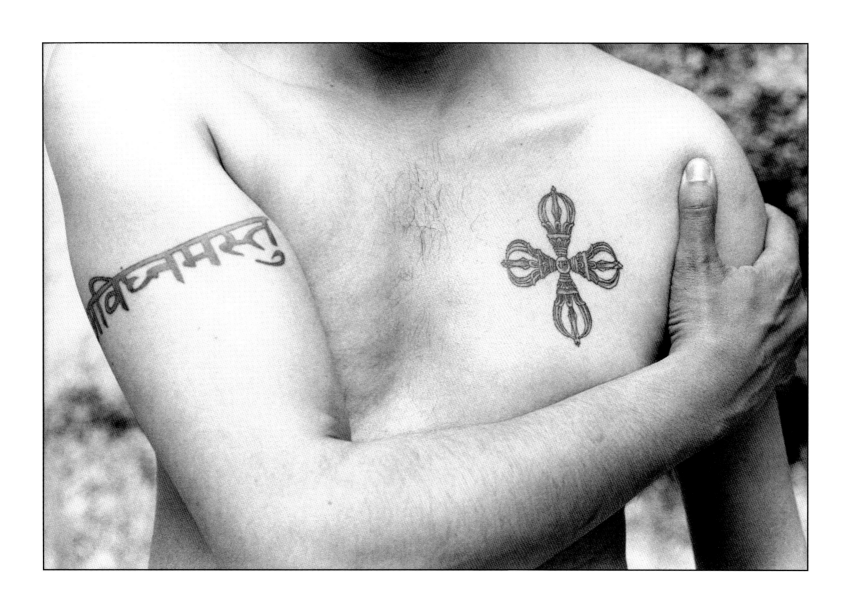

Double dorje line drawing by Robert Beer with Sanskrit mantra armband.

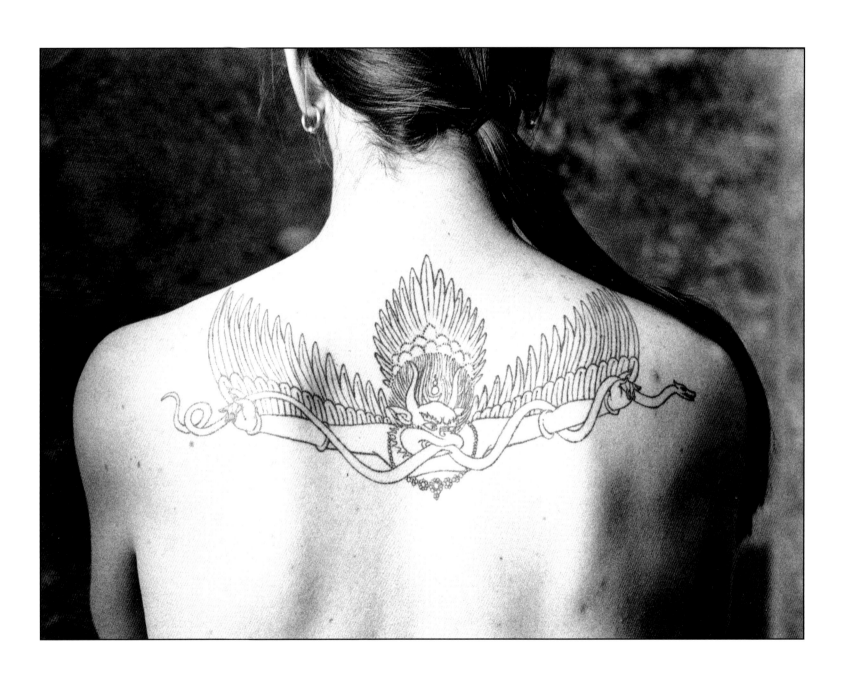

Line work of Tibetan Garuda in flight. Drawing by Robert Beer.

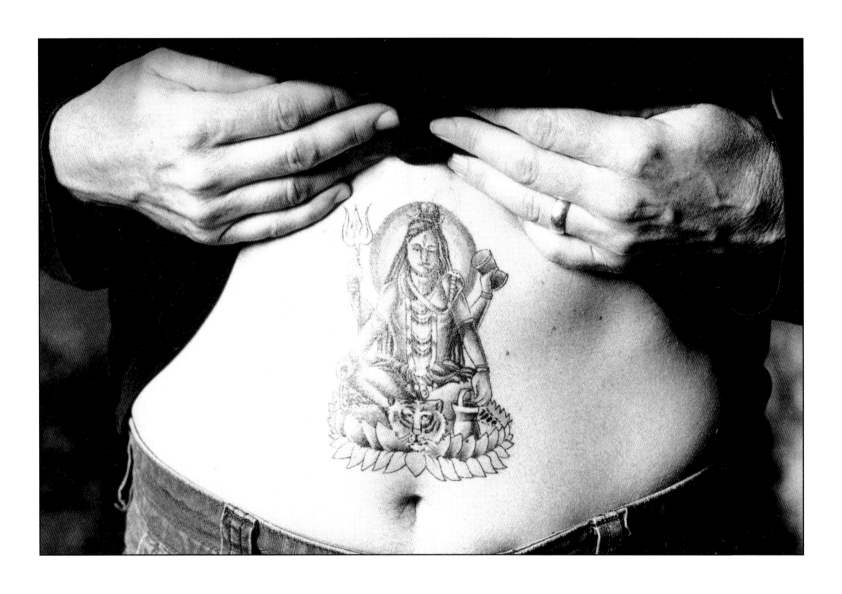

Lord Shiva seated on a tiger skin and lotus throne,
from a popular Hindu image.

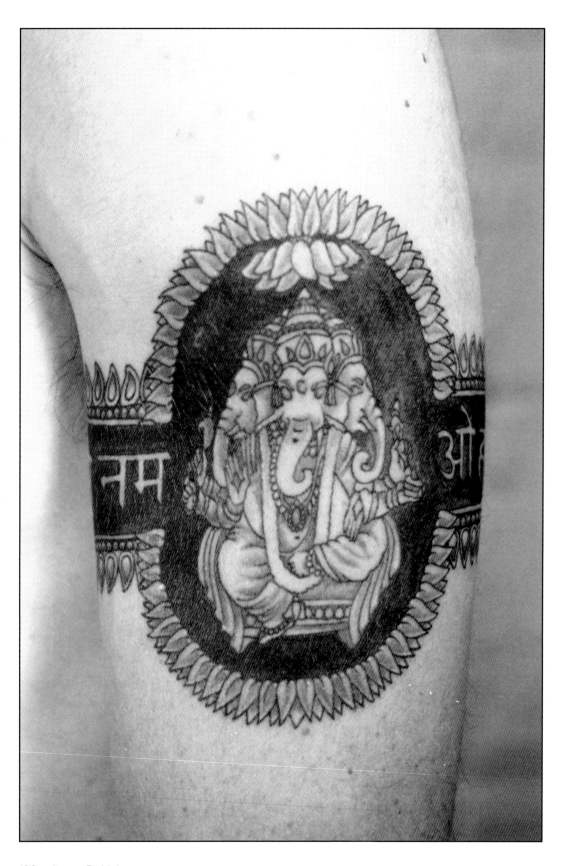

Three-headed Ganesh armband in black, golden yellow and orange with auspicious mango-shaped jewels. Sanskrit mantra: "Adoration to the rapturously joyful One."

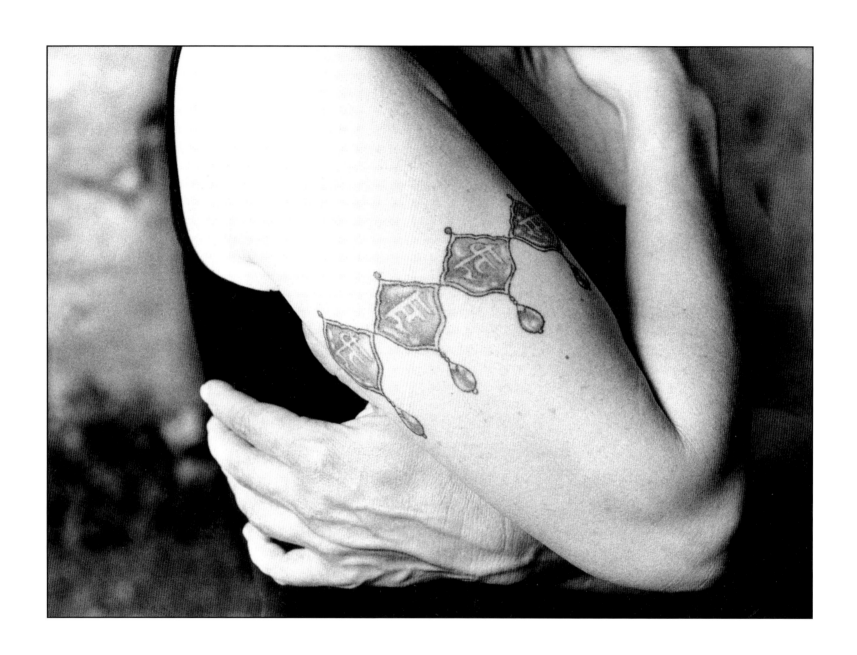

Temple bazuband imagined as engraved sapphire and emeralds with
Sanskrit mantra to the goddess: "To She who is extremely beautiful."

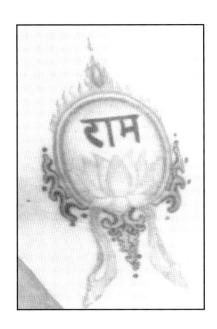

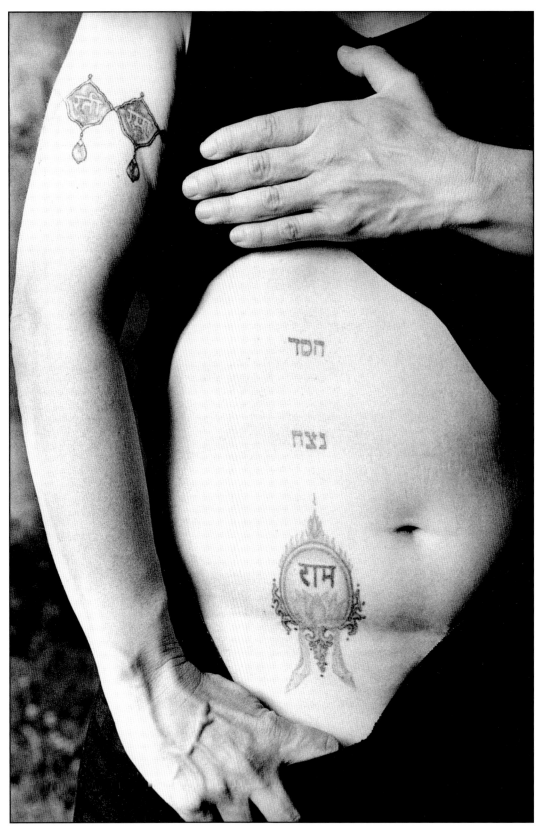

Sanskrit "Ram" on lotus throne below Hebrew words, "Chesed," mercy, and "Netzach," splendor.

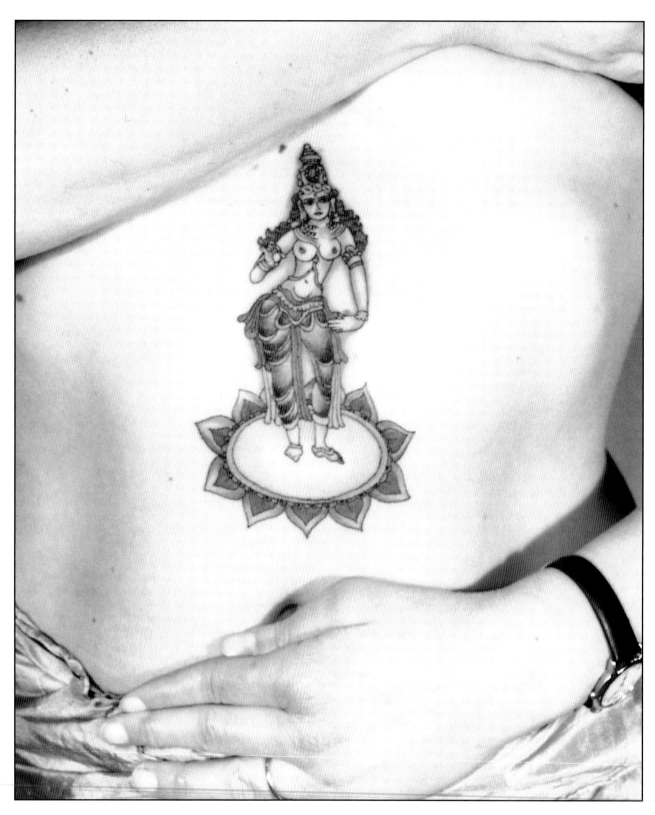

Parvati, from a popular Hindu image.

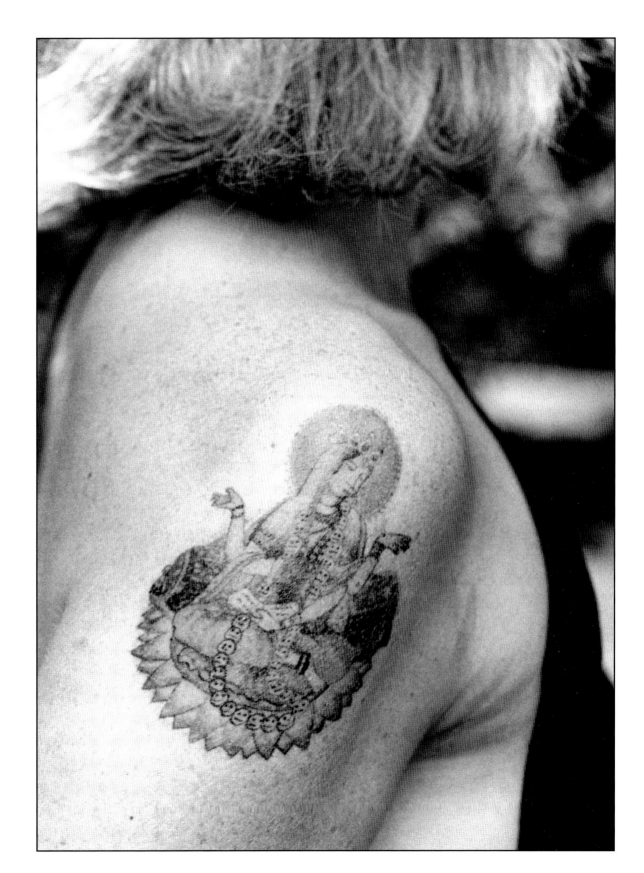

The Hindu
goddess
Jagatambe, a
peaceful form of
Durga, seated on
a lotus with skull
necklace. From a
popular Indian
image.

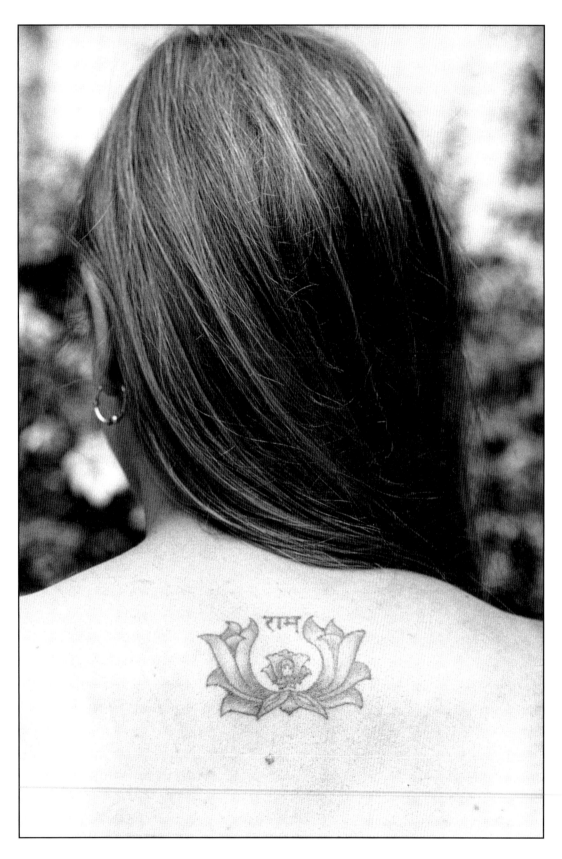

Sanskrit "Ram" with
stylized lotus motif.

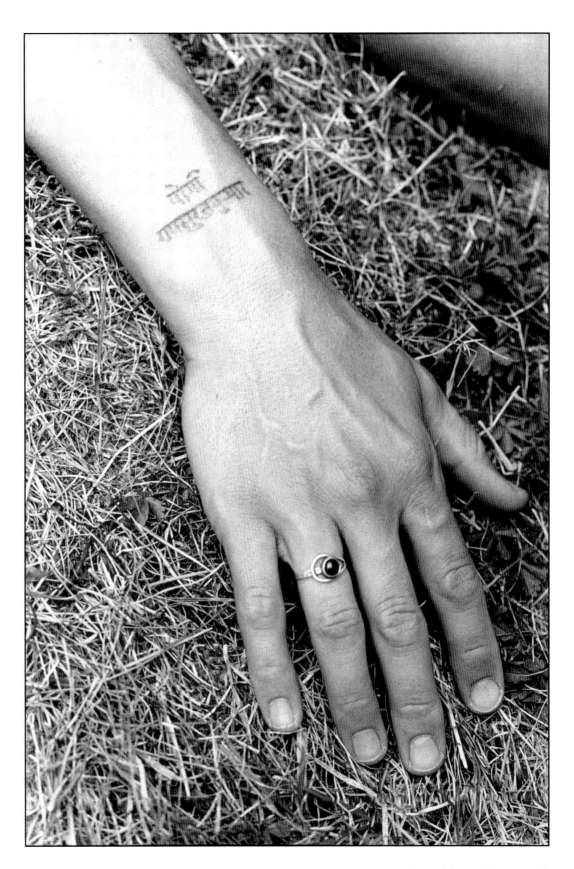

Invocational prayer in
Sanskrit.

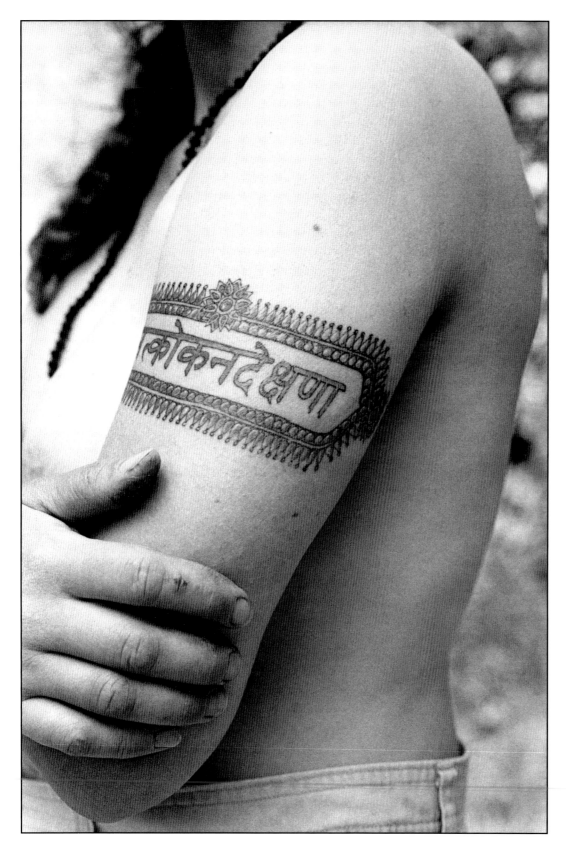

*Her youthful beauty was like a painting that unfolds under a painter's brush or the lotuses that bloom under the sun.*

*Her feet, because of Her painted toes, gave to the earth the color of red lotuses.*

*Kalidasa*

Temple bazuband in ruby and gold, Lasatkokanadeksana: Sanskrit mantra meaning "She who especially loves the red lotus flower."

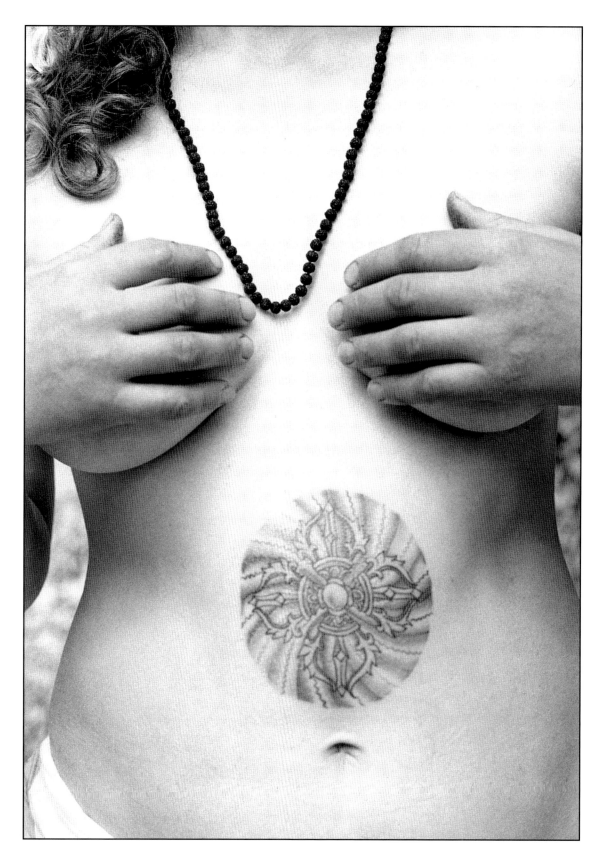

Double vajra
emanating rainbow
rays of light.

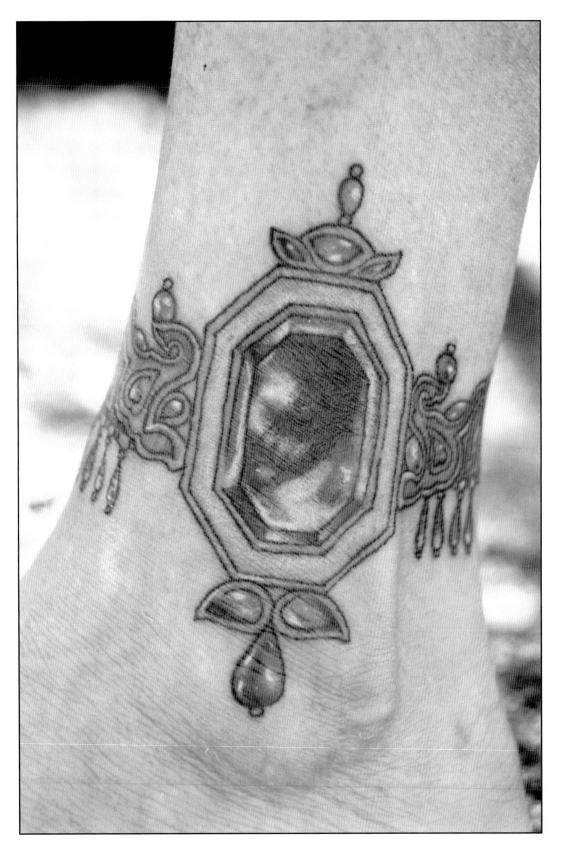

Cover up of old tattoo
with temple bazuband
as ankle bracelet
imagined in sapphire
and Jaipur pink
enamel.

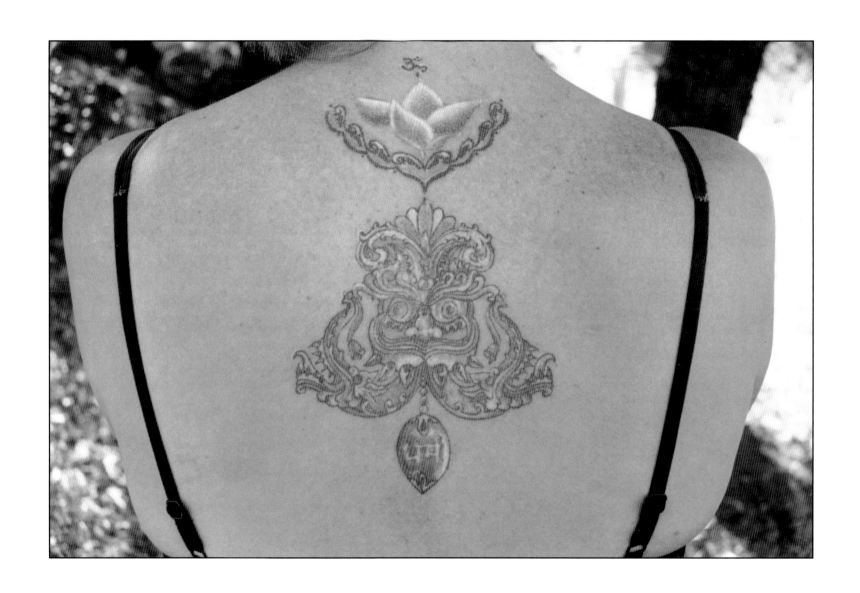

Top: "Om" and popular image of a stylized lotus.
Below: "Kiriti Mukha" or Face of Glory, with makaras
and jewel engraved with Sanskrit: "Dharma."

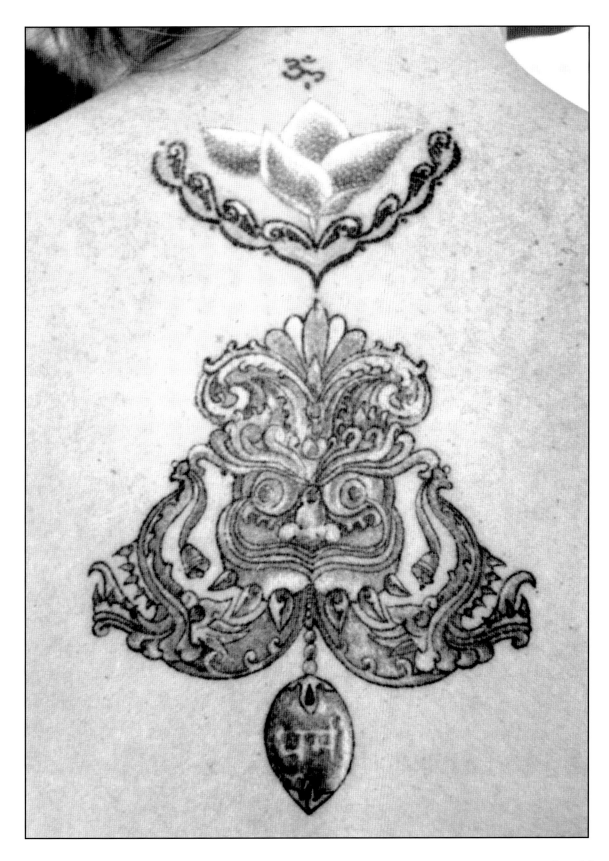

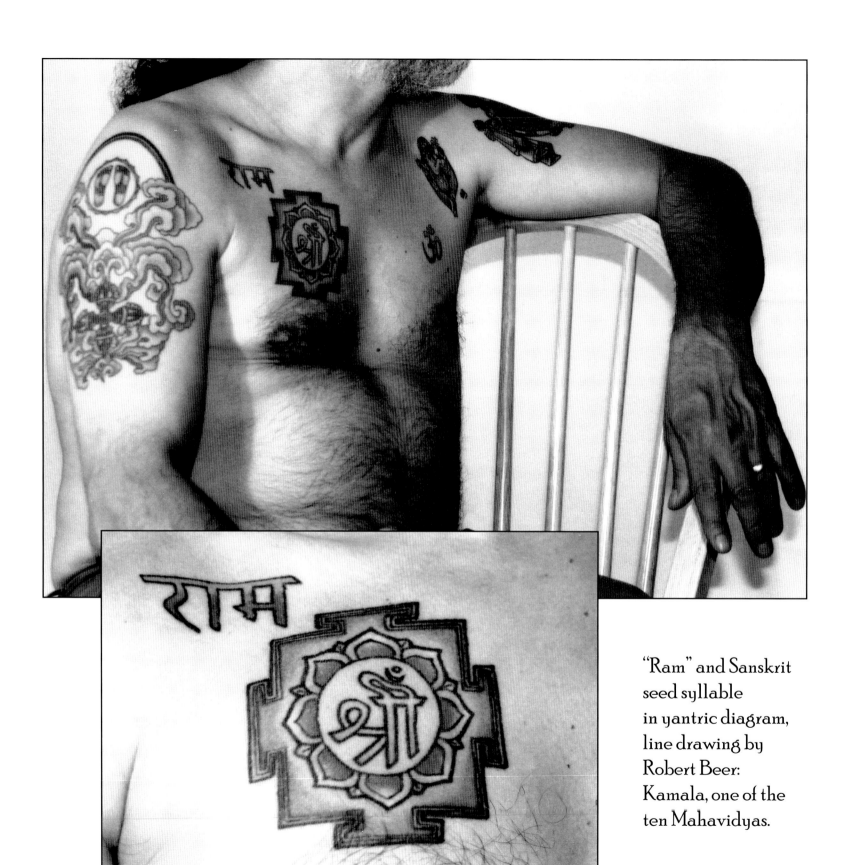

"Ram" and Sanskrit
seed syllable
in yantric diagram,
line drawing by
Robert Beer:
Kamala, one of the
ten Mahavidyas.

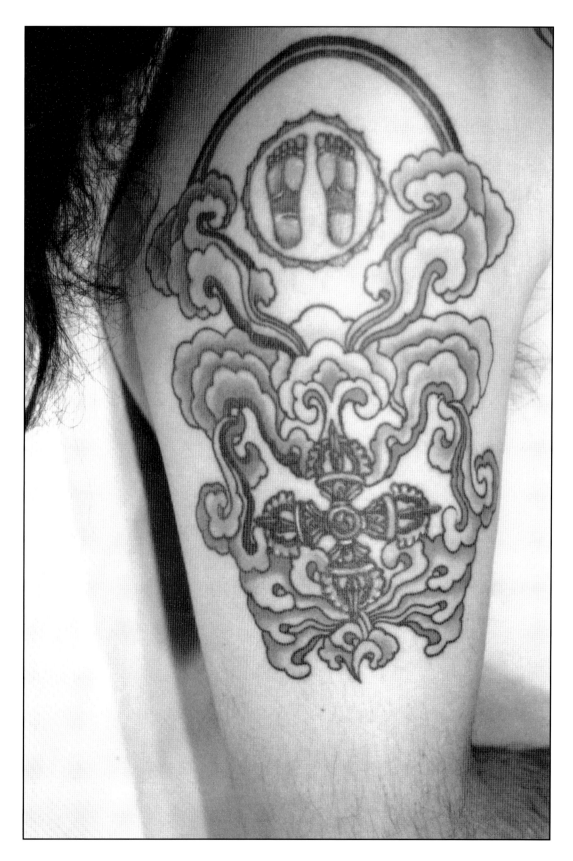

Vishnupada, or the feet of the god Vishnu, with a double vajra resting in cloud banks.

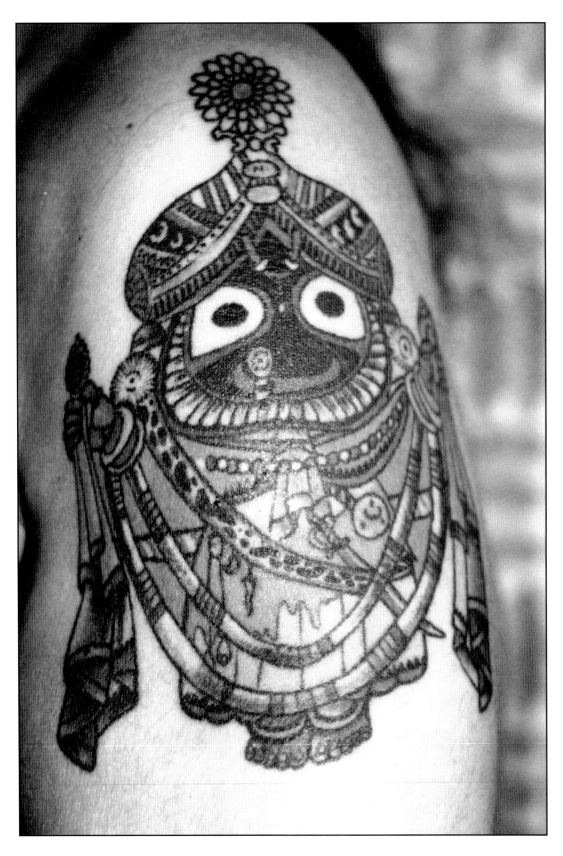

The Hindu god
Jagannatha, a
form of Krishna.

Tamil mantra with
Vishnu's Sudarshan
Chakra.

Sanskrit mantra with stylized conch design.

Sanskrit as
invocational prayer.

Sacred red hibiscus flowers with Vishnupada
and an invocational prayer in Tamil.

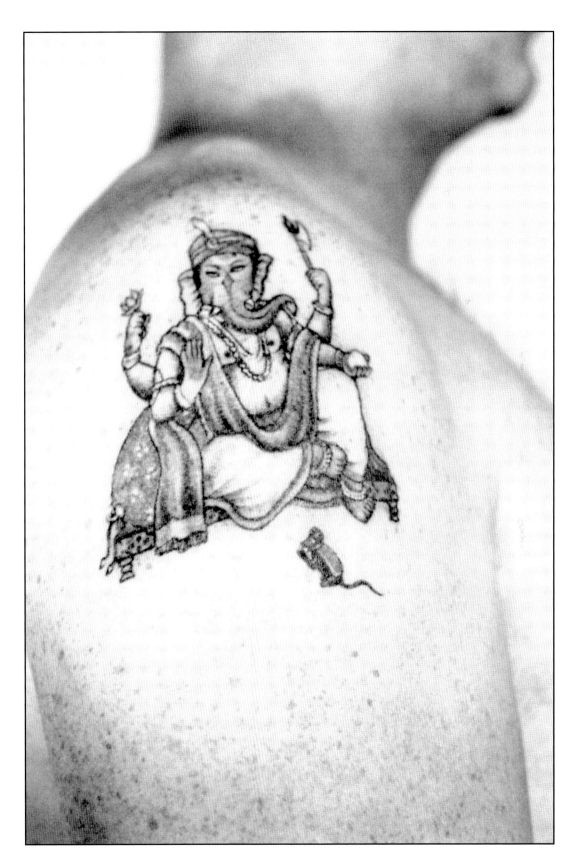

The Hindu god Ganesh
in blessing posture,
holding sacred
implements: axe, lotus
and sweet ball.

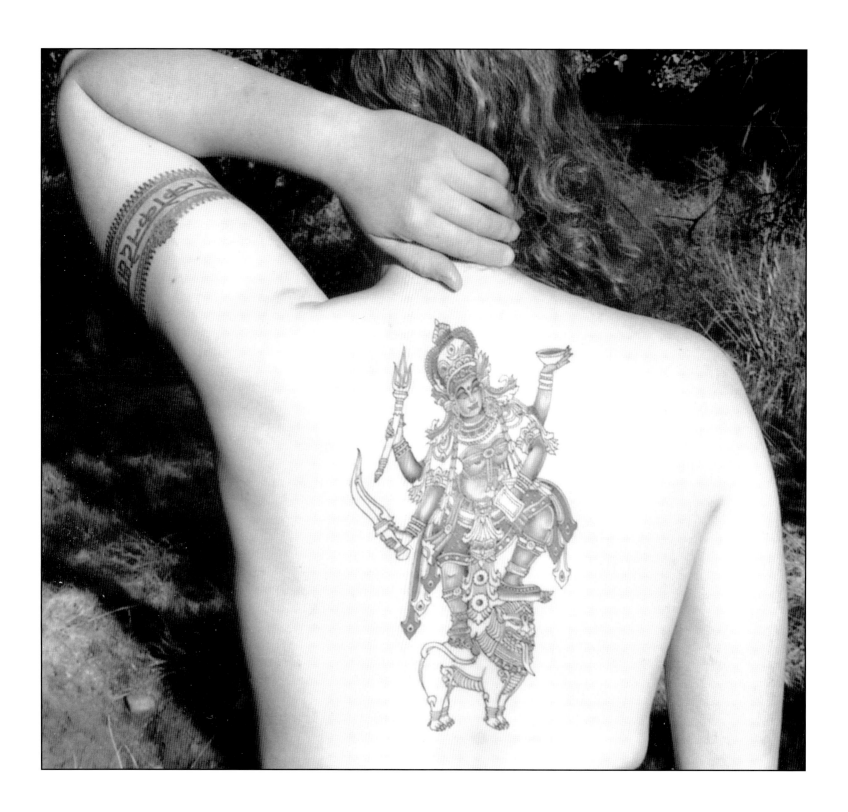

Keralan Durga in warrior pose.

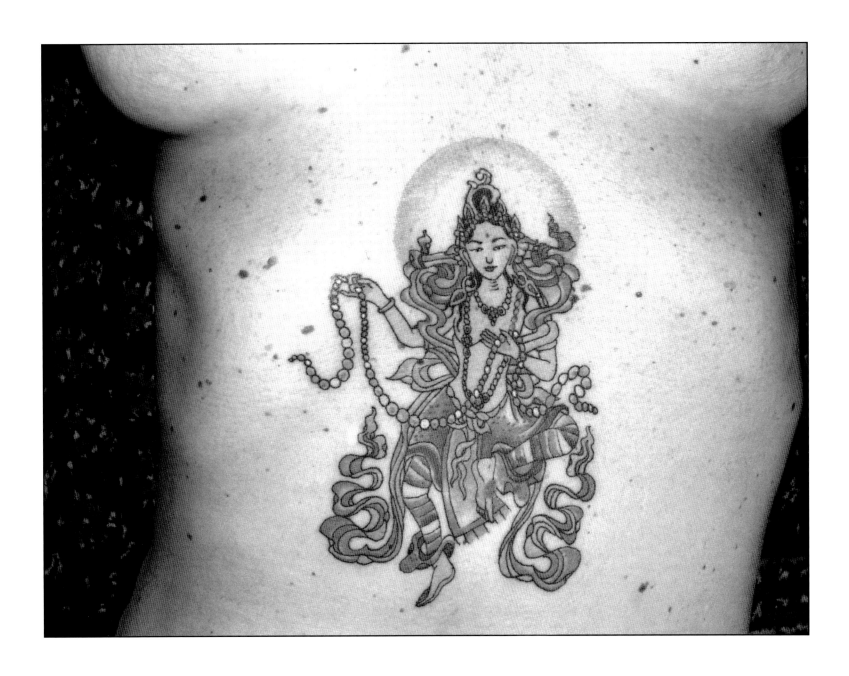

Yellow Hase, the Tibetan goddess of laughter.

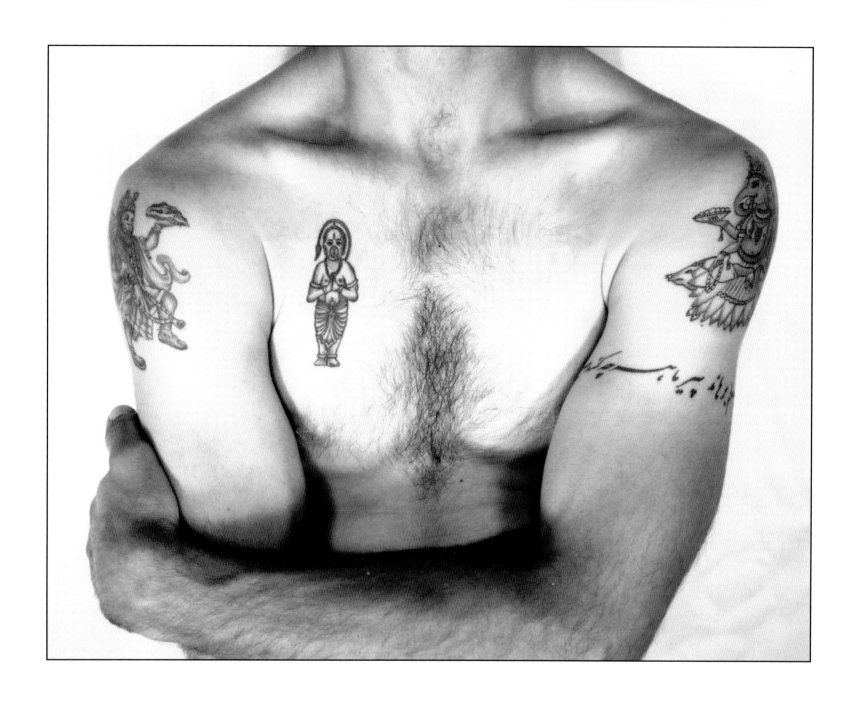

Hanuman (left shoulder) in warrior mode, from a popular Hindu image.
Standing Hanuman (chest) in Anjali-mudra; Lord Ganesh on right arm.
(Close ups opposite and next page.)

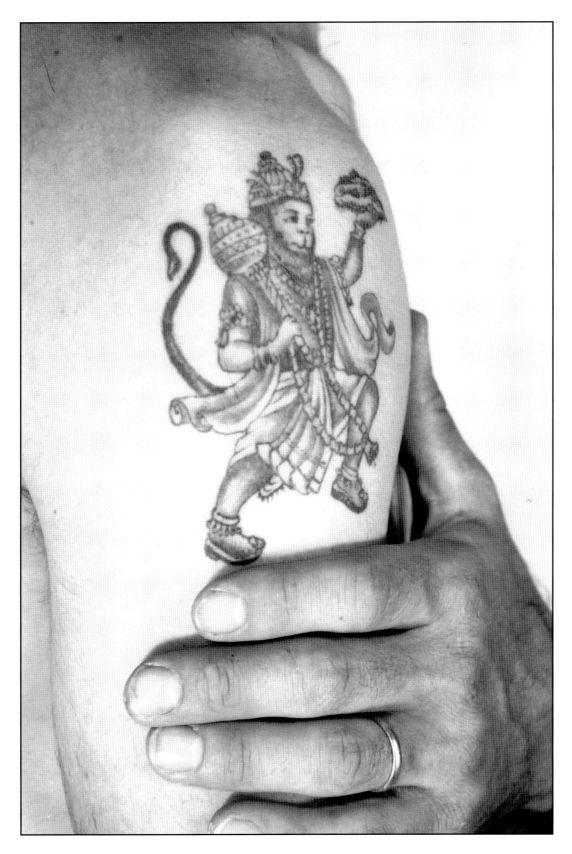

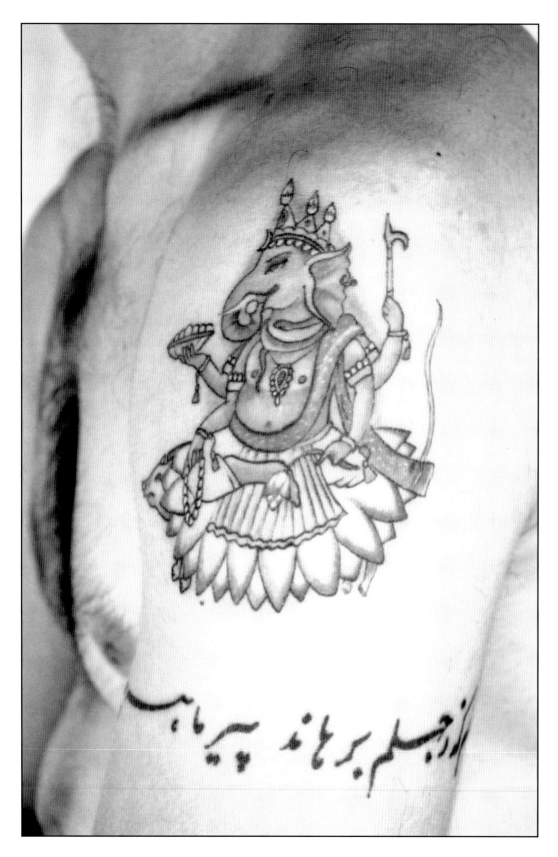

Ganesh seated on
lotus throne with
implements above
an Arabic prayer
armband

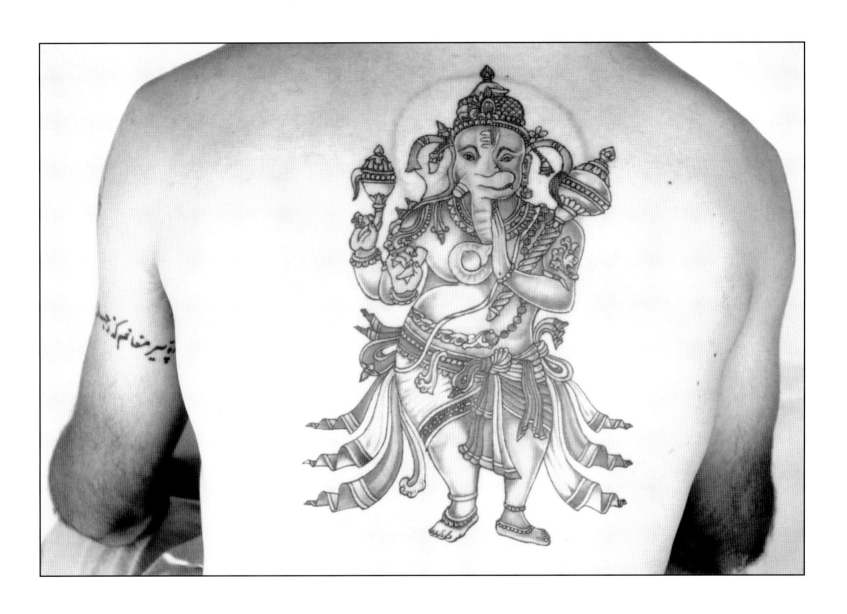

A composite Hindu god, Anjaneya Vinayaka,
half Ganesh and half Hanuman.

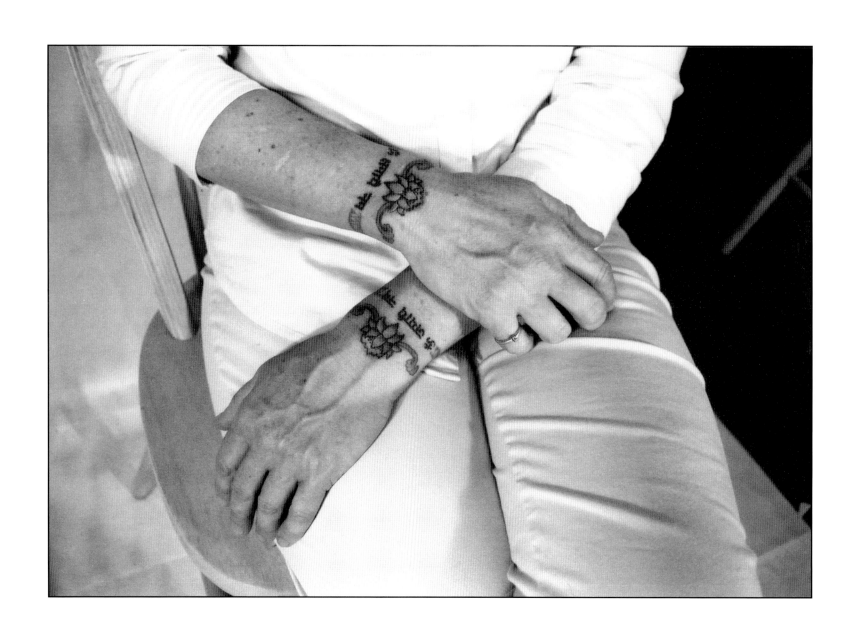

Above and opposite page: Durga mantra bracelets with lotus,
conch and dharmachakra motifs, design by Aaron Funk.

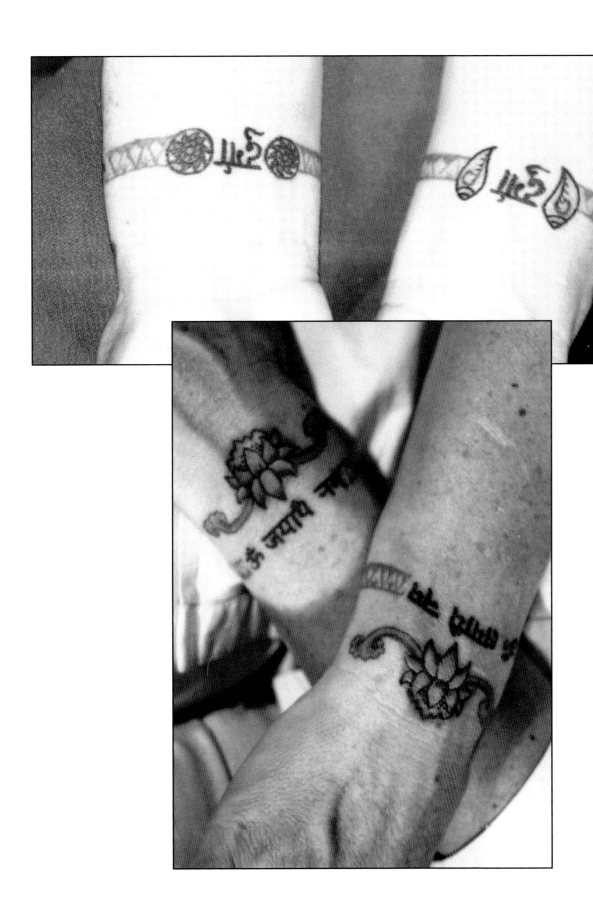

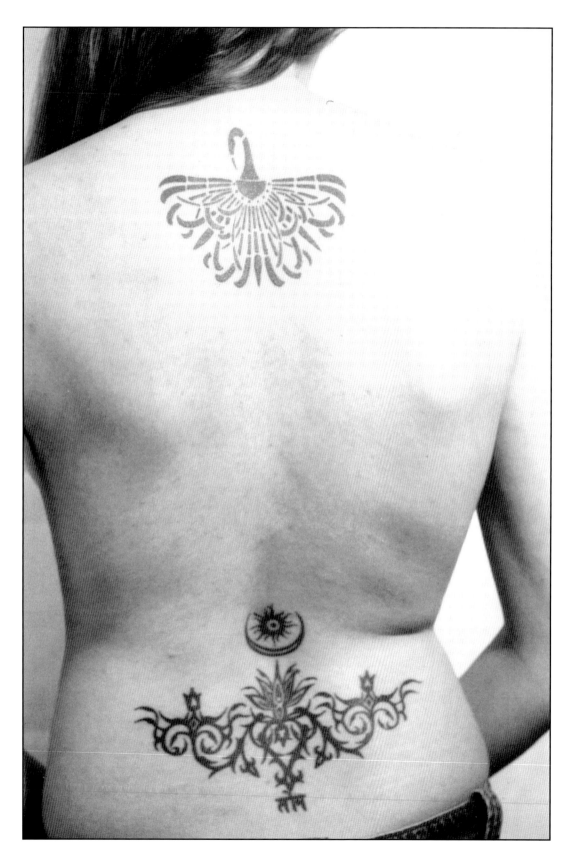

Alchemical symbols: Lower back sun and moon with a stylized lotus motif and Sanskrit "Soma" in black. Upper back, popular design of a phoenix.

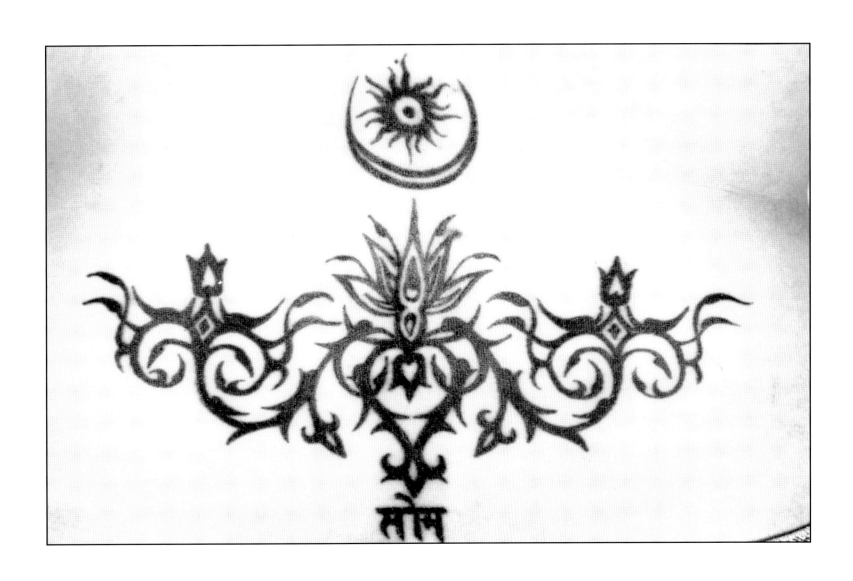

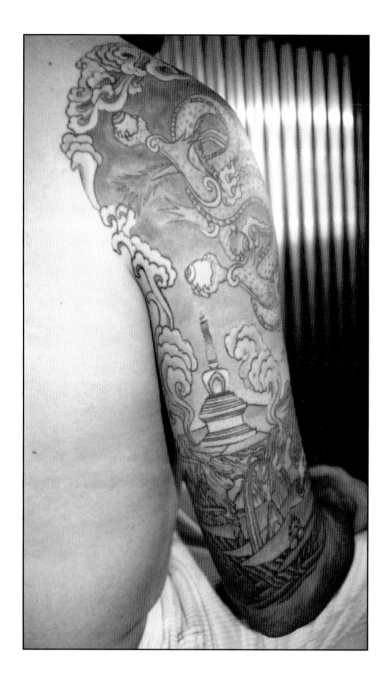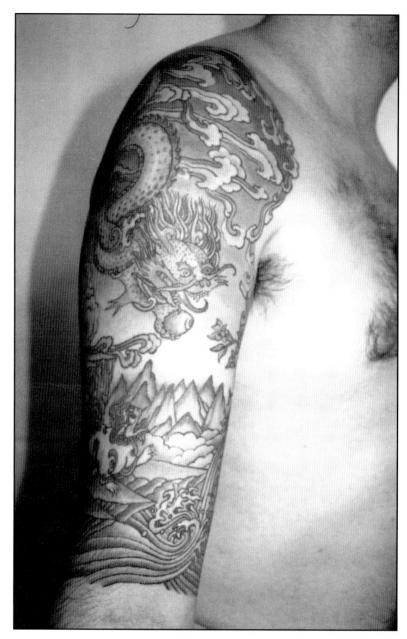

Half sleeve depiction of Sukhavati, the Pure Land of Amitayus Buddha,
seen here with a stupa (shrine), celestial dragon, snow lion and makara
in a background of mountains, trees, clouds, sky and water.

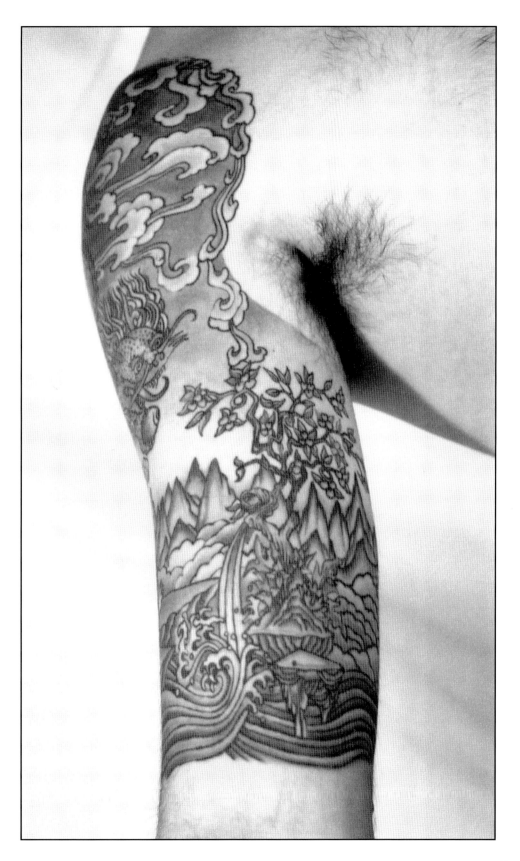

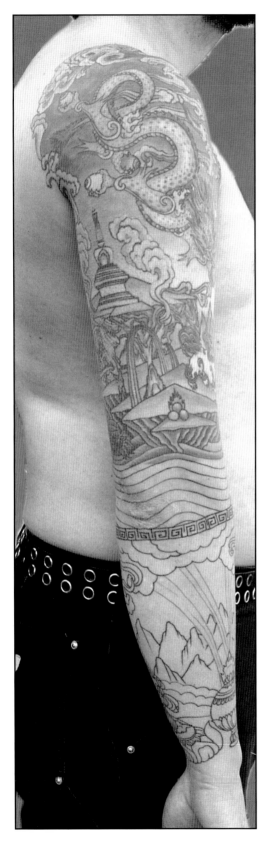
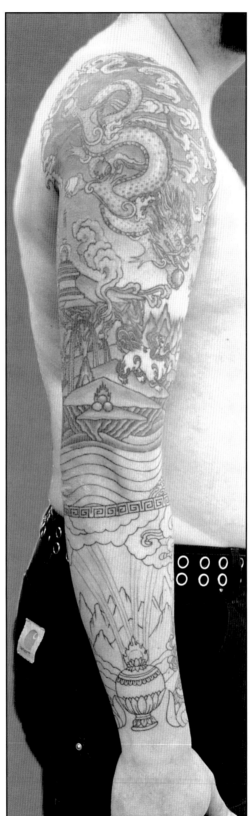
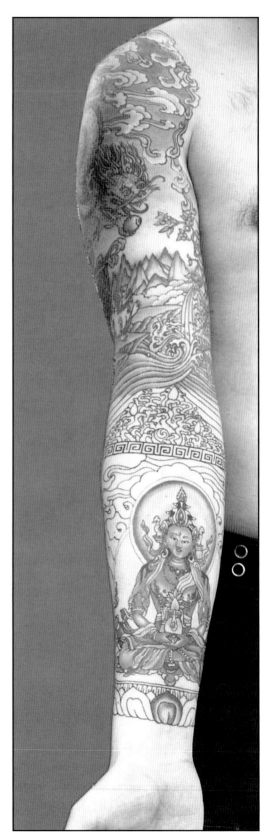

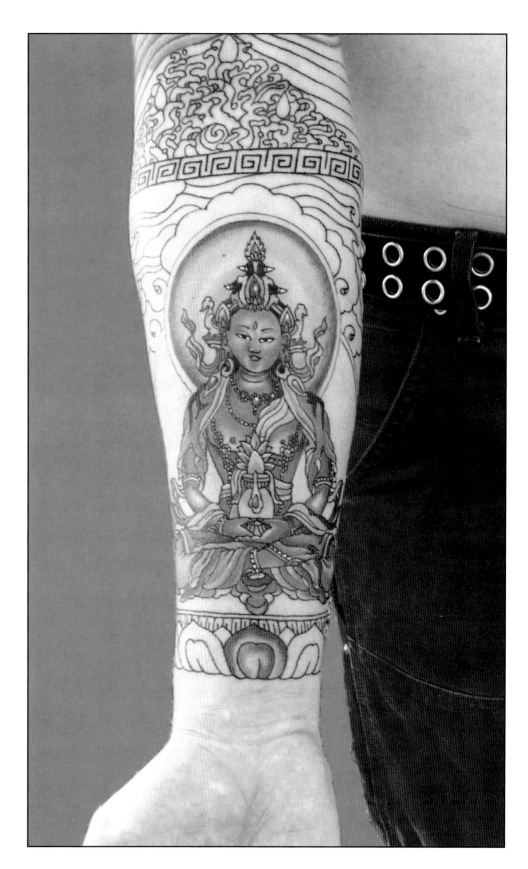

A work in progress:
Amitayus Buddha appearing
in Sukhavarti, the Pure Land,
with precious dharma offerings.

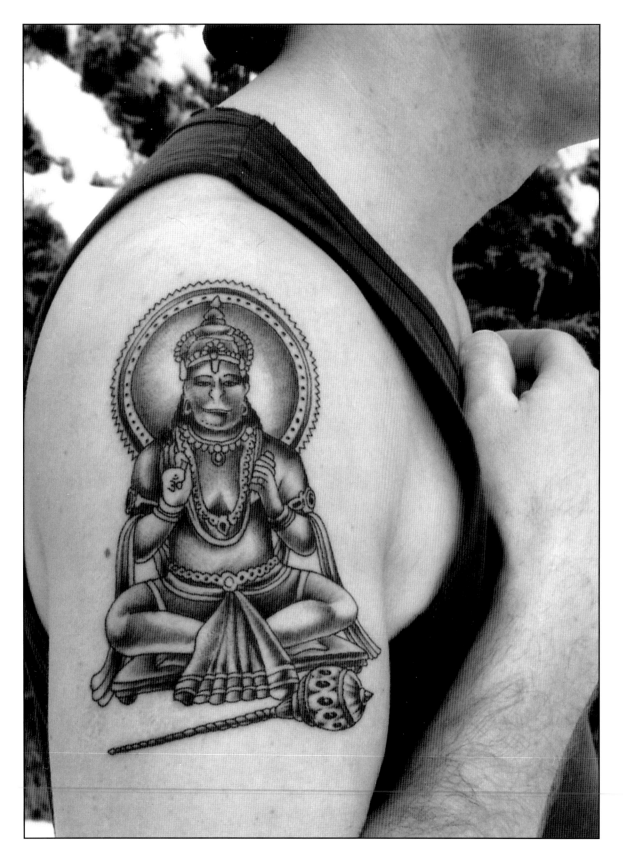

A popular image of Hanuman.

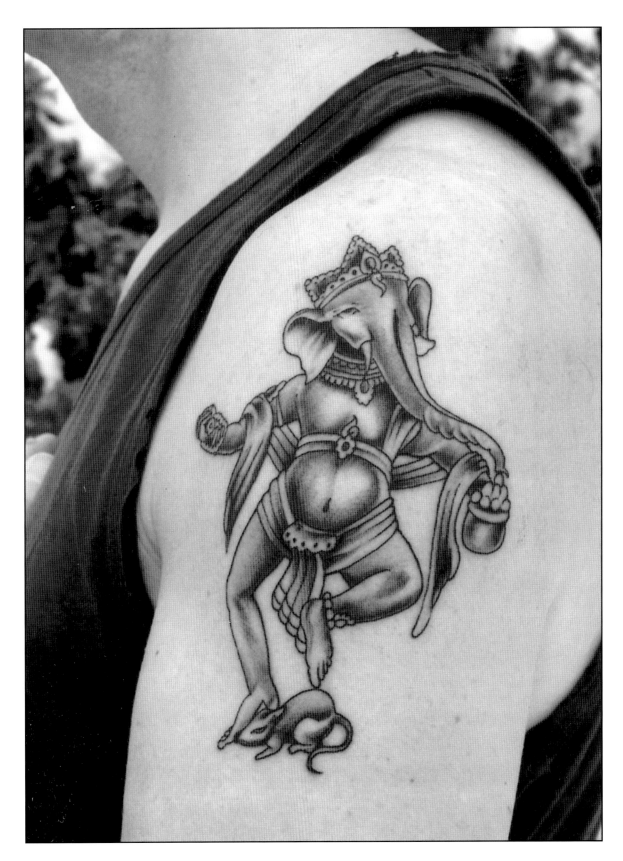

An image of
Ganesh drawn
from bronze
statuary.

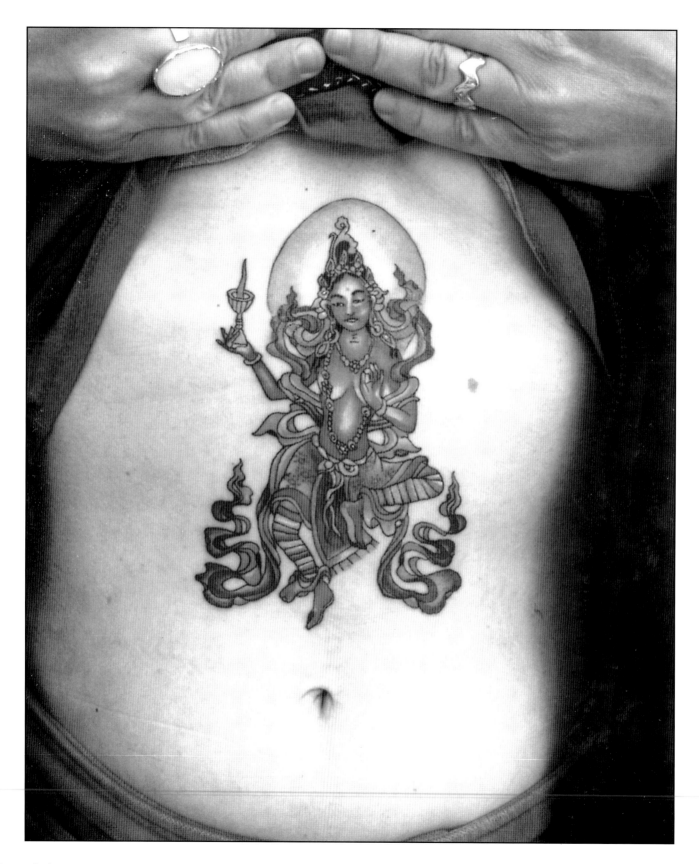

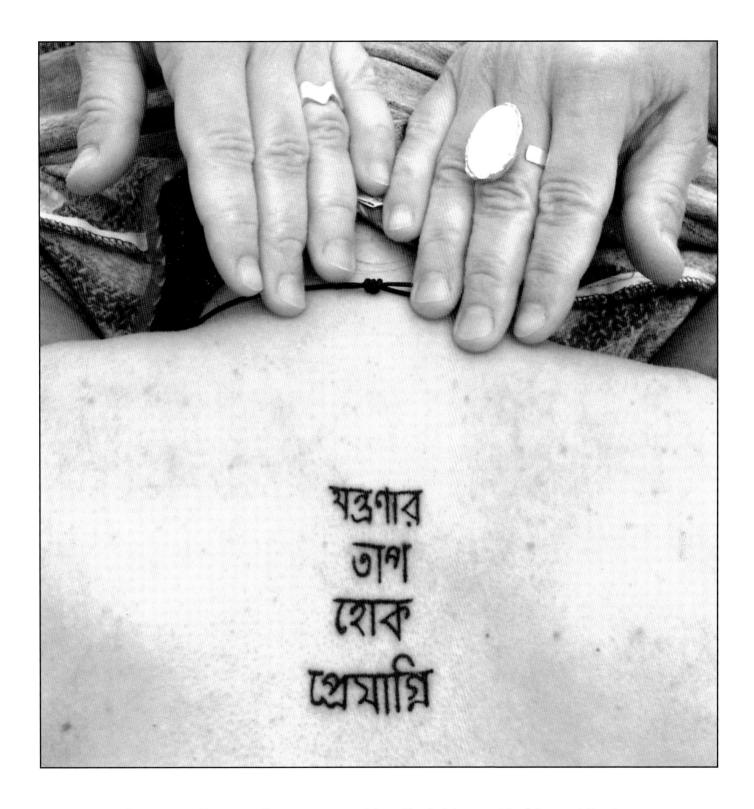

Opposite: Tibetan Buddhist goddess Red Alokes, Goddess of Lights.
Above: A prayer written in Bengali.

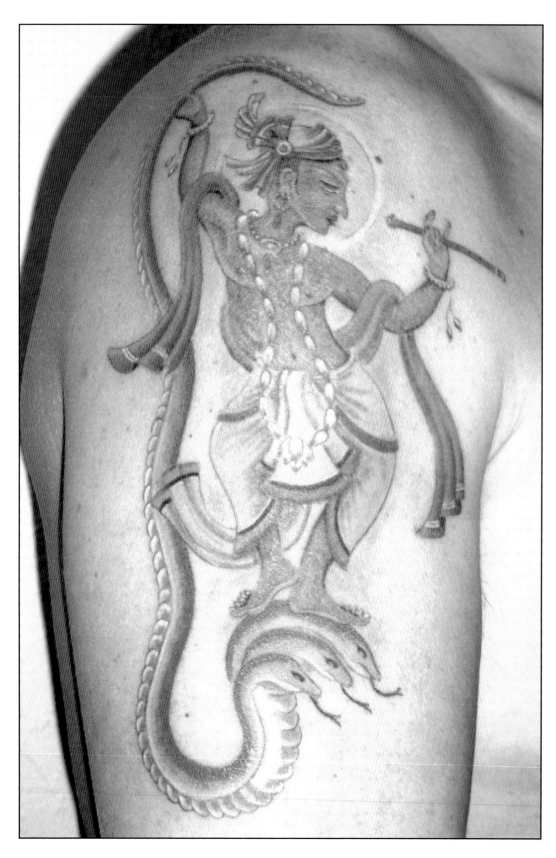

Krishna dancing on the serpent Kaliya; tattoo by Pele in St. Galen, Switzerland.

ॐ

पूर्णमदः पूर्णमिदं पूर्णात् पूर्णमुदच्यते ।
पूर्णस्य पूर्णमादाय पूर्णमेवावशिष्यते ॥

O M
*purnam adah*
*purnam idam*
*purnat purnam udacyate*
*purnasya purnam adaya purnam evavashishyate*

O M
That is the Whole.
This is the Whole.
From wholeness emerges wholeness.
Wholeness coming from wholeness,
wholeness still remains.

# The Art

# Om Kali

Ambiguity and paradox are the hallmarks of many deities, and thus each one, such as Kali, can demonstrate a vast range of attributes: destroyers are also creators, while creators are also destroyers. Everything is malleable; all things are possible. As a generalization, for example, there are forms of Kali that depict beauty beyond comprehension, while the same deity may at times appear horrific, in the sense of the inability to perceive what is truly at the heart of things. Om Kali is a particular representation of this famously fierce deity in her wisdom manifestation. This is the cosmic Kali of tantric tradition—a creatrix and absolute divine being who stands on her own, rather than an aspect of the mother goddess Durga and a consort to Lord Shiva.

Om Kali has a profound relationship with Om, the primordial sound of the universe—that from which everything emanates. Her weaponry symbolizes her willingness to enter into every element of creation. She is the totality of everything; she represents the cosmic night and absolute open space; as destructress she is the fire at the end of time. She is also absolute liberation, the pure feminine sex force, wild and untamed. She tramples on the sensibilities of normal, respectable society.

In this version Kali is painted wearing the colors in which she is traditionally depicted, with the exception that her skin is red rather than the usual black or dark blue. She has eight arms holding implements, each one representing a particular cosmic function. Described in descending order from her upper right they are: a noose, with which Kali binds the devotee to her; a sword representing penetrating wisdom; a trident, which depicts her mastery of all time, past, present and future; a discus, which serves to sever ignorance. In descending order from the top left hand Om Kali carries a *damaru* drum, the action and sound of which represents the play of creation and destruction, or cosmic time, kept in place by a king cobra signifying mastery of the kundalini shakti and divine protection; a shield, or divine armor, which matches the sword in her opposite hand; a bell, which represents a call to clarity or an awakening; and a skull cup filled with blood or wine.

Furthermore, Om Kali wears a single tiger claw necklace, representing fearlessness and strength. Her forehead is marked with purifying ash, symbolizing one who has left the world of normal society and conquered death. She is surrounded by a halo of flames because her hair is enflamed with power. Artwork by Nara. This tattoo appears on page 43.

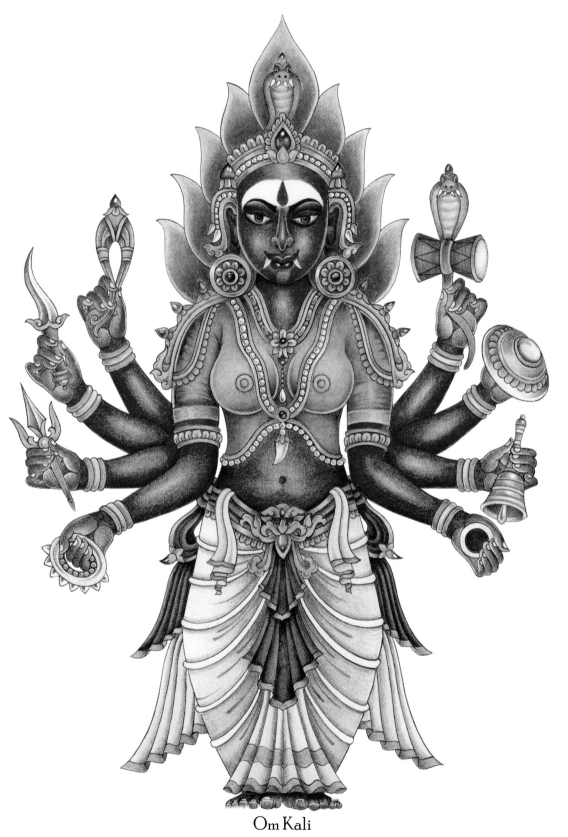

Om Kali

# Green Tara

There is a story that recounts the mythic origins of Tara, the Great Savioress of Buddhism. It begins in an imaginal realm, when a Buddha appeared in a land called "Various Lights." A princess of that realm named Jnanachandra, which means Wisdom Moon, or Yeshe Dawa in the Tibetan language, developed a very great faith in and devotion for the Buddha. By virtue of her good deeds and pure mind, the awareness of supreme enlightenment arose within her. She became "Tara," from the Sanskrit "Tar," meaning to cross over, as in crossing over the ocean of illusion. Although advised by the monks of the realm to take rebirth in a male body, which was considered vastly superior for the expression of enlightened mind, Jnanachandra as Tara has manifested throughout lifetimes in a feminine form, demonstrating to all that enlightenment is for everyone.

Tibetan Buddhism recognizes twenty-one Taras, each one having a particular function such as averting disasters, wish-fulfilling, increasing wisdom, healing and so on. Each Tara is associated with one of the five Buddha families and is depicted with a particular color, mudra and mantra. Some of these twenty-one Taras are peaceful and benign, while others are wrathful. All Taras are said to come from Green Tara.

Green Tara is a bodhisattva of compassion who represents the vast range of virtuous and awakened activity; she is said to be the mother of the Buddhas of the past, present and future—an attribute symbolized by the three blue utpala flowers held in her left hand. The mudra of her left hand symbolizes refuge while her right hand is in the boon-granting mudra. Her left leg is withdrawn to symbolize renunciation of worldly passion, while her right leg is extended, ever-ready to come to the aid of those who need her blessings. Because Green Tara is so quick to come to the aid of those who seek her, she is known as the Swift Liberator. This Green Tara is from a traditional Tibetan *thangka* line drawing, with color work and additional drawing by Nara. This tattoo appears on page 86.

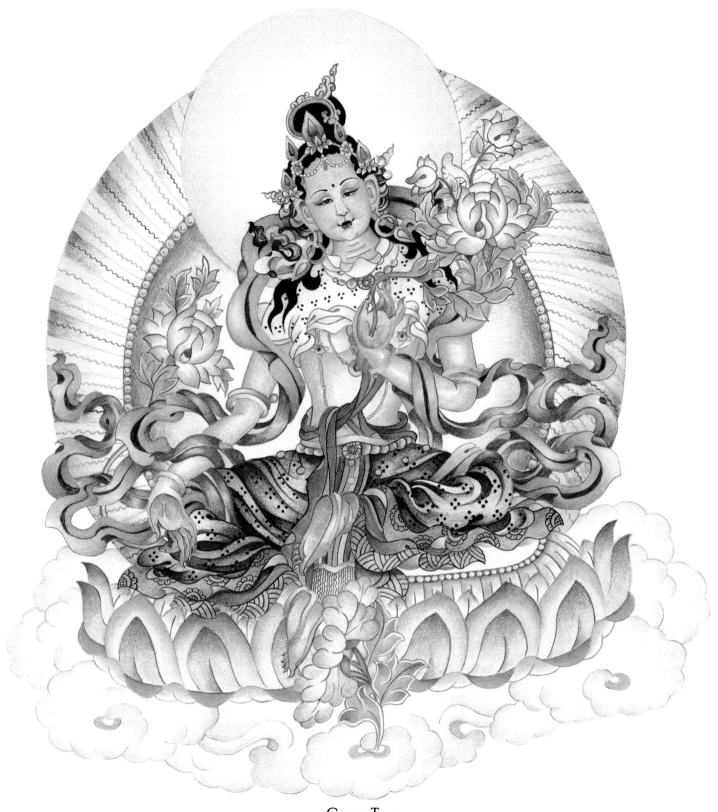

Green Tara

## Ganga

The goddess Ganga represents the celestial waters flowing on earth. The story of how the river Ganges came to earth from its celestial source is a famous mythological tale in the Hindu tradition. Ganga originally flowed through heaven before she agreed to come to earth when a king named Bhagirata prayed to purify the ashes of his ancestors. Gushing forth from Vishnu's toe with cosmic force, the celestial torrent would have destroyed the earth, but Shiva intervened by catching the roaring waters in his *jatta*—the matted locks of his hair—and thus mitigating its power, made it possible for the Ganges to flow peacefully.

Ganga is the embodiment of purity and purification. She rides on the magical water monster, *makara*, which is sometimes depicted as a crocodile. She represents perfect nurturing; she is the most beautiful, supreme mother and giver of eternal life. She washes away sins; her waters are a river of nectar. Because Ganga is a celestial river that has come down to the world, the Ganges River is known to have amazing purifying spiritual effects and healing properties.

Ganga's skin is white, the color of purity and luminescence. In this particular form, Ganga symbolizes the alchemical process; her attendant *makaras* are regurgitating a ball of mercury, which they hold between them as an offering to the goddess. Her hands are in *abhaya* and *varada mudras*: *abhaya* is open palm facing out with fingers pointing up, representing blessing power; the *varada mudra* is open palm out with fingers pointing down, representing the granting of boons. Her two golden pots are overflowing with ambrosia or divine nectar. The river Ganges emanates from her being. Seated on a lotus throne she is in a classic meditation posture.

The style of this piece is Newari from Nepal, which is known to produce many fine artists. Many Nepalese people are both Hindu and Buddhist, which results in a natural syncretism of Tibetan Buddhist and Hindu styles that typically occurs in that area and is reflected in the art. Drawn and painted by Nara. This tattoo appears on page 44.

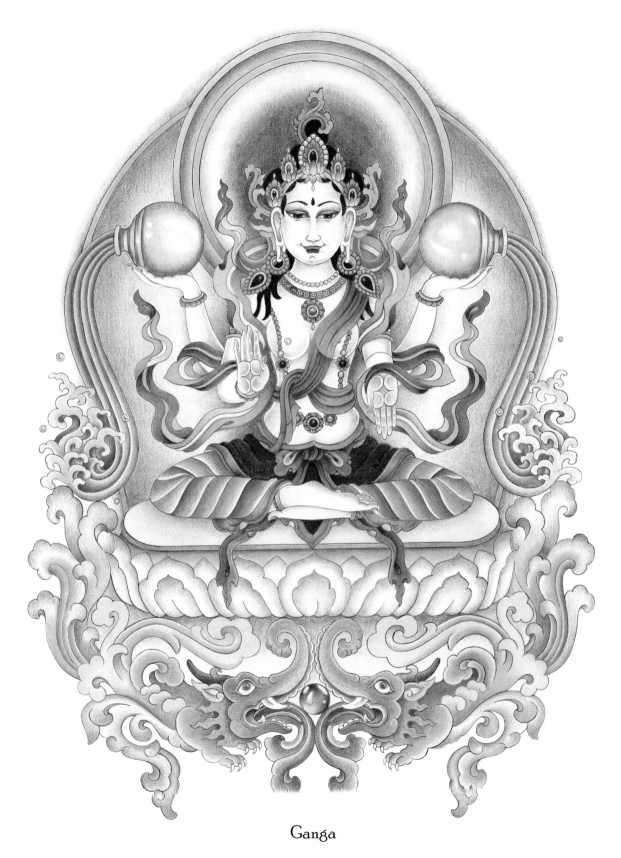

Ganga

## Snow Lions

Snow lions are the presiding deity of Tibet's snow-peaked mountains and are considered the national animal of Tibet. The lion is a profoundly universal symbol of solar origins, found extensively in sacred cultures around the world, including Greece, Rome, Egypt, India, Mesopotamia and later, Europe. One of the premiere symbols of Buddhism, the lion is also related directly to Shakyamuni Buddha, who is called "The lion of the Shakya clan." Signifying royalty of blood and/or spirit, the lion is also associated with the astrological sign of Leo, which rules the heart in the human body. The snow lions depicted here are magical and auspicious animals that are simultaneously fierce, wrathful, powerful and playful. Snow lions are often found in male-female pairings; when symmetrically depicted, the male is to the left and the female is to the right. These two snow lions, one green and one blue, are guarding a peaceful, ritual offering of precious jewels, used for the worship and adornment of deities. Drawn and painted by Nara. This tattoo appears on page 38.

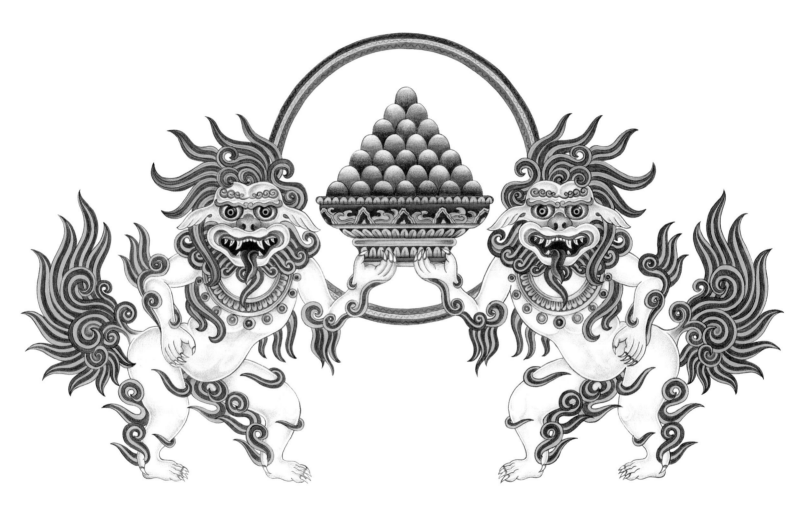

Snow Lions

## Amitayus Buddha

Amitayus Buddha is the "Boundless Life" manifestation of Amitabha Buddha, associated with longevity. He is known to live in a supreme paradise called Sukhavati, to be understood not as an actual land but a state of consciousness. Drawn in the Tibetan style, this Buddha appears highly androgynous. Amitayus Buddha is red, the color of the setting sun, and holds in his lap a vase filled with the nectar of immortality. As a manifestation of the Amitabha Buddha, Amitayus symbolizes wisdom and mercy and is of particular help in transitioning through after death states. Amitabha is said to have been a king who renounced his throne and became a monk named Dharmakara who vowed to realize buddha nature. Amitabha Buddha became the bodhisattva Amitayus, who made a paradise or pure land available to those who called upon him, particularly in the hour of death. Thus it was that through the stainless motivation and pure practice of Dharmakara that Sukhavati, where Amitayus dwells, came into existence. Artwork by Nara. This tattoo appears on page 141.

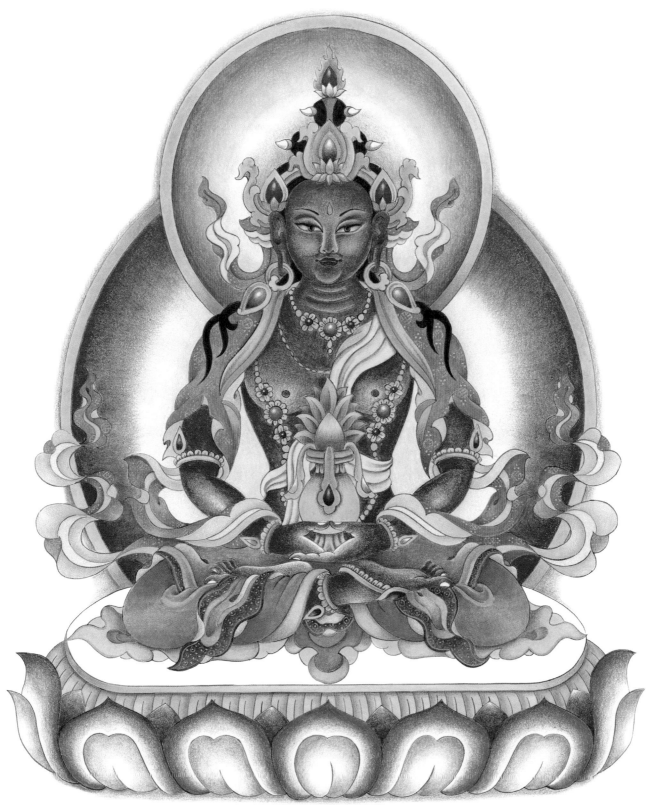

Amitayus Buddha

## Mayuresvara Ganesha

Mayuresvara Ganesha (Lord of the Peacock) is a yogic warrior form of the Hindu elephant-headed god Ganesha, the remover of obstacles. In this form he also represents perfect control of the five senses symbolzied by the five serpents in the painting. The peacock is the vehicle of Ganesha's brother Kartikeya, the god of war and beauty, in charge of the celestial armies, so it seems that this form of Ganesha has appropriated this vehicle, although in some myths it is said that Kartikeya gets his vehicle from Ganesha. The *Mudgala Purana* tells the story of Ganesha fighting and winning a battle against the demon of desire, Kamasura. He carries the warrior's axe and the noose. The noose is made of three strings that are twisted and tied together, representing the three impurities to be overcome with Ganesha's help: *ahamkara* (self-reference); karma (action); and maya (illusions). Ganesh is the Lord of obstacles and the Remover of obstacles; with the axe he is cutting away obstructions, with the noose he holds one in place until the time is right for the obstruction to be removed. Drawn and painted by Nara. This tattoo appears on page 37.

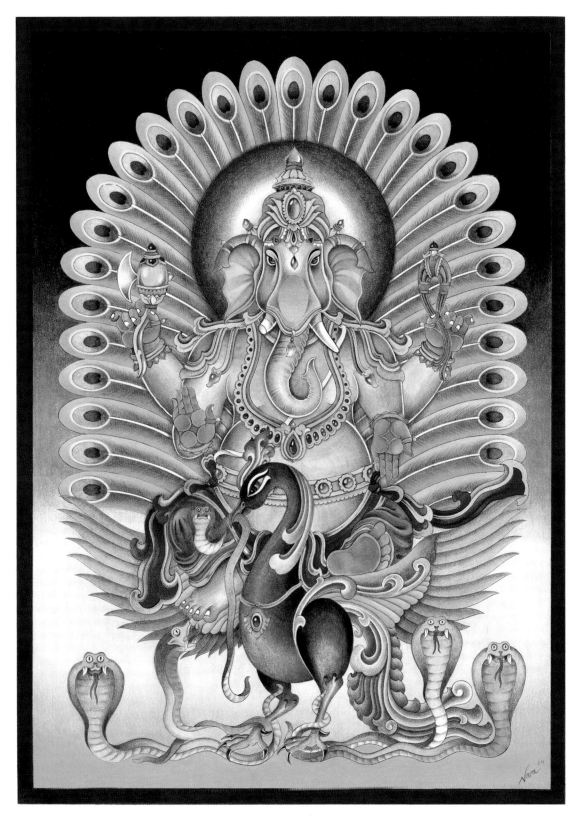

**Mayuresvara Ganesha**

### Nepalese Ganesh

This magical ten-armed Ganesh is a syncretic form of the popular Hindu deity. Incorporating the Tibetan-style, wrathful form, Ganesh takes on an almost demonic stance, even though he is worshipped as a god. The synthesis is seen especially in the Tibetan implements in his front hands and the posture, which is more typically found in Tibetan forms. Ganesh rides a mouse (in earlier forms) or a rat (a later form). The mouse represents Ganesh's ability to traverse or gnaw his way through the tiniest and tightest of spaces—everything is accessible to him, which symbolizes his all-pervasive influence. Thus, Ganesh has the ability to deal with any obstacle—extending his influence in any direction—in the same way that a mouse can go wherever it wants to go. Line drawing inspired by a traditional Nepali painting, color by Nara. This tattoo appears on page 64.

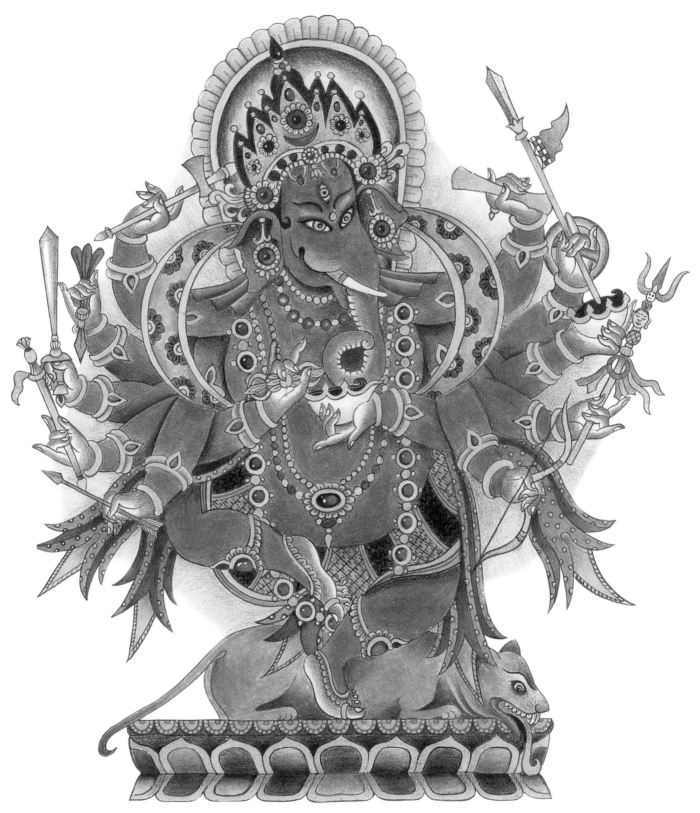

Nepalese Ganesh

## Iswarya Lakshmi

Lakshmi is the consort of Lord Vishnu of the triune Godhead of Hinduism: Brahma, the creator, Vishnu, the preserver, and Shiva, the destroyer. As the feminine or active principle (Shakti) of Vishnu, Lakshmi is always related to the preservation, maintenance and evolution of life. Lakshmi represents wealth, abundance, love and relationship. In this rare form of Lakshmi riding a horse, she is a wealth-producing force. Horses are considered to be divine beings themselves who were once thought to have the power of flight. Associated with victory, the last incarnation of Vishnu is the horse incarnation—the Kalki avatar, which ushers in the next *sat yuga*, or age of peace and plenty.

Lakshmi's golden skin represents opulence and divine gifts. Her jewelry and clothing are drawn in the south Indian style. She carries two lotuses because Lakshmi herself is said to be the lotus, the fullness of divine beauty and earthly feminine beauty. The lotus is the most significant single symbol representing transformation and purity in the Eastern tradition, rising as it does out of darkness and mud to unfold in complete perfection in the light of the sun. Thus, there is the depiction of the soul's unfoldment from root to bud to flower—from the state of darkness, obscuration, confusion, illusion, into the beauty and light of perfect illumination, perfect clarity, perfect love. Drawing and color by Nara. This tattoo appears on page 61.

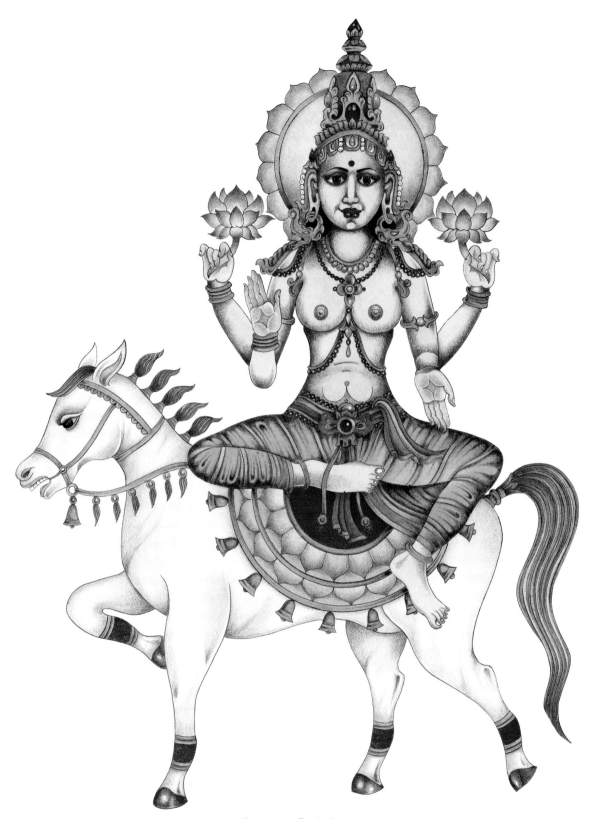

Iswarya Lakshmi

## Red Alokes and Yellow Hase

Red Alokes, or the Tibetan goddess of lights, and Yellow Hase, the Tibetan goddess of laughter, are two of the goddesses representing objective pure states of being, which are reflected back to the Absolute as a pure gift or offering. Red Alokes and Yellow Hase are similar to the *dakinis* of Vajrayana Buddhism in that they are female embodiments of enlightened wisdom energy. Subsidiary figures often appearing on *thangkas*, they are found with many deities, peaceful or wrathful. Depicted in joyful, dancing postures, Red Alokes holds a traditional Tibetan butter offering lamp. Yellow Hase is holding a large string of pearls representing the precious jewel of laughter. Artwork by Nara. The Red Alokes tattoo appears on page 144. The Yellow Hase tattoo appears on page 129.

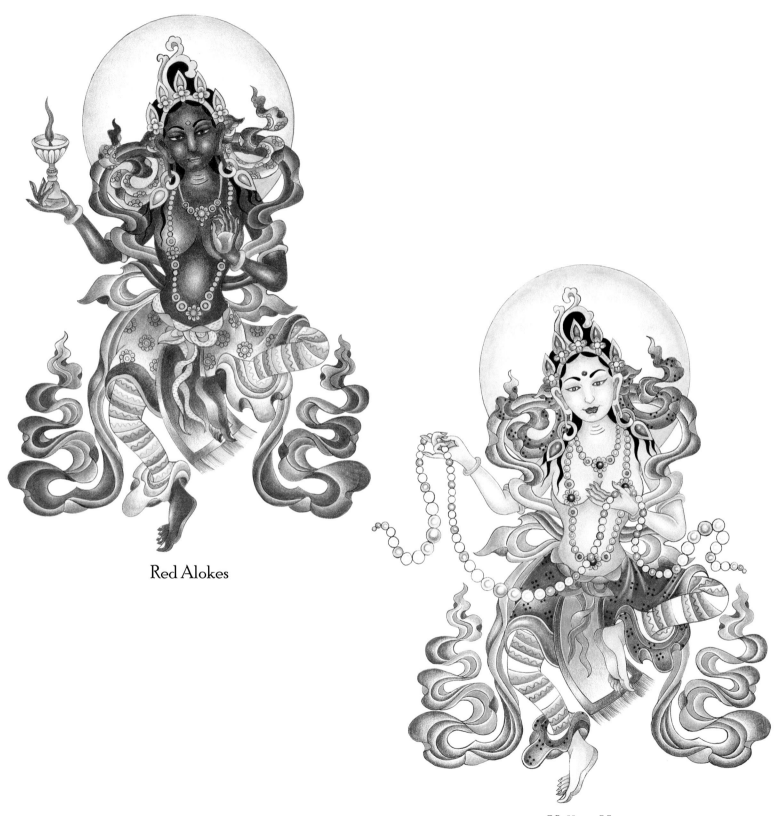

Red Alokes

Yellow Hase

### Madurai Minakshi Makara

The Hindu *makara* is a mythological composite animal that symbolizes alchemy and eros. With the lower jaw of a crocodile, the trunk of an elephant, the upper tusk and ears of a wild boar, the wide and staring eyes of a monkey, the supple body of a fish and the extended tail feathers of a peacock, the *makara* is the vehicle of the popular Hindu goddess Ganga and the ancient Vedic god Varuna. The *makara* is also connected with Kama, the Hindu deity of love and passion (known in the West as Aphrodite, goddess of love, who also has a predilection for oceans and oceanic creatures).

The *makara* is commonly found in south Indian temples and appears sculpted in the earliest cave pillars at Ajanta. An ancient Indian symbol of power and virility, the *makara* was adopted by Buddhism and has been widely used in Vajrayana Buddhist iconography. In this tattoo the *makara* is depicted in south Indian Vijayanagar style, "vomiting" temple bells. This tattoo appears on page 65. Drawn and painted by Nara.

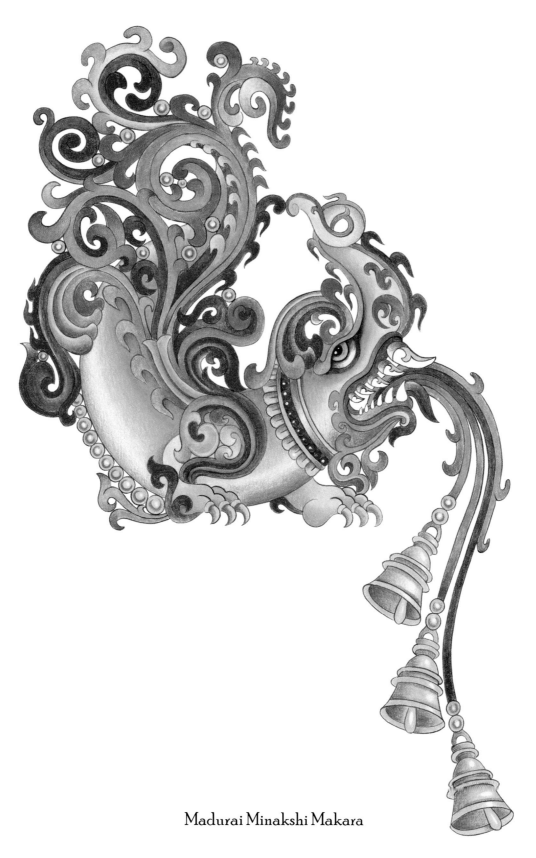

Madurai Minakshi Makara

# Krishna

As the sixth incarnation of Lord Vishnu, Krishna is perhaps the most wildly popular deity of the Hindu pantheon. Krishna is primarily a deity of love; he has no interest in anything but the offerings of a pure heart. The *Bhagavata Purana* expounds the Krishna myth and its *rasa* (divine flavor or moods), detailing the pastimes or *lilas* (play or games) of Sri Krishna as Gopala and Govinda—Krishna in his childhood and youth. Devotional Vaishnava Hinduism is pervaded with the symbolic stories of Krishna as the youth, Govinda, and his play with the *gopis* (milk maids) of Vraja, a small village, as an extensive metaphor for the mystical relationship of love play between the human being and the divine beloved.

Theologically speaking, the human being, male or female, is considered female in relationship to Krishna, the cosmic masculine principle. It is only through love, surrender and sacrifice of the separate personality, with all of its pride and selfishness, that the individual soul may come into the intimate embrace of Sri Krishna. Krishna's flute is an extremely mystical symbol; it is the alluring, sweet sound of Krishna's magic flute that attracts the mind and lures the soul to this play of love.

The Krishna of the *gopis* is an erotic god of love, beauty, sacrifice and devotion enacted within the tableau of a sublime pastoral life. A great deal of literature and poetry has been inspired by the religious myth of Krishna and Radha, his primary consort during this phase (although he supposedly had as many as 12,000), which is highly erotic in nature and archetypically comparable to the *Song of Songs* in the Old Testament or the stories and hymns of the great goddess Inanna and her consort, Dumuzi, from ancient Sumer. It is a universal theme that speaks to every human heart, once tenderized and opened by a glimpse of transcendental beauty. In this piece Krishna is shown dancing on the head of the Kaliya serpent, whose presence was poisoning the sacred Yamuna river where Krishna and the *gopis* sported. The esoteric meaning of the image is the perfect mastery of the awakened life force. Drawing and color by Nara. This tattoo appears on page 146.

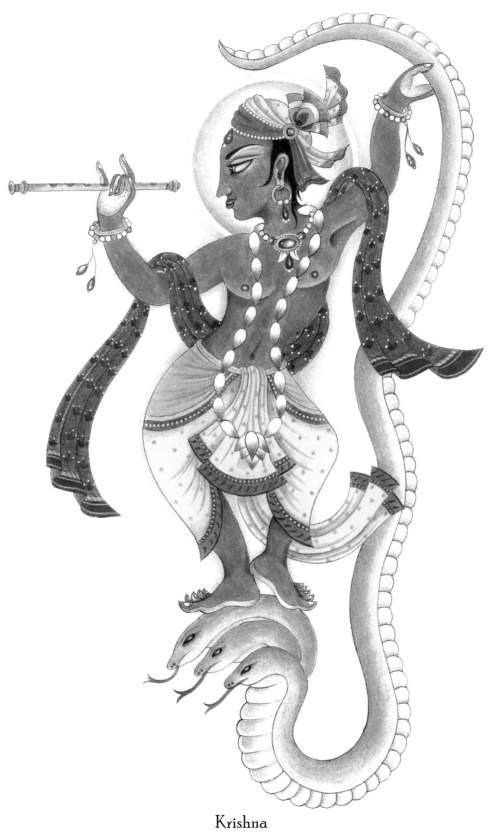

Krishna

## Kiriti Mukha

The *Kiriti Mukha* or "Face of Glory" is a common mythological motif found in temple art and architecture throughout India and particularly in southern India in art of the Hoysala and Vijayanagar periods. It represents that aspect of the divine that literally spews forth or vomits out a cornucopia of life in the burst of original creation; at the same time it is emblematic of regurgitation and absorption, creation and destruction, appearance and disappearance, as it symbolizes time. This particular representation is imaged in the style of temple jewelry: a highly ornate ruby and green enamel and gold repoussé *Kiriti Mukha* with a massive, engraved ruby pendant and *makaras*—mythological creatures representing alchemy—coming out of its mouth and ringing temple bells in their trunks. The ruby is engraved with the Sanskrit word "dharma," which signifies righteousness, truth or virtue. To live according to dharma is to follow cosmic law, leading to the accumulation of positive karmas. Artwork by Nara. This tattoo appears on page 118.

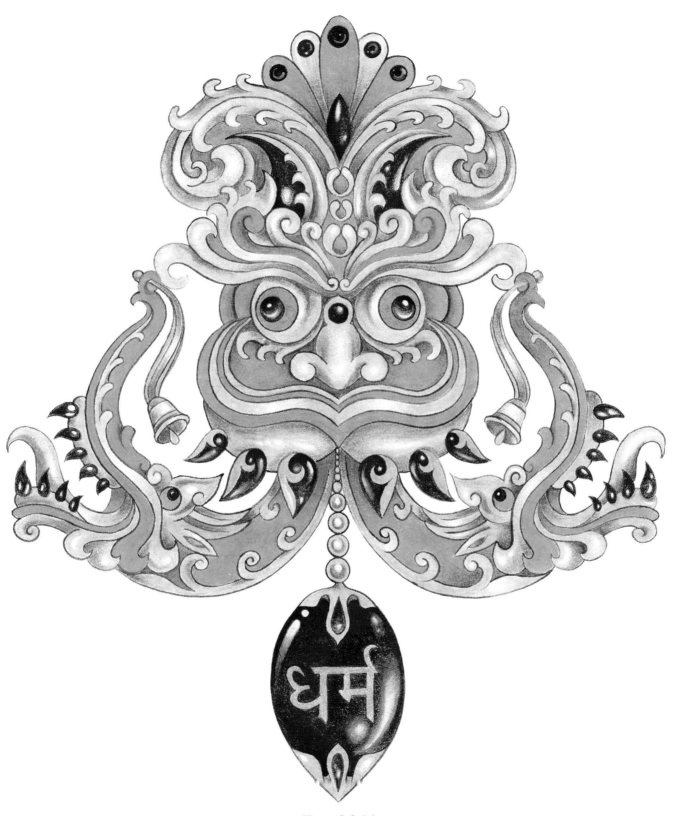

Kiriti Mukha

### Green Tara Bazuband

Green Tara, the "savioress" of Tibetan Buddhism, has inspired this temple *bazuband* with the Sanskrit mantra, "Om Tare Tu Tare Tare Svaha," written in Tibetan script. The *bazuband* is embellished with a Nepalese-style *Kiriti Mukha* (Face of Glory) vomiting precious dharma jewels. A pair of protective male and female dragons hold between their tongues Tara's sacred blue lotus or *utpala* flower, symbolizing the great force of her great wisdom and compassion. The mantra of Green Tara is said to swiftly bring aid to suffering beings of all categories, times and places. In Asian art the color green represents wind, movement and speed; hence Green Tara's swiftness of responding to the prayers of her supplicants. Artwork by Nara. This tattoo appears on page 82.

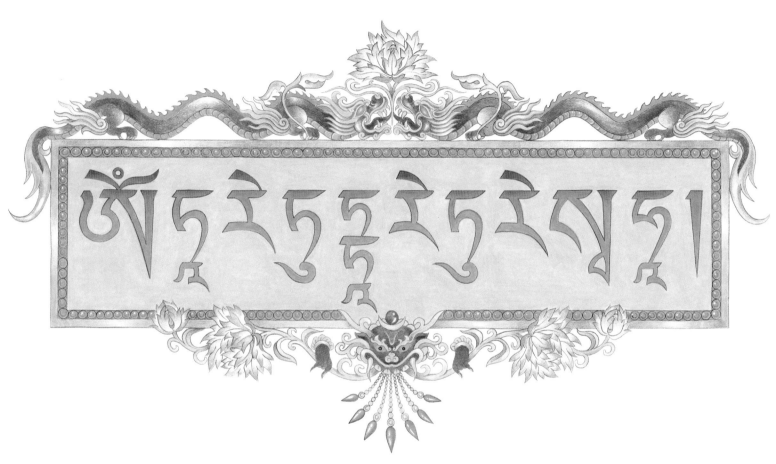

Green Tara Bazuband

## Medicine Buddha

Bhaisajyaguru is the "Radiant lapis lazuli Master of Healing Buddha." Known for his healing power, the Medicine Buddha is a popular deity of Mahayana Buddhism, whose blessing also confers longevity, protection from disasters and the transformation of negative states of mind. Bhaisajyaguru is depicted holding a lapis lazuli medicine bowl containing nectar, cupped in the *dhyana* (meditation mudra) of his left hand, to indicate the importance of meditation for healing. His right hand holds the yellow medicinal *myrobalan* fruit between thumb and index finger, with three fingers pointed down to bestow blessings. Bhaisajyaguru is also the deep blue color of lapis lazuli. Artwork by Nara. This tattoo appears on page 49.

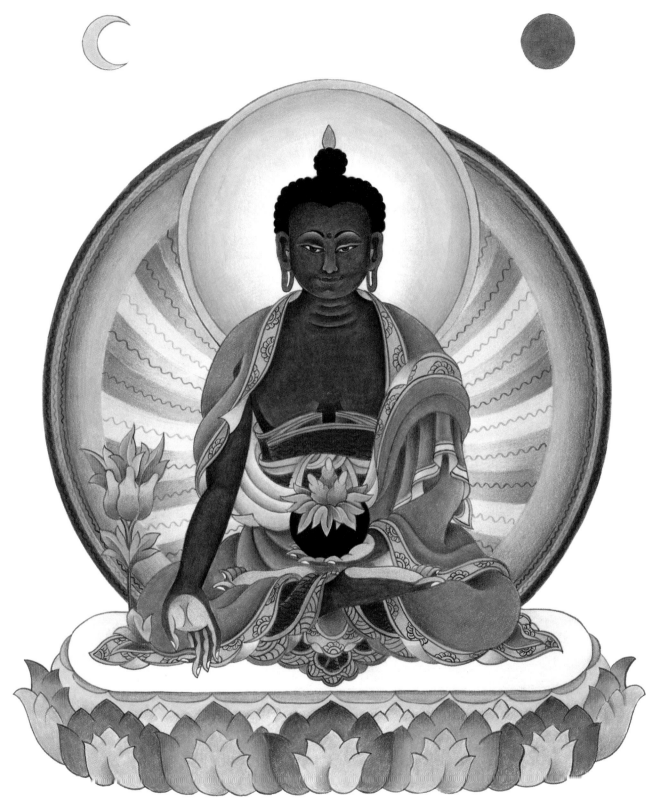

Medicine Buddha

## Anjaneya Vinayaka

From the most archaic times there have been polytheistic traditions in which the gods take animal form, such as the Native American trickster-god, Coyote. In Greco-Roman myths Apollo was a wolf, Athena an owl and Diana a bear. For many peoples of antiquity the elephant was regarded as the wisest of all the animals, who also lived the longest, while the monkey represented tremendous agility, tensile strength and a certain fluidity in traveling over terrain—strong qualities that were incorporated into the deified images of Ganesha and Hanuman.

This Anjaneya Vinayaka is a rare deity that combines the cosmic functions of Ganesh and Hanuman in a composite form. Hanuman carries his warrior's mace with hands placed together in the devotional *anjali* mudra. His green color denotes speed and auspiciousness. Hanuman is the Hindu monkey-god, who is the attendant of Lord Rama (Ramachandra), one of the most widely worshipped incarnations of Vishnu. Hanuman personifies the archetypal devotee. He plays a major role in the great Hindu epic, the *Ramayana*, in which he leads an army of monkeys against Ravana and frees Sita from the demon king's clutches.

Ganesha carries an elephant goad and his broken tusk in two hands. As the first scribe, Ganesha is the patron deity of writers. The great Hindu epic, the *Mahabharata*, was dictated to Ganesha by the blind sage Vyasa. One version of the myth says that when Vyasa was ready to dictate the fabulous story of the *Mahabharata*, Ganesh broke off his tusk to use it as a pen, therefore Ganesh appears with only one tusk. This particular image was taken from a print in a temple dedicated to Anjaneya Vinayaka, located on the outskirts of Chennai in south India, re-interpreted and painted by Nara. The tattoo appears on page 133.

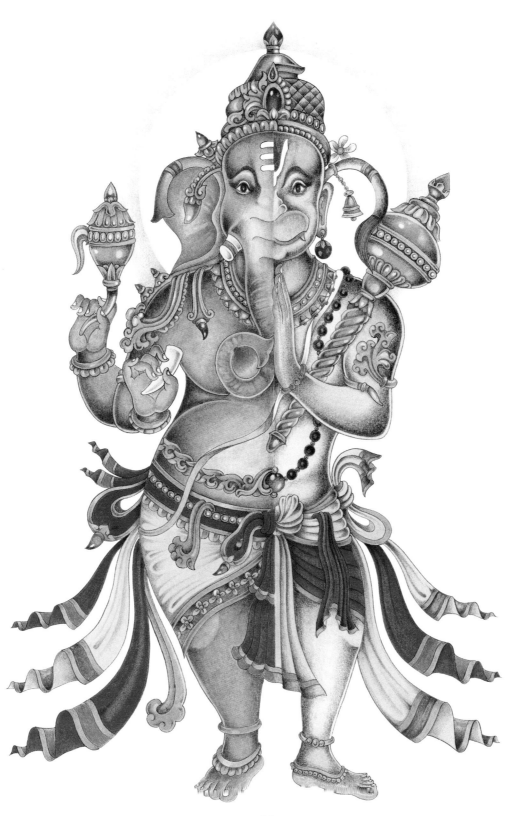

Anjaneya Vinayaka

# Durga

The beloved Hindu goddess Durga has numerous myths that relate her origins in various ways. Some of the *Puranas* depict Durga as an independent divinity, though she is popular as a form of Parvati, consort of Shiva. According to the Vedas, a mighty demon named Durga was tormenting gods and men. Shiva himself could not kill this demon, nor could any of the other gods, because Durga was protected by a boon that made it impossible for any male being to kill him. At Shiva's request, his consort Parvati assumed the form of a warrior and killed the demon. Parvati herself was then called Durga, and became one of the most mportant goddesses of the vast Hindu pantheon. The epic *Mahabharata* states that Durga dwelt on the Vindhya mountains, rode a lion and was offered oblations of meat and wine.

In one of the *Puranas* it is Vishnu who initiates, with Brahma's help, Shiva calling forth Durga to battle against the demon Tripura. With Durga's blessing Shiva was able to win the battle, and from that time Durga has been also associated with the power of Vishnu as well as Shiva. She is not depicted as the consort of Vishnu or Shiva in her shrines but as the widely-worshipped divine Shakti—a benign mother goddess and a fierce protectress with a feminine warrior spirit.

In another well-known mythological story, Kali, an important demon-slaying goddess of this "family," was born from Durga's side during a particularly wrathful battle with demons. Durga as Kali in particular is also worshipped as the cardinal goddess of Tantra (for example, Om Kali), a creatrix and cosmic Absolute who stands on her own, as opposed to the demon killer aspect of Durga found in the *Puranas*. Durga is addressed by over a hundred names, the more notable and distinctive of which are Chandika or Chandi, Ambika, Kaushiki and Gauri. In this image she is found in a dynamic warrior posture, intoxicated and anticipating victory in a coming battle. Her implements are: sword, trident, shield and cup of wine. This particular form is in Keralan (south Indian) style, where she is depicted as green in color and standing on a Yali lion. Artwork by Nara. This tattoo appears on page 128.

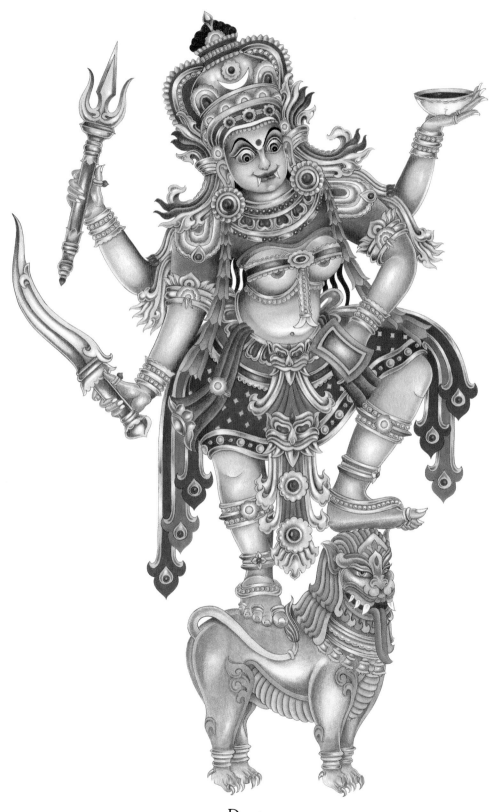

Durga

# Interviews with the Artists

# Interviews with the Artists

## "The Mad Lord Who Runs this Crazy Universe ..."
### An interview with Nara

*In the following ruminations, taken from a series of interviews with Nara near his studio in the mountains of Arizona in November 2004, he reflects on coming of age, tattoos, art and the amazing world of India's temples and deities.*

I got my first tattoo, a burning skull, when I was sixteen. It was a skull engulfed in flames. I was very attracted to death imagery, gothic imagery, occult imagery. I actually found it to be beautiful, but in a way that was "other." There seemed to be some power in it; I didn't know what that was, but I was eager to access it. Like most teenagers I had a morbid fascination with death. I used to think about death a lot, and for sure, I was in a lot of deep internal pain, but at that point in my life I hadn't fully recognized that. I wanted to fly out of the conventions of my middle class home and into another world. Where I went was completely into the underworld.

In the next four years I got seven tattoos. At least three of them were of a considerable size. There's something about having those old tattoos on my body now because there is a complete connection with where I've come along the way—where I've been in my life, where I was lost. I was lost, but I was also in quest of something. My life was completely of the underworld: drugs, alcohol, sex. Everything was there. And it wasn't as though it was a period of great joy for me. It was hedonistic, but I wasn't a joyful hedonist; I was trying to push through into something, and there was a considerable amount of pain in that. Part of the reason why I started getting tattoos was because I was extremely

androgynous and feminine as a young man, and I wanted to enter into a new kind of masculinity. Those were some of the things that were going on—it was all very mixed up.

When I got my first tattoo I wanted to be an outsider; I wanted to be a freak. I was going around wearing fishnet stockings underneath ripped jeans and a completely white face with Gothic makeup, diamanté jewelry, leathers, a Mohawk. As much as you could push it with your physical appearance, I would do that. Invariably every time I went out I would get chased by some man who wanted to beat me up. But I was finding beauty in all that. All this was in an extremely working class, macho, ship building, coal mining town in northern England, where men were men!

The tattoos were always about physical transformation. You know, there's a Sanskrit word that I love: *kavacha*. It means a divine armor. When you are doing ritual work, you place, through the imagination, various mantras and deities on different parts of the body, and then you have *kavacha*. You have your divine armor in place so you cannot be penetrated by negative influences. There is power in a basic image of a dragon—there is such archetypal power in that imagery. It's something wild and beautiful and unbound. Of course, you want to align yourself to that, as an insecure teenager or young person grasping for a place in life, when you have no idea where you're going or even what you're here for. So in that sense I think tattooing is very important, because it becomes a self-initiated rite of passage, when it's taken seriously. It's also an acknowledgement of an inner wounding, but with the right imagery it's about the transformation of that wound.

I felt that I was starting to own my body with my tattoos, instead of being what my parents thought I should be—having some middle class identity pushed onto me, being a doctor or something. I was stamping my own body with what I wanted to align to, even if I wasn't sure of what that was.

I went to India in 1989 when I was twenty-one. While I was there I went through an intense journey into hell that I pulled myself out of with my life just barely intact. It involved me and a confrontation with archetypal sources of human suffering and being thrown into the deepest levels of hell. Certainly my mental health was gone afterwards. I was completely broken down through a life-threatening experience that was the fruition of my bad karma. Without that experience I don't know if I would have ever come to the spiritual path, and I'm very grateful for it, because for sure I burned off some karma in those hours.

Shortly thereafter, when returning to the West, I started to look for answers to the experience that I'd had in India. An Indian palmist told me at some time later—he actually named the date that that had happened—that I'd had a severe car accident on that day. It wasn't a car accident he was seeing in my palm, but that life-threatening experience. That first trip to India was the first time that I tangibly came into contact with Hindu imagery. Even then it spoke to me very loudly.

I got back to the West and began a very intense practice of yoga, with a lot of fasting. I had some visionary episodes where the gods of the Hindu and Buddhist pantheon revealed themselves to me as living beings, which was of such great solace to me, because I'd finally found a world of real beauty, and that divine beauty was just so enchanting. That was when I first formulated the idea that I would like to serve God through art.

It was the one saving grace in my life that I had artistic ability. I'd painted and drawn, and I'd actually exhibited some art in a London gallery that Andy Warhol had seen. I was told that he had admired the work: massive, bright intense images of urban angst and decay. When I came into contact with the divine beings, with the deities, and really saw into what Eastern art was experientially, it blew me away as an artist. It completely finished me for contemporary Western art movements. From having a lot of interest I went to zero interest. I immersed myself in Hindu and Buddhist imagery; I even had Robert Beer prints on my walls and fantasized about meeting him one day, though I never thought I would! So it was a recognition of how my life

would develop, but it was all very far away at that point, which was why it was such a miracle that I met my guru, and through his blessing, I actually met Robert Beer.

During my rehabilitation period, I was trying to be a good yoga student. The yoga scene at that time was so different then—people were not impressed with my tattoos one little bit! People recoiled from them. It may be hard to imagine what it was like even ten years ago, when people would look at you like you were a dangerous criminal if you had a tattooed forearm! There was so much general disapproval. At that point in my life I was distressed by it. I just wanted to be anonymous. I was also trying to do things differently than I'd done them before. I got my hair cut in way that was patently unfashionable. My friends were horrified. I started wearing corduroy. It didn't last.

It's easy to see now that all this was preparation for the work I would do; there were so many things pointing toward this work. I was already tattooed; I was already obsessed with India and with deities. The next trip I made to India—in December 1997, when I met Yogi Ramsuratkumar—changed everything. After the depths of ravaging pain I'd been put through on my first trip, the blessings that were poured on me in the second trip turned everything around.

There were several instances: I remember coming out of the Banke Bihari Temple in Brindavan, and I gave some money to some widows who were standing outside. Suddenly I was surrounded by about twenty beggars who harassed and pulled and pushed at me. I just started laughing! It struck me as being funny. I was having very strange moods; I could feel the blood of the people, and I wanted to be the blood of the people; I wanted to be the dust on the road. I was so completely in love with India. Every interaction I had with anybody was another opportunity to gather energy. I can even remember feeling romantic about the pollution in Varanasi! You know, Shiva has his *ganas*—a ragtag band of trouble causers! They have animal heads, they get drunk, they're always fighting, and Varanasi reflects that. One thing that always struck me about India was the relationship between the deities and the place: I discovered that it's true what they say—Varanasi was Shiva; Brindavan was Krishna.

About a year later I had a dream that very simply stated, in large, typed letters flashing across my dreamscape, "Paint Buddhas." A friend suggested that I learn *thangka* painting. So that was the beginning. What I basically understood was that

art had an objective function and a job to do, and that function was to communicate divine realities. If I wasn't prepared to give myself in service to that, then I wasn't interested in creating art. I totally lost interest in having a vehicle that was about personal expression. I was completely inspired by the anonymous artists of the great Asian traditions, where the work isn't even signed. I only started signing my work at the request of my guru. After I experienced the high reality that Hindu and Buddhist art was depicting, virtually all contemporary art seemed dark, violent, childish, pretentious, built up around a personality cult and quite often without a lot of worth.

I had some prints of images drawn and painted by Robert Beer, which I had had for years, and on the back of one was a phone number. I rang it up and it was Robert's phone number. We had quite a long conversation on the phone; I was on some public phone box somewhere in London. Initially Robert was discouraging, telling me that it was a very difficult art to study, there weren't many teachers who were teaching at that time, and it would be very challenging. I persisted and eventually he invited me to come to see him and to bring some of my work with me. It took me about two months to pluck up the courage to go see him. I already knew his book, *Masters of Enchantment*, a book by Keith Diamond that Robert illustrated. I had spent a long time looking at those images, a long time, and here I was, going to meet the man who painted them!

I had a very strong internal conflict about learning Tibetan Buddhist *thangka* painting, because I didn't believe I would be able to do it. I didn't have that kind of faith in my own ability. I'd had a feeling that I wanted to do modern, abstract but still figurative images of Buddha heads, the kind that are very popular in contemporary art but not traditional. At that point that was one of my aspirations. Then I had another dream, and in this dream my spiritual guide was taking me around an ashram where all these paintings that I had done in this modern style were hanging, but underneath every single painting there was a small typed label. As I was admiring my own work on these walls, he pointed out the small label and indicated that I should go read it. I went to read the label, which was under every single painting. It said, "Not for contemplation."

I woke up after that dream having lost any desire to do that kind of work. The desire for that kind of art has never come back, much to the frustration of some of my artist friends. So I started working with Robert Beer. If I look at the time I spent with Robert Beer, I've spent no more than two weeks total with him, but I will be carrying that instruction for the rest of my life. Robert would see me for half a day, then he would send me off to paint for four months. I was working on his line drawings, which were just so incredibly meticulous. So for two years it was strictly painting Robert's drawings of deities, and during that time I did two paintings: the Vajrayana Buddhist deities Mahakala and Vajrakilaya.

Two years after apprenticing to Robert Beer, I painted a Milarepa from a woodblock print. Traditionally in Tibet, one way that *thangkas* are produced is by the circulation of woodblock prints on rice paper. A master artist carves the line drawing of the deity into wood, and then the Buddhist monasteries would print them on rice paper that was distributed throughout various regions, so artists would produce many different versions or interpretations of one woodblock print, based on the vision of the painter. It's like a piece of classical music, you know; it changes depending on who is conducting and playing.

I spent two years painting that Milarepa, and I learned a lot on that piece. I look at it now and I see that it was a learning piece, like all pieces. I hit a curve in the learning process at some point. My guru had asked me to do some very rough sketches with *nagas* and conch shells representing the dharma—that was in the winter of 2001. My first drawings for tattoos specifically were very influenced, if not directly taken, from Robert's work, with some of my input into it. I was very nervous at that point about doing my own interpretation. Then I got the opportunity to visit Jaipur, Rajasthan and study a little of the Indian miniature painting tradition, with a well-known family of Indian artists, the Ramdevs, who have been painters for several generations. My love of Hindu deities was revivified there. So there were two more trips to India in which I stayed for extended periods of time and visited hundreds of temples, taking photographs, just absorbing the iconography, the style and the look of the various regions of India.

Up until this point my work was mostly with the Tibetan iconography that I was learning from Robert Beer. Although, prior to that, five years before, I'd done several drawings and paintings of deities—a head of Kali, very trippy with light rays coming from the eyes, the night sky and a Ganesh. I had also done a painting of the goddess Lakshmi for a yoga center

I was involved with. I was magnetically drawn to deities, any deity really. That was when I was studying at a yoga center of the lineage of Swami Shivananda of Rishikesh, run by Swami Vishnudevananda. He saw this painting of Lakshmi I'd done, which wasn't very good, but at the time, at that point I guess it was okay. He looked at that and his instruction was, "Paint everything," which concerned the center there, because I was being groomed as a yoga teacher, not as an artist. When he said it I knew that was what I wanted to do.

I have a love for the Jain deities and the deities of all the Eastern traditions—not so much the Western tradition. One of the earliest experiences I had was, when I was about twenty-two I was lying down on my bed, and I was doing the Hare Krishna mantra. I drifted into a half-asleep, half-awake state, and it was as though my bloodstream poured out of my body and became a giant bull made out of liquid blood or life force that pressed me down on the bed. On the back of the bull was an incredible, dancing, luminous Buddhist god, and yet, I'd been singing the Hare Krishna mantra. So one thing was very clear: All these things interpenetrated one another. Even if scholastic minds and people are rigid or over-traditional in their relationship to the deities of their path, these deities represent massive, open, infinite, free energies that will operate as and how they see fit. That was my understanding.

So throughout this time I was simultaneously having dreams and some visionary experiences of deities from various different traditions, and I didn't distinguish between them. There didn't seem to be any point to that. They are all manifestations of absolute wisdom. Like the first time I went to see Yogi Ramsuratkumar, and I saw hundreds of Ganeshas dancing around him; who knows if those were the sixty-four classic forms of Ganesh! These things can't be limited. Yet at the same time I think the artist has to get to a point where their relationship to the classic discipline of how a deity should appear is reliable; then there can be some expression. I think I have a natural sense now of where it is acceptable to improvise or be inspired, and where it's just coming from an independent artistic drive for focused creativity that serves my own ego. "Oh, I thought of it, so I can do it!" Just because it appears in your imagination doesn't mean that it's necessarily a reliable representation of the deity, but there is a point at which you know you've seen something that has some authenticity. Painting deities is a very disciplined art form,

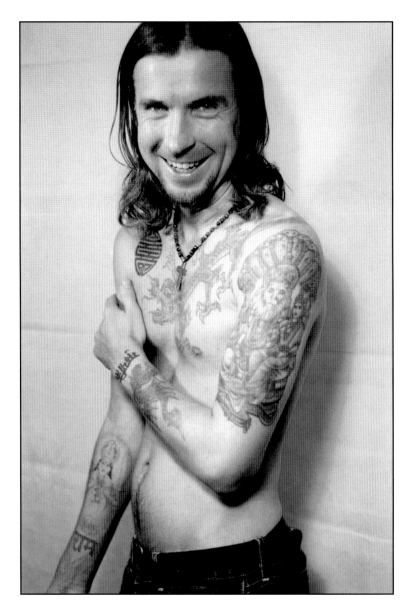

and you have to have a lot of technique together before you can reliably have that sense.

For example, when I did the painting of the three-headed Camunda I wasn't aware of any precedent for that. I hadn't seen any sculpture or painting of a three-headed form of Camunda, and yet I'd had a vision of this three-headed form of her, and based on that I embarked on the painting. Two months later I received a magazine with an article with a picture of a three-headed form of Camunda. It was like I was getting the message, "Yes, it's okay." But I'd have to have that sense. I feel it more and more as I go along in my relationship to the deities, that I can

be used by them. I don't mean used as a channel, but to reliably represent their beauty in a way that has some life and objectivity in it.

What I've experienced time and time again from Western artists is that they have a negativity to this art form because they know that to produce it requires much more sacrifice of time and discipline than they are usually willing to give to a piece of art. They resent the discipline, and they feel that it is a restriction. Instead of fully coming to an appreciation of what that discipline is about, they would rather just say, "Well, I'm going to interpret this *my* way." It's just too threatening—it's pretty horrible to have to spend fifty hours painting wave tops on a *thangka*. It really bends your mind. You have to be completely dedicated to the vision of what you want the end product to be, to be willing to make that kind of sacrifice. I really got that—the discipline and sense of commitment to the form—from Robert Beer.

I think there is a lot of dishonesty in contemporary art—that is, people's unwillingness to have something that is beyond the latest fashion, which is usually pretty easy to execute artistically. Obviously there are exceptions. I think there's a possibility in the tattoo world of people going beyond just taking an image and then warping it. I think there is more possibility now for people to get behind the meaning of the symbols, so that you don't take a Ganesh and splice and dice him and use colors that aren't traditional to that particular form that you've represented. Most of that is done innocently, but the image will not have the same resonance with the living force of the tradition.

There are forms of Ganesh that are green, blue, white, yellow, red, but they are not interchangeable. They each have different attributes, they carry different implements and are seated on different vehicles. For example, Vishnu, who is *always* blue, can sometimes be red or golden, but those colors have specific histories behind them, and the deity is seated in a particular way, and each one has a different cosmic function. So when you warp that, you are distorting the function—into who knows what! Often with these pieces of art there is very little to say about them because I am reaching out to very obscure areas of iconography, where there isn't very much information about that particular form of the deity, just for the joy of giving people something that I know is going to be absolutely unique to them.

The *dakini* script tattoos that I've seen on Buddhist practitioners are another example. *Dakini* script can only be read by the *dakinis*. It's a revealed language. In the tradition of Padmasambhava they have these dharma treasures, called *tormas*, that were hidden during his lifetime and would be discovered over the centuries. Some of them are hidden in rocks, found in the air or moving water. By yogic practice, they sit and meditate on the rock until it cracks. The *dakini* script is kind of hieroglyphic. I've seen Buddhist practitioners, Western monks and nuns, with these scripts tattooed on their bodies. Those would have to be exact, like Sanskrit.

A few years ago I went to the Banke Bihari Temple in Brindavan. Several hundred years ago, a devotee of Krishna had a dream in which Krishna told him to recover him from the bottom of a well. So he finds this deity in the bottom of a well and it becomes the most celebrated deity in Brindavan. Ramakrishna himself went into that temple and fainted in ecstasy when he saw the deity. It pulses with an ecstasy of joyous abandon. It communicates the whole sense of play, of *lila*, of Creation as divine sport and the mad Lord who runs this crazy universe. It's very joyful. It's the strongest contrast to the contemplative, almost dour atmosphere of a Western church that you can imagine. In the famous Venkatesvara Temple in Tirupati, the deity itself was said to have been a living incarnation of Vishnu, who, at the end of his incarnation, turned himself into stone for the benefit of his devotees. The historical worship of that deity has gone on uninterruptedly for centuries.

Each of these deities, particularly some of the celebrated ones, have arisen in mysterious circumstances. They have attention poured on them, and there is something they transmit if you are open to it, always. They are a window into another world. When you go to a temple, you are given the opportunity for your mind to expand in an act of divine imagination. It's reciprocal. Each deity inhabits its own universe with its own mood and theme. So the experience of going into a Shaivite or Shiva temple can be very different from going into a temple to Surya, the sun god. Each has a particular vibration, and some of these temples are like cities, they are so vast. That's my favorite thing to do in the world. It feeds me, it feeds me very deeply.

Some friends just came back from India; I had recommended that they go to a particular temple in Haridwar, a Shakti temple. Their main insight was about how mechanical organized religion can be. You go there, they put the tilak on your head, you are moved through like a herd and so on. But who cares about that?

It's like looking at a painting and getting hung up on the texture of the paint on the surface of the canvas instead of seeing the beauty of the picture. It's very easy to criticize the ritualism and greed that goes on there and how people are treated like sheep and act like sheep (they aren't very conscious of what it is), but who cares? These places were created from divine revelation and imagination; they have power and sanctity.

There are all those profane images on the outside of the temples. On nearly all the temples in Tamil Nadu there are figures of masturbating lions, sometimes with other lions looking over their heads. I think the masturbating lions represent the virility of the Hindu tradition—its pride and its virility. There are masses of erotic imagery, of acts that are clearly in the realm of human pleasure rather than tantric imagery. Our sensibilities are tested, that's for sure. One has to understand that in the Hindu universe, demons get liberated and become divine beings. In one sense Ravana might be this horrendous egoic demon of selfishness, but through his interaction with divine forces—Lord Rama and his forces—Ravana becomes divinized. Certain sages have offspring that become demons and they have a role to play in the drama of life. It's about the constant tension of polarity, the constant play of forces. Sometimes you're up, sometimes you're down.

These temples have been a meeting ground for centuries for all the arts: sculpture, painting, dance, music, poetry. Nearly all of them have great saints and presences attributed to them—particular poet saints who would sing the praises of the deity of that particular temple. How blessed is Arunachalesvara Temple in Tiruvannamalai? It's had Seshadri Swami, Arunagirinatha, Ramana Maharshi, Yogi Ramsuratkumar, Gnanananda Giri! These temples are the product of an enlightened culture. I think at this point in time we can't even begin to imagine the great heights that Eastern cultures have reached in their remote pasts, where religious mood and sentiment could be freely expressed, often without any kind of repression. That's not entirely true, perhaps, but to a large degree. I think about the lifestyle of the Bauls, the Shaivite yogis, the worshippers of Krishna, the great Shaivite saints of South India. That was a time when people would sacrifice their lives to the gods, you know. Maybe it's not unlike our tattoos. These incisions made into our flesh are an act of faith and remembrance in a universe that is much greater than the one we currently hold to be true.

I've had two of my tattoos redone in recent years. The skull wrapped in flames on my upper left arm, that I got when I was sixteen, was taking up prime space where I wanted a big deity. So many of my tattoos were associated with very specific times of my life, and I wanted something less specific and more about the universal blessing force. I've got a whole bunch of tattoos that can't be covered up because they're just too big and black, and that's fine, I can live with them. It's not that I dislike these pieces; it's just that there are other things that I would prefer, things I feel are more powerful or refined.

It's good to have both of those kinds of things on my body; it's good to have real street tattoos and something that's really refined also. I'm never going to have one of those perfectly considered bodies with tattoo placement; it's too late. I've already got too many things there. The value in that is just accepting what is; this is it, and it's okay, because I did go through a stage in my mid-twenties where I considered laser removal. I came through that phase of just not liking my tattoos and decided against it. It was very different back then; you were still considered a criminal if you had a tattoo! Now my tattoos are part of me.

The first tattoo, the burning skull, has been subsumed. It's like Lakshmi-Narasimha has eaten the skull. I can still see the skull if I look closely; it's like the ground, the foundation, that allowed the Lakshmi-Narasimha to come to me. The burning skull underneath actually gives the Lakshmi-Narasimha more substance. The Lakshmi-Narasimha image was taken from a poster from India that belonged to a friend who died unexpectedly in a car crash, and then interpreted by Aaron, who did the tattoo.

Having had a willingness to throw myself headlong into seeing the darkest areas of my personal psyche, and into questioning everything that I was seeing in the world that had the nature of destruction and shadow, and wanting to see what my part in that was, simultaneously allowed me to have access to realms of more positive experience—although that came a little later.

This process wasn't so conscious at sixteen. I was pushed there by force of habit or karma; so much momentum was built up internally that it took me into the darkest regions of hell, and that's what I got to see and experience, and in experiencing that, something opened. In that opening a whole realm of other influences were allowed in. That's when I saw the living reality of the deities, in vivid dreams and visions. So, going from the

burning skull to the Lakshmi-Narasimha is a journey and reflects my journey. Narasimha is also about discipline; it's only by discipline that I am going to make a difference in my life, and that needs to be honored. It's only when I've exercised discipline that I can see that I'm really happy anyway, rather than the amorphous state that you get yourself into when you're just running along with things. There's something very unsatisfying about that.

I'm either traversing the road to hell, or I'm traversing the road to heaven. That's probably a bit too much for some people. But I want my tattoos to be about traversing the road to heaven, in the big sense. That route may very well go by hell, but it's no longer in the way of self-indulgent desperation that is just one of distress and ignorance. And, I have to acknowledge that there is wisdom behind everything that has happened.

# Epilogue
## An Interview with Aaron Funk

We left Arizona on December 20, 2004 before dawn to drive, once again, through the desert and the hulking stony masses of snow speckled mountains outside Los Angeles. Coming into L.A. these days is like being in a movie—something postmodern and apocalyptic, like *Mad Max*. The first threshold one passes through on the way to the mythical City of Angels are the surrealistic fields of monstrous wind turbines—enormous steel windmills that cover the slopes like mechanical troops waiting for the war, whose purpose is to generate electricity for the San Fernando Valley. Then, long before you reach the outskirts of the urban jungle, the unmistakable brown cloud that hovers for miles like a blanket over land and sea comes into view. Once you are into the surrounding suburban towns, the haze of pollution renders the magnificent southern California mountains invisible. The thick chaos of the freeway and interstate traffic alone is enough to daunt even the best drivers.

Still, Los Angeles and its surrounding environs is one of the greatest urban areas on the planet—a place where you can get anything you might want, be it from heaven or from hell. If you are fortunate enough to have a yard and a garden and trees, despite the toxicity of the air, it is the land of milk and honey, rampant with roses, jasmine and all kinds of flowers and growing things that thrive in the moist Pacific atmosphere.

Arriving at Tattoo Revolution in the late morning, we were scheduled for a whole day of tattooing with Aaron. The day usually begins at the shop between twelve noon and one o'clock, so we stood around in the parking lot for awhile, waiting for someone to open the front door. Alan Fitzgerald was the first to arrive and set up for the day's business. Before long Jimmy Martinez arrived. Not long after that Aaron drove up, greeted us warmly, then made the short jaunt down a few doors to the liquor store to get his morning espresso in a can before starting the first tattoo.

While Aaron looked over our designs and prepared his space for the first tattoo, I looked around at the walls. In the waiting area there was, among other things, a large poster print of a naked, voluptuous supine fairy in bondage, the familiar flash art of Oriental dragons, a snake and knife motif, and a big green snowflake. Two large standing portfolios of popular flash and original tattoo art stood in the waiting area, ready to be perused. On the back wall was a huge poster of Al Pacino in *Scarface*. The walls above the tattooer's stalls on the left side of the room were decorated with a beautiful print of the Virgin of Guadalupe in a gold rococo frame, a poster of Marlon Brando as the Godfather, and a second version of the Virgin of Guadalupe, represented as a skeletal death figure standing on a skull.

In Aaron's stall an almost life-size photo of Audrey Hepburn looked out from the half wall divider on one side, while two small, framed photos of tattoos done by Aaron—the Frankenstein monster and Leatherface, the villain in *The Texas Chainsaw Massacre*—provided an interesting juxtaposition to the gorgeous black and white Nepalese Avalokitesvara that still hung in its central spot above his work space, flanked on either side and above by long tribal masks carved in wood.

There was an easy camaraderie in the shop as it slowly came to life for the day, with people coming and going for various reasons. One woman with short hair, dressed in plain suburban clothes, was talking with Jimmy. I heard her say, "I just turned fifty. It sucks."

Jimmy rejoined, "Don't say that! Fifty is the new thirty!" She

laughed and bantered with him some more, but I could tell she was pleased. It's never too late to get a tattoo if you really want one . . . and anyway, sheer vanity is the cheapest coin of the tattoo trade.

As the first tattoo got underway, the buzz of the needle began its inevitable drone that would be the background noise for most of the next ten or eleven hours. Aaron had agreed to a taped interview for this book and wanted to do it later in the day. Right away he said, "You should interview Jimmy too. He'll have a lot to say." Jimmy Martinez is an artist who got his start as a tattooer with Aaron.

By four o'clock that afternoon Aaron had started my tattoo and was well into it when a young African American woman came in with her mother. She wanted to get a portrait of her father tattooed on the back of her right shoulder. Her father had died of cancer a year before, and her mother had his portrait tattooed on her ankle. Jimmy quickly got set up and started the tattoo. We could easily talk back and forth between the two booths, and we started a conversation with Jimmy while he tattooed the young woman.

"I love doing photographs," Jimmy said. "The challenge of light source and capturing the personality of the person. I'm doing a lot of charcoal portraits now."

"When did you get your first tattoo?"

"When I was fifteen years old I started getting tattoos. It was kind of a preoccupation. I thought I was a tough guy," he laughed. "I got four or five, and then I just grew into big ones." Now he has two full sleeve patterns.

Jimmy went on to tell us that he first met Aaron through Jeff Baker six or seven years ago at a gym, and then they kept in touch for the next two years. When Aaron decided to open his own shop, Jimmy was the first person that Aaron invited to come on staff.

"I've learned a lot from Aaron about tattooing," Jimmy said. When Jimmy started tattooing he had been into art for years and was going to school at the Riverside Community College. At the time he was managing a gas station and going to school at the same time, and at first he just wanted to do something that would free up his time for school.

"What do you think is the value of tattoos?" I asked.

After thinking for a few seconds, Jimmy said, "Individual expression."

Aaron added, "People are always trying to give meaning to it. People take themselves too seriously. I mean, there are some designs that *deserve* reverence."

"What do you think is the spiritual value of tattoos?"

"I think it's subjective," Jimmy said. "I think it's a life changing experience, like a marker. It changes your body, whether it's good or bad. It's more like graphic art for me—I get to decorate my body."

Gita, who was visiting with us during for the day, told us that her friend Molly had gone to Samoa to get a tattoo. In her experience the main difference between American and Samoan tattooing was that in the Samoan process there was a lot more pressure used. She said that the tattooer actually picks the design for their client and decides where it is going to go. Because the symbols are sacred to Samoan culture, and the tattoo artist is more like a shaman or medicine man, he is the only one who knows what is right for the person who is getting the tattoo.

"What about you, Gita? Why did you get tattooed?" I asked, admiring the gorgeous tattoos, art and tattoo by Aaron, in vibrant colors that covered her upper arms. Across her chest a golden yellow *dorje* glowed, wreathed in heavenly clouds of celestial blue, artwork by Nara, tattoo by Aaron. Her back is currently a work in progress, where Aaron is executing a bit of a masterpiece: two magnificent Oriental women in a water landscape with lotuses, their faces a study in feminine grace, beauty and serenity.

She shrugged, laughed and said, "I've always wanted a tattoo, since I was fifteen years old! I had to wait until I was eighteen because my mother didn't want me to have one."

I asked Aaron, who was busy tattooing my back, "Have you ever known anyone whose life was really changed by a tattoo?"

"I have," Aaron answered emphatically. "About a year ago I tattooed this kid with a crown and heart and the name, 'Sherry.' He came to me four days later, crying and thanking me for it. He brought me a lot of gifts. I said, 'It's just my job.' Then he told me that his mom was dying of cancer and that he had gotten the tattoo for her. She was on her deathbed in the hospital when he showed it to her. It became a moment for them. He said it was his last chance to show his mom how much he loved her, and evidently it moved her tremendously. She died about a year ago. His father came in the other day and got a tattoo—a portrait of her. His first tattoo."

Knowing that I was in for another three hours under

the needle and feeling the intensity begin to build, I asked Aaron, "Does anyone ever leave in the middle of their tattoo experience because it's too painful?"

"I won't let them leave," Aaron answered. "I'd much rather they hate their tattoo experience than hate their tattoo. I never let people go half finished. I'll lie to them," Aaron chuckled, "making them think they're almost done so they stay and finish it!" Very wise, I thought.

Hours later, after two tattoos, a visit from Gabriel and a dinner break for all, Aaron started on his last tattoo for the day. It was after eight o'clock at night as I set up the tape recorder for a more extended interview and

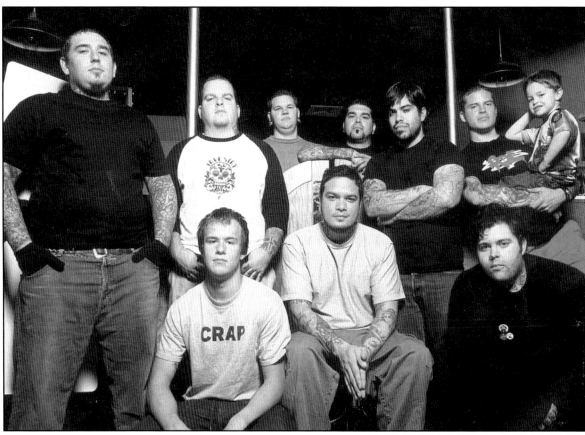

The staff at Tattoo Revolution.

settled down in a chair beside my friend M., who was lying on the massage table for her tattoo, a beautiful deity that would be done in shades of black and grey scale tones.

I was most interested in Aaron's story, which I had heard many years ago. Earlier that day two of Aaron's long-time friends came by the shop to visit. He mentioned that he'd been in the circus with one of them, a young woman. That seemed like a good place to start.

"So you were in the circus when you were a kid?" I began. Aaron was bent over, the needle in his hand, concentrating on his work. Somehow he managed to answer my questions and do the tattoo at the same time.

"Yeah, I joined the circus when I was about twelve. I met a girl that was in the circus, and it was the first extracurricular activity I was ever interested in. So, I got into it. I didn't really know what to do, and she suggested that I get into acro-gynastics—acrobats and gymnastics—which I did. I was in the circus for about two years doing human pyramids and stuff like that. I

also got into this thing called 'Cradle' that was an aerial act—like where you're hanging literally thirty feet off the ground by your knees and you're holding other people by your hands and they're doing tricks. That was a lot of fun. I did that from about age twelve to fourteen. For a couple of the shows the following year I was a roustabout—a person who set up and broke down the stage between the acts and things like that. I really liked being involved. I was still living with my parents, and the circus was a local thing here in Redlands. They just had shows here once a year at the YMCA."

"You gave your first tattoo when you were fourteen years old. Something major happened to you that year, didn't it?" I asked.

Aaron answered, "Somewhere between fourteen and fifteen I started getting wound up in drugs. My older sister, who you may meet this evening, was really going through a rough time when I was at that age. She was living in San Bernardino with a drug dealin' skinhead dude. When I got out of the circus … I don't know really what lead me from one path to the next, but I

guess I just wanted to find another group of friends. I ended up hanging out with all of her friends, who were a bunch of drug dealing skinheads. One thing led to the next, and before you know it I was a skinhead and I was doing drugs and dealing and everything else that goes along with it. At age fifteen is when I really took a downward spiral that led me to get kicked out of my parent's house—which I don't blame my parents one little bit for doin'! I would have done the same!" Aaron laughed. "It led me to my life on the streets, living underneath the bridges with the rest of the street people."

I had heard some of Aaron's stories years before of what it was like living on the street—like the time he and his friends were sleeping in refrigerator boxes underneath a drainage bridge, and they woke up at two in the morning with their boxes burning. Unmistakably, someone had set them on fire, because the boxes were located at some distance from each other. They jumped out and headed down the block to an old abandoned house where they could sleep. Homeless kids mingling in with all the other homeless people on the streets, they were constantly on the move, going from one place to another, everybody focused on his own survival.

"Jeff Baker was the first person you tattooed, right? How did you do it? Did you have the equipment, or did you rig something up?"

"Yeah, I made my own machine. I met people through my sister that had been in and out of prison and knew how to make tattoo machines."

Sitting in this professional environment, watching Aaron concentrate on the image that was just beginning to take form, I reflected on how different things are for him now.

"Were you doing artwork at that time?" I prompted.

"Oh yeah. Well, I was doing artwork since birth, basically, which was what led me to do my first tattoo. We were kind of bored, just sittin' around, and I was kind of nominated as the one to give the tattoos," he chuckled at the memory, "cause no one else really knew how to draw!" We laughed, remembering how it is as kids, the spontaneity, the devil-may-care risks we take.

"So you've been drawing since birth . . ."

"Well, I can't remember the first drawing I did, but I know that my first memories are of drawing."

"And you learned how to make a tattoo machine from people you knew who had been in and out of prison?"

"I first started making my own tattoo machines in a drug-induced creative haze. I'd made one before that was actually attached to a glove, and the conductor was on the fingertips of the glove, and it would only turn on when you put the glove all the way on, because then your finger would make the two electrical currents go together and turn on." The grind of the tattoo needle stopped as Aaron lifted it up and laughed heartily for a moment. "Not very uh . . . what's the word? Practical . . . When I actually did the first tattoo I wasn't living on the streets yet. It wasn't until probably nine months after that that I was full-time on the streets. That was around 1991 or 1992."

"You were fifteen, you were living on the streets, kicked out of your parents' house, you were a skinhead. What was being a skinhead about for you?"

"You know," Aaron responded after a moment's reflection, "I don't remember one time when the topic of race was brought up among me and my friends. It was basically just a bunch of scared kids gettin' together—you know? If it had to do with any one thing, I'd have to say drugs."

I remembered that Aaron had spent two years in Juvenile Hall in San Bernardino during his teenage years. I asked, "You were in Juvenile Hall. Locked down, right?"

He stopped for a moment and answered, "Yeah, you're locked down, but basically Juvenile Hall is eighteen and under. I was kind of in and out of it from age fourteen. Finally when I was about fifteen and a half or sixteen they decided to put me away for awhile, which was the *greatest* thing on earth!" He laughed again. The sincerity of Aaron's statement was unquestionable. "Yeah, at fifteen and a half or sixteen they put me in for a year and a half to two years." His attention returned to the tattoo.

"What was that like for you?" I asked.

"It was *great*! I loved it! By the time I got arrested it was the first time in two years that I'd been sober for more than three days at a time—you know what I mean? Also, I was getting reacquainted with my family. They knew where I was, they started visiting. I started building a constructive relationship with them. Basically that was the start of my good life."

"So it turned everything around for you?"

"For sure. You know the people that helped me the most? I was in Juvenile Hall for about six months, and then I was in a boy's home for about a year to a year and a half. I learned so much within that time. Take the whole skinhead thing, for example;

you know the people who helped me out the most were two ladies, Miss Andrews and Wanda Patterson. Miss Andrews was in Juvenile Hall; Wanda Patterson was in the boy's home. And they were both black ladies, and they were the *greatest* people in the world.

"Wanda was the director of the arts and crafts department, and so when I first got in there I stuck to myself for probably three weeks. I hardly even left my room. She had caught wind that I was an artist, and so she invited me down to the arts and crafts department. She really spent a lot of time with me and, man, she lead to all kinds of great opportunities in my life as far as going to art centers. She would send us there for Saturday programs. She was always trying to get me to do one thing or the next. We hosted some shows at the Museum of Natural History. We did a show down there called 'Sculptures and Stone.' It was a Zimbabwe stone sculpture exhibit. Awesome! Anyway, she always had something going on for us. She really, really cared about people."

"And the other woman you mentioned?"

"Miss Andrews. Her nickname when I was in Juvenile Hall was 'Mad Dog 20/20 Andrews.' She was mean! Mean, mean, mean! But then she just had a smile that would melt your heart. If you were nice to her, if you weren't just a knucklehead, she would try to help you out as much as possible."

"A 'tough love' kind of thing," I said.

"Oh yeah, she was great," Aaron added with emphasis, not taking his eyes off the tattoo, the needle droning on.

"So you got back into your art when you were in Juvenile Hall?"

"Yeah. I was more focused on it than I had ever been in my life, because I didn't have anything else to do. I got a lot of positive reinforcement from my social workers and the staff. I was about eighteen when I got out. It was 1995 when I got out, because I got out the same year that I graduated from high school. The Juvenile Detention Center has school and everything. I had to do a lot of catch-up because I didn't go to school for two years prior to being in Juvenile Hall. So I'm actually really happy that I got to graduate with my class. I did three years of work in one year to do it."

The buzz stopped briefly while Aaron dipped the needle into the ink.

"After I got out I always kept in touch with the people who helped me. Actually by that point I was going around giving speeches for the boy's home that I was in. The boys' home was called Optimism International Boys' Home. The Optimists International groups around the world support these homes, and they didn't really know what they were giving their money to, and so they would send me around to the different Optimists International groups to talk about my past, present and future, and how the boys' home had helped me. I was doing that, and then they helped me out with some jobs. I also kept in contact with my arresting officer."

Aaron laughed, and the intense buzzing stopped for a few minutes while he stopped to greet some friends who walked by. Immediately the drone started up again, and Aaron picked up his train of thought, speaking with tremendous respect of the man who arrested him.

"To this day I still talk to him. He's the greatest guy on the earth. He wrote me letters while I was in there. He was just a detective in Redlands, in the Redlands City Police. He was probably in his early to mid-thirties when he arrested me—the last time he arrested me! He arrested me a lot." Once again the memories were punctuated with laughter.

"His name was Detective Steve Dickey—the *greatest* dude in the world! Still! He got switched over to the sex crimes unit and stuff like that. He really wanted to help people rather than be a cop, you know?"

"Were you doing tattoos when you first got out?" I asked.

"No, I took a break for about five months after I got out. I didn't want to do anything that would remind me of how I was. I didn't want to jump back into tattooing because I didn't want to jump back into anything that would lead me back into the [old] direction.

"So, about six months later," he continued, "I was working at Aaron Brothers' and I got this roommate, his name was Naaman Ledbetter. He ended up being one of my best friends. We were sittin' around the house one day and he started askin' me about tattooing, and I said, 'I can do it.' By that point I had come to grips with all the old memories, so I was okay to do a tattoo again. I bought the machine and did the tattoo on him, then tons of people started coming over to my house, wanting to get them. I did them basically for free, or I'd tell people to bring me a six-pack of Pepsi. Nothing much. I stayed clear of a lot of things at that time. I drank only occasionally. I knew at that point that I was still very weak, and if I got myself into a situation where drugs would come around again, I wasn't positive that I could

say no, so I stayed clear of a lot of things."

"You really formed a completely different philosophy of life after all that… How would you describe that change?"

"I don't know how to describe it. I don't know. I do distinctly remember just being the most focused and motivated and healthy that I've ever, ever, ever been in my life. It's hard to put into words. At that point art was still a pastime. I knew it was a good opportunity, but I wasn't seriously considering a career in art. I didn't know what I wanted to do. I'd always done tattoos, and I knew that they were fun, but … It was just kind of natural for me. I had some other jobs that I absolutely hated. Tattoos were something that I could always fall back on.

"Then I realized that you can't do tattoos as something to fall back on. In the meantime, I couldn't find anything that even compared to how I loved tattooing. By the time I came to that realization I was eighteen. I wasn't even in a shop yet. I just started learning everything that I could. I didn't have an apprenticeship. I didn't have anybody to show me what to do, so I taught myself a lot of the wrong way to do things.

"I was really, really fortunate to have the owners of Empire Tattoo—they took me in as an employee. I came in with five pictures, not even in a portfolio, and one person who I'd just tattooed that day, and they hired me on the spot! That's unheard of in the tattoo world. You have to pretty much be established or at least have more than five pictures!" Aaron looked up at me and laughed.

"The Rialto and Inland Empire Tattoo Studios are the same company. I was from Redlands and I said to them, 'Look, I know everybody, and I can get a good clientele going up there and help the business succeed.' They ended up agreeing with me and sending me to Redlands to Empire Tattoo.

"I worked at Rialto for six months to a year. Then when the Redlands shop opened, they sent me over, and I was the first one there. That was the first time I met Gita. Shortly after meeting Gita, it was Gita, Molly, Dana and Shea, and they became like a staple of the shop." Aaron chuckled at the memory.

"They were there [in the shop] nonstop! I can probably attribute a lot of the success of that shop to them, because they went to the University of Redlands, you know, and they really spread the word around. Lots and lots of people came around because of them. I can't remember exactly how long it was after that that I met Lee."

"What happened next? It kind of started mushrooming, didn't it?"

"Yeah! Business went crazy! I was always networking, but one day I didn't know if I was going to have anybody, and the next day I was booked for like a week! It just kind of built from there. I'd say it was around 2000 when it really, really hit strong."

"And then you started doing these 'sacred art tattoos,'" I remembered. "That was a change. Was it hard in any way to do this kind of art, where you usually couldn't improvise at all?"

"That was in the midst of everything," Aaron spoke candidly, "Oh, it was a freakin' headache at first. I'm serious! It was a really, really bad headache. I learned a lot about what could be done and what couldn't be done. As I learned I tried to tell people, 'You can't do things that are *that* detailed, you need a black outline.' It's important to understand what really translates as a tattoo—some things work and others don't. But it was all well worth it. It was definitely a struggle, though—so much of a struggle that I didn't even want to start to learn about what all this stuff was! If I knew all that on top of what I was doing I'd go out of my mind!"

Aaron laughed again. The needle droned on. "It was worth it, for sure! You know, I mean any knowledge gained is well worth it, and I gained so much . . .'

"Do you think this art has had an effect on you?"

"Yes, I think so. Certain pieces more than others. Or maybe it's the people I tattoo. I don't know. I remember I had a powerful experience that really stands out in my head. It's hard to say, because, on the other hand, I was tattooing [her] for seven or eight hours straight, and I was tattooing on her [mastectomy] scar, and I could tell that it was painful for her, and I'd been tattooing long hours for four days nonstop at that point. It could have been any mixture of delirium or whatever. Usually I try to handle whatever happens pretty well. That was the only point when I actually had to really smack myself into shape and get *me* through doing the tattoo.

"But if, for example, you look at the way my house was decorated, and look at the way it is decorated now, I have definitely grown a very deep appreciation for this art. I've found that in custom pieces that I do, say I'm doing water or flames, I've noticed that they have a little bit more of that influence, just because I've done them so much. I know how to make that sort of water or those types of clouds—those kinds of flames look clean and flow well."

The whine of the tattoo needle stopped again for a moment while Aaron pointed to three sculptures of deities—Vishnu, Shiva and a warrior form of Buddha—that sat on top of the cabinet in his work space.

"I have grown an appreciation for this art," he continued. "It's all over, here in my booth, you know. And it's definitely made me more worldly. I've started to look into different cultures for their artwork a lot more. I used to be totally enveloped in American-style artwork or just tattoo-style, traditional tattoos. Black and gray scale portraits are my favorite thing to do. Now when I work with something I try to branch out and appreciate more things and try to learn about more things. And … be more *patient!*" Again Aaron laughed heartily. "It's helped my patience leaps and bounds, which is great, 'cause I've got a son." He chuckled.

I found Aaron's pervasive sense of humor refreshing. I commented, "You know, the context of this book is that these sacred images can make a difference in us, can help us develop kindness, honesty, compassion, mercy, can help elevate the mind through the body, because the images are so powerful. What's your take on that?"

"Yeah, I believe that," Aaron began. "Not for me personally as the *tattooer*. If I was to try to take on what every single tattoo means to every single different person, I'd go out of my mind!" Aaron laughed at the thought. "I think that being a tattooer and doing the tattoos, I have to kind of separate myself from them a little bit. I dream about the images sometimes. But even then, my dreams are very abstract. It's not like some clear message, you know? I'm not analytical enough to try to figure it out."

"You seem to have more of a natural, instinctual relationship to the images, more of a gut level response . . ."

"Yes, for sure … One of the differences I try to create between myself and other tattooers is, just because of the fact that I don't try to understand every tattoo that everybody's doing, or realize that on the same level that they are, doesn't mean that I don't treat it with the utmost respect. You know what I mean? So many tattooers would just blow it off, 'Well it's no big deal,' rush through it as quickly as possible and get what they want as far as money.

"You know, to be a tattooer is to be in a people-pleasing business. You need to have compassion for people and understand people and be able to work with people. I have thousands of people that would say that they know me, but they don't!" He

laughed. "They know what happens here at the shop on a daily basis. People call me up and say, 'This person says they know you and you guys are great friends.' They come in here and of course I'm going to treat them that way. They deserve it."

"You're talking about having compassion for people, and it seems like part of what you're saying is that you don't make any judgments of people."

"Oh sure I do! To an extent. If somebody wants to come and get something racist, I will not do it. At all. Of course, there's going to be judgments in your mind if somebody wants to get their baby's daddy's name on them, and they're covering up their old baby's daddy's name, you know!" Aaron laughed. "You have to kind of laugh to yourself about it—like the thing that Jimmy did earlier today. Certain tattoos do demand more respect than others, that's for sure."

"So the image is speaking to you right away on that level?"

"Definitely. You can also tell just by working with people long enough, you can tell by the mood or feel of somebody what it means to them, as soon as they walk through the door, without a word coming out of their mouths. Usually somebody will give me a real brief description of what they want, and I'll draw it on with Sharpie markers. But within that process, I've got to figure out what they want within a short amount of time. I've gotten to where, nine times out of ten, I can figure it out without asking. I've got to figure out the size of it, what they're going for, the mood they want it to be. You know what I mean? Lately I think I've been a pretty strong ten for ten," Aaron chuckled, "where I haven't had to erase something because people say, 'That's not what I'm looking for at all.'

"I just draw it right on their bodies. It flows a little bit better for me that way. I can make it fit an area of the body better. I think there is always something to be said for having your hands on somebody while you're drawing it because then you're getting their energy as well. I do that with about eighty-five percent of my clientele."

"Nara was talking about how it requires so much discipline to draw this kind of sacred art; I would think it requires a lot of discipline to tattoo it too," I said.

Aaron stopped the needle briefly, then resumed. He shook his head in the negative and said, "I have no discipline to draw. None. If somebody gave me five hundred bucks to sit down for twelve hours and draw a picture like Nara does, I'd just give your

money back, because I know it wouldn't be done by that time. I'd just beat around it for about a year and a half and finally get it done—maybe." He chuckled.

"I was very interested in finding that a lot of tattoo magazines and books are talking about tattoos being 'transformational' and 'mind altering,' and how they can really change your life," I ventured. "Tattoos can really be very strong for people."

"It's true," Aaron agreed.

"Is that a new perspective, a recent change—about tattoos being transformational," I wondered.

"No, I think, for example, it's like what we think about therapy, or acupuncture. Acupuncture used to be completely taboo. Now more and more and more people are going to do it. I don't know. I think on the therapy level it's just becoming more realized by a more well-read group of people who can appreciate it for that, rather than the bikers and the sailors. You know, people who try to look at it in a different way than just, 'Gettin' a tattoo, brother!'"

Aaron laughed then continued, "The sailors actually got into tattoos at a really deep, superstitious level. You know what I mean? Bikers don't necessarily do that—they kind of got them for the same reasons that the Picts did. The Pictish people."

"The warriorship aspect," I commented, "and to ward off evil."

"Yeah, the Picts got a lot of tattoos to look scary in battle." Aaron stopped the needle, looked up and laughed. "I'm talking about way back when. Even as close as the thirties and forties, a lot of sailors would get tattoos, like the nautical star, for the purpose of not getting lost at sea. Or the birds, you know. They would get tattoos to signify how many times they'd been around the world. They were both tokens for them and, yeah, I would say to ward off evil as well."

"In one way that's not far from the idea that the image has inherent power," I said. "Maybe it's warriorship they're looking for, or to ward off evil …"

Without looking up, needle steady in his hand and droning away, Aaron rejoined, "Yeah, that's true. I never thought about it like that. I've always really slighted people who got the tattoos *just* to be tough, you know? I've never appreciated that at all." He laughed.

"What about your tattoos?"

"It depends. And it changes. The first one I got was a skinhead tattoo, and it obviously had to do with my teenage years. Luckily

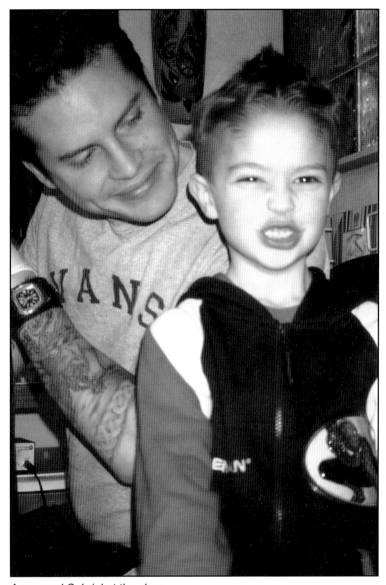

*Aaron and Gabriel at the shop.*

I had that one removed. The next one I did on myself was a big jumbled mess of Celtic knot work, because the Irish thing is something that I was born and raised around and could relate to and take pride in, that wasn't going to go away. My family was Irish and German, but my mom kind of drilled into our heads that we were more Irish than German, even though she is—but us kids aren't!" He laughed.

That was a familiar note for me, and I said, "My grandmother was Irish. The Irish blood has a very strong pull. It kind of blocks

everything else out. So you got a Celtic knot of eternity?"

"Yeah, I did those tattoos on myself, on my leg. After that, then I got the Celtic knot on my wrist. Then I got this one, the whole Celtic war scene. Lately I've been taking a more light-hearted pace. The one that means the most to me that I've gotten lately is the one on my back, from Alisha, a tattoo artist in Sacramento that I met at a convention. I've invited her to come down here and do a guests spot—it's a good chance for tattoo artists to learn from each other.

"The tattoo on my back is an Oni mask," he continued. "They're used a lot in Japanese theatre. They're also like gargoyles."

"All these mythologies have these protective spirits, they're very sacred. Do you see the Oni mask that way?" I asked.

"Yeah, for sure. And with the rest of my back, what I'm going to do is stick with the mask and statue theme from all different cultures. On one side of my back—and these are going to be huge—just faces, like stone sculpture faces, all in super-soft black and grays. One is going to be looking off this way and one's going to be looking off that way, and maybe I might do a Hindu god, an African god—something like that. And then I've always appreciated the lotus. I thought I'd do that with smoke going up my spine, up around the mask."

It was my turn to laugh as I said, "Oh man, that's going to be awesome. A major work in progress! But that doesn't sound so light-hearted! That sounds pretty serious to me!"

Aaron laughed too. "That one I'm not taking so lightly. These other ones, like up here," he pointed to his upper arm, "I have a koi fish getting chopped in half with a samurai sword. Or this one, a tattoo machine, paint brush and pencil, for obvious reasons. You want some goofy ones too that people can look at and laugh. For example, above this koi fish right here, I'm going to get a geisha girl drawing the sword, and with the other hand she's going to be swinging nunchuks and hittin' herself in the back of the head, almost knocking herself out."

I laughed, "That's definitely more light-hearted. Kind of trickster-ish."

"Yeah. I remember I always used to get into fights at school when I was a kid, so on my chest I'm going have two real cartoony-looking kids in the school yard beatin' each other up. One of them fish-hooking a kid and the other kid doin' an uppercut, and then I'm going have like a random tooth flying up on my neck." Aaron laughed.

My friend was lying there quietly, deep into the tattoo. The drone of the needle—the pervasive sound that underscored the flow of time, the emerging image, the sound of our voices talking—took over completely for awhile. It was about ten o'clock at night, and the kids had gone to our hotel to sleep. Outside the vast swarming sprawl of L.A. and its urban satellites glittered and pulsed like an immense starship, the Death Star out of *Star Wars*. Tattoo Revolution, tucked away in the little town of Redlands, seemed like a curious kind of haven for us.

Aaron began again, saying, "I was thinkin' about the tattoo I'm going to get on my chest, and thinking about when I was a kid. I didn't fight a lot for no reason. I fought a lot because I was picked on, constantly, and it used to freak me out. It was bad, really bad. It caused me a lot of turmoil and heartache. So maybe by doing that tattoo I'm kind of turning that into something that I can look back on and laugh about nowadays. You know what I mean? Rather than having it be painful for me."

We talked for a while about tattooing in Japan, and how the tattoo scene has changed in America. Aaron continued, "Oh, tattoo shops in America used to get bombed, blown up. If you didn't ask everybody within a ten mile radius if it was okay if you opened up a shop in that location and just went ahead and did, it would be set on fire—I mean by other tattoo shops. Other tattoo shops would blow you up. There's definitely a lot of respect that has to be gained and earned and kept. There are a lot of people who talk about 'paying your dues' and like that. There are a lot of people now who think they can do it, and they can't."

I asked Aaron about his offer to re-do tattoos for people coming out of prison. He responded, "Nobody ever took me up on that. It was a risk because I'd really have to screen people, and there was the risk of getting gang members mad and all that, but I was willing to take that on because I wanted to do something that really impacted people and helped them in their lives in a constructive manner. Somebody helped me out, and I wanted to do the same thing. I put the word out with probation officers, but nothing ever came of it."

Jimmy Martinez walked over and joined in the conversation at this point.

"What do you think about all the new trends in the tattoo industry?" I asked. Aaron and Jimmy both agreed that the trend had gone from tattoos being ninety percent "traditional" tattoo images or flash art to ninety percent tribal and "New Skool."

"How would you describe the difference?" I asked Aaron.

He replied, "The big difference is that the 'New Skool' tattoos are ultra colorful and sort of bubbly. You take a realistic picture and then distort everything about it. With 'New Skool' tattoo art you draw the image the way it's supposed to look and then twist it."

They spoke about how tattoo artists are beginning to work together, like the New Skool Tattoo Collective in San Jose that, as Jimmy said, "has really broken ground in the Bay Area, doing sculpturing kind of stuff with a heavy emphasis on art. They've set a new standard where everybody works together to boost each other and learn from each other. That's really encouraging. Now that you have co-operation, you have to realize that you have to take your work more seriously."

Jimmy continued, "Right now there is an extreme separation between artists and tattooers. Most of the younger generation are going in an art direction—not just image-based art, but art based on [creativity]. It used to be real secretive, you know, like trade secrets and things like that, and now that you have co-operation, people are starting to realize that it's just helping the industry. You have to be more committed and take your job a lot more seriously and take your art a lot more seriously, instead of taking patterns down and reduplicating and regurgitating them.

"You know, the future is having an art background and/or having some type of induction into some type of art. We've got guys who are tattooing now who are freakin' amazing illustrators, who have art pieces in galleries, and their day job is giving tattoos. The artist never had this luxury before. You'd struggle over painting for years and not get any benefit from it; you wouldn't make any money, and maybe you would die and become recognized. Maybe you'd sell some pieces in some low-brow galleries and eat. Now you can tattoo and make an income and focus on your art.

"In the past you were just a tattooer. You came from some biker family and you got dropped off at some tattoo shop and learned how to tattoo. That's cool in its own respect.

"I think I got into tattooing, maybe not in its most lucrative sense, but definitely in the best part, because it's like a renaissance of art right now. It's incredibly competitive, and you can't get rich off tattooing, but you can definitely push yourself to be an amazing tattoo artist if you want to."

"What do you think about sacred images like this one?" I asked Jimmy.

"It's very historical art. Every genre of art influences other art. I think it's cool stuff. I like it a lot. It has an aesthetic quality."

"Where do you see it fitting into this trend we're talking about? Here it is showing up, and we're seeing it more and more …"

"Most definitely," Jimmy reflected. "Like Aaron was saying earlier about musical art, you see people today taking Tibetan images, Hindu images, and integrating them into their own personal art. It's just going to lose its religious meaning, but the art itself has influenced the tattoo industry, most definitely. You see a lot of deities and symbolism. It's kind of hodge podge, because a lot of these guys don't really know the significance behind it, but the pure beauty of it is influencing [tattoo art]. You have these Japanese traditionalists who do Japanese art with such mathematical precision, you know, you have to have certain seasons for certain spiritual animals, and all these certain types of flowers and leaves will be used. And then you have other guys who are like, 'This is my art and I'm going to do it the way I want to do it.'"

I responded, "These sacred images, the deity art and all that, are very specific, if you do it by the tradition. Certain colors mean certain things, certain implements that the deities hold, you know, all that has meaning symbolically. Earlier you were mentioning the beauty in the art. Where does that fit into it all?"

"One person's beauty is another person's fear," Jimmy reflected. "I think you have to have a compromise between you and your client. He is going to come and address what he finds attractive, and you have to find some type of communication—a happy medium between you, what you will both feel happy with. That's when I think it becomes less art and more of a job."

"You become more of a technician," I commented.

"Exactly. 'Cause I've got to feed myself. Sometimes I've had a big smile on my face and had to tattoo some stuff that I don't necessarily like. But as long as they're happy … If they're stoked when they leave here, then I've done my job. Now if I'm tattooing stuff that I like all the time and everyone's bummed, I'm in the wrong field." Jimmy laughed. "Unfortunately, I'm starting to think that in Western culture it may be more a trend, you know, for a lot of young people."

"You think it's a short-lived fad?"

"I don't think it's going to be short-lived. I just think that everything we do is for a season … And right now, you know …"

Aaron added, "I can see it dyin' out and comin' back and dyin' out and comin' back, but never going away."

Turning to Aaron, Jimmy said, "We're probably on the downward slope, wouldn't you think?"

"Yeah, for sure."

Interested in the direction they were going in, I asked, "You mean it's already peaked in this cycle?"

"Yeah, I think it peaked, probably, back in '98," Aaron answered.

Jimmy continued, "I think once you start to see a bigger separation between people that are really skilled technicians as tattooers, and then a bunch of what we call 'scratchers,' it's not gray anymore. You can see the separation really easily, and then the general collective of people know that there's places to get art tattooed on you and there's places to get [anything tattooed on you.]"

"'Scratchers' are people who … ?"

"They don't really care about what they do," Jimmy answered my question, "and they're not tryin' to improve. They just get themselves into a money-making mindset."

"Or they want to do it because people think tattoos and tattooers are cool," Aaron said, looking up from his work for a moment.

"I'm the biggest nerd alive!" Jimmy laughed. We all chuckled at his humorous non sequitur. I was appreciating the way he and Aaron seemed to enjoy debunking some of the misplaced ideas behind the trendy aspect of tattoos today.

Jimmy continued, "It's good to make a living at it. I enjoy it. I feel real fortunate to be a tattoo artist. I finally succeeded in that. I conceded. I didn't know if I was going to do something else with my life. I think my art has improved since I've kind of given up on doing anything else. It's something I needed to feel; once I gave up on a future career in some other field—ever since I started tattooing here—I was, like, 'I'm going to be a tattoo artist for the rest of my life.' I think I've improved leaps and bounds in this environment!"

Aaron agreed with this statement wholeheartedly. He was putting the last shading touches on the tattoo. We got into a conversation about whether or not tattoos are a statement of protest against the prevailing social norms and the power of the political machine. Aaron said that he thought that had "died out in 1984." Then, with a dry laugh, he added astutely, "I mean,

tattooing is *not* the way to get away from the machine!"

"Do you really think tattoos as social protest ended as early as 1984?" I asked, pressing further.

"No, it was probably after that," Aaron said, "but … that's when the whole punk rock revolution happened, and that's kind of when it peaked."

Jimmy said, "Once you start seeing iconic figures getting tattoos, you started seeing rock stars with tattoos all the time—everyone wants to emulate that. Every frickin' punk pop boy band has tattoos! It's almost the exact opposite now. I think people are into tattoos to conform now. You know, they see the bands, they see the rock stars. They're not doing it [to rebel]. Not that I really give a shit!" He laughed, then continued, "And they're the kids that are placing the hollow significance on it—you know, 'I got this and that.'"

"Do you see a lot of people like that come in here?"

Jimmy answered, "Oh, most definitely! They pay my bills!" We all laughed. "Then there are professionals who have families and just like to have tattoos—they're getting full sleeves right now."

Aaron commented, "Yeah, I would say the biggest rebel is the lawyer that gets a tattoo on his forearm and has to cover it up with long sleeves every day, you know? He's got the most to risk and he's the most dedicated."

It was ten-thirty by now and the tattoo Aaron had been working on was almost finished. Jimmy stood up and said goodnight. The buzz of the needle droned on. There were only a few minutes left to go. The hum hum hum hum hum of the needle bearing down on flesh came in waves as Aaron did the final shading. I looked up at the awards decorating Aaron's stall: The "First Place Best Color" trophy for a piece on Jeff Baker's arm in the Hollywood 2000 Tattoo Expo, and another first place trophy won at the Valley of the Sun Tattoo Jamboree 2002 for the Mayan/Incan deities and landscape on Paul Diaz's arm—a full sleeve in shades of black and gray.

"Well Aaron, where are you going from here? You've gone from the life of a teenage drug addict and delinquent, a refugee from mainstream culture living on the streets under bridges with street people, to being incarcerated in Juvenile Hall for two years, to becoming a respected tattoo artist with a beautiful son, owning a very successful business. That transformation is truly inspiring."

Aaron just laughed. All he said was, "And a lot of fun! All of it, for sure."

# Endnotes

## Prologue

1    Garson, Paul, "Tattoo Revolution—A Fistful of Friendly Ink," *Tattoo Magazine*, July 2004, p. 66.

2    Henk Schiffmacher, *True Love Tattoos*, p. 9.

## Truth, Beauty & Tattoos

1    Rush, John A. *Spiritual Tattoo: A Cultural History of Tattooing, Piercing, Scarification, Branding and Implants.*

2    Krakow, Amy, *The Total Tattoo Book*, pp. 16–17.

3    Horowitz, Tony, *Blue Latitudes: Boldly Going Where Captain Cook Has Gone Before*, p. 58.

4    Ibid.

5    Ibid, p. 59.

6    Ibid.

7    Rafael Pérez Estrada, from the Fall/Winter 2003 *Jubilat*, translated from the Spanish by Steven J. Stewart, published in *Harper's Magazine*, September 2003, p. 25.

8    Coulton, G.G. *Inquisition and Liberty*, p. 61.

9    Robbins, Rossell Hope, *Encyclopedia of Witchcraft and Demonology*, p. 269.

10    Jean Chris-Miller, *The Body Art Book*, p. 41.

11    *The Total Tattoo Book*, p. 7, and *Modern Primitives*, Vale and Juno, Editors, p. 114.

12    "The primacy of natural ecstasy" is a term coined by Lee Lozowick.

13    Friedrich Nietzsche, *Beyond Good and Evil*, p. 103.

14    *Modern Primitives*, Vale and Juno, Editors, p. 193, 199.

15    Chris Rainier and Mark Kirby, "Ancient Marks," *National Geographic Adventure*, November 2004, National Geographic Society, New York, New York, p. 85.

16    Columbia Encyclopedia, Sixth Edition, 2001.

17    Carl Jung, *Essays on a Science of Mythology*, p. 70.

18    James Hillman, *Archetypal Psychology*, p. 2.

[19] James Hillman, *A Blue Fire*, p. 253–254.

[20] Garson, Paul, "Tattoo Revolution—A Fistful of Friendly Ink," *Tattoo Magazine*, March 2005, Issue 187, p. 28.

[21] *Tatouage Magazine*, Aout/Septembre 2004, p. 38.

[22] Trilok Chandra Majupuria, *Sacred Animals of Nepal and India*, p. 35.

[23] Don Ed Hardy, *Pierced Hearts and True Love*, p. 25.

[24] John Fire/Lame Deer and Richard Erdoes. *Lame Deer, Seeker of Visions*, p. 101.

[25] Masaru Emoto, I.H.M. General Research Institute, *The Messages from Water*.

[26] Judith M. Tyberg, *Language of the Gods*, pp. 16–19.

[27] Ibid, pp. 18–20.

# Bibliography

Beer, Robert. *The Encyclopedia of Tibetan Symbols and Motifs*. Boston, MA: Shambhala, 1999.

Chandra, Suresh. *Encyclopaedia of Hindu Gods and Goddesses*. New Delhi: Sarup & Sons, 1998.

Chris-Miller, Jean. *The Body Art Book*. New York: Berkley Books, 1997.

Coulton, G.G. *Inquisition and Liberty*. Boston: Beacon Press, 1959.

Emoto, Masaru. *The Messages From Water*. Tokyo: Hado Kyoikusha Co., Ltd., 1999.

Feuerstein, Georg. *The Yoga Tradition: Its History, Literature, Philosophy and Practice*. Prescott, Arizona: Hohm Press, 1998.

Gerard, Jim. *Celebrity Skin: Tattoos, Brands and Body Adornments of the Stars*. New York: Thunder's Mouth Press, 2001.

Hardy, Don Ed, et al. *Pierced Hearts and True Love*. New York: The Drawing Center, 1995.

Hillman, James. *A Blue Fire*. New York: Harper Perennial, 1989.

————. *The Dream and the Underworld*. New York: Harper & Row Publishers, 1979.

————. *Archetypal Psychology*. Dallas, Texas: Spring Publications, 1983.

Horowitz, Tony. *Blue Latitudes: Boldly Going Where Captain Cook Has Gone Before*. New York: Henry Holt and Company, LLC, 2002.

Jung, Carl. *Essays on a Science of Mythology*. New York: Bollingen Series, Princeton University Press, 1949.

————. *Memories, Dreams and Reflections*. New York: Vintage Books, 1965.

————. *Psychology and Alchemy*. Princeton, NJ: Princeton University Press, 1968.

Krakow, Amy. *The Total Tattoo Book*. New York: Warner Books, 1994.

Lame Deer (Fire, John) and Erdoes, Richard. *Lame Deer, Seeker of Visions*. New York: Pocket Books, 1972.

Majupuria, Trilok Chandra. *Sacred Animals of Nepal and India*. Bangkok: Craftsmen Press, 1991.

*Modern Primitives*. Editors: Vale, V. and Juno, Andrea. San Francisco, California: RE/SEARCH PUBLICATIONS, 1989.

Nietzsche, Friedrich. *Beyond Good and Evil*. London: Penguin Classics, 1990.

Robbins, Rossell Hope. *Encyclopedia of Witchcraft and Demonology*. New York: Crown Publishers, 1959.

Rush, John A. *Spiritual Tattoo: A Cultural History of Tattooing, Piercing, Scarification, Branding and Implants*. Berkeley, California: North Atlantic Books, Frog, Ltd., 2005.

Schiffmacher, Henk. *True Love Tattoos*. Koln, London: Taschen, 2001.

*Tatouage Magazine*. Editeur, Jacques Tillier. 12 rue Mozart, 92587 Clichy Cedex, France: Editions Larivière.

*Tattoo Magazine*. Editor in Chief, Billy Tinney. Agoura Hills, California: Paisano Publications LLC.

*The Encyclopedia of Eastern Philosophy and Religion*. Schuhmacher, Stephan and Woerner, Gert, Editors. Boston: Shambhala, 1994.

*The Oxford Dictionary of World Religions*. Bowker, John, Editor. Oxford: Oxford University Press, 1997.

Tyberg, Judith M. *Language of the Gods*. Los Angeles, California: East-West Cultural Centre, 1970.

Walker, Barbara G. *The Woman's Encyclopedia of Myths and Secrets*. San Francisco, California: HarperSanFrancisco/HarperCollins Publishers, Inc., 1983.